COLORED PENCIL
PAINTING PORTRAITS

Master a Revolutionary Method for Rendering Depth and Imitating Life

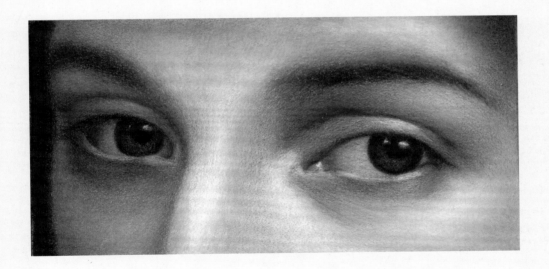

ALYONA NICKELSEN

WATSON-GUPTILL PUBLICATIONS
California | New York

Front Cover: Alyona Nickelsen, *Emma*, 2016, colored pencil painting on sanded paper, 24 x 20 inches

Back Cover: Alyona Nickelsen, *Caleb*, 2016, colored pencil painting on sanded paper, 16 x 13 inches

Page i: Alyona Nickelsen, *Gabrielle's Eyes*, (after William-Adolphe Bouguereau's *Gabrielle Cot*), 2015, colored pencil painting on acrylic gesso, 4 x 8 inches

Page iv: Alyona Nickelsen, *Caleb*, 2016, colored pencil painting on sanded paper, 16 x 13 inches

Published in the United States by Watson-Guptill Publications, an imprint of the Crown Publishing Group, a division of Penguin Random House LLC, New York.
www.crownpublishing.com
www.watsonguptill.com

Most illustrations by the author.

WATSON-GUPTILL and the WG and Horse designs are registered trademarks of Penguin Random House LLC.

Library of Congress Cataloging-in-Publication Data
Names: Nickelsen, Alyona, author.
Title: Colored pencil painting portraits : master a revolutionary method for rendering depth and imitating life / by Alyona Nickelsen.
Description: First edition. | Berkeley : Watson-Guptill, 2017. | Includes bibliographical references and index.
Identifiers: LCCN 2016037019 (print) | LCCN 2016038657 (ebook)
Subjects: LCSH: Portrait drawing—Technique. | Colored pencil drawing—Technique. | Water-soluble colored pencils.
Classification: LCC NC773 .N53 2017 (print) | LCC NC773 (ebook) | DDC 741.2/4—dc23
LC record available at https://lccn.loc.gov/2016037019

Trade Paperback ISBN: 978-0-38534-627-6
eBook ISBN: 978-0-38534-628-3

Printed in China

Design by Chloe Rawlins

10 9 8 7 6 5 4 3 2 1

First Edition

This book is dedicated to the One who guides my hand and mind.

I am eternally grateful to the love of my life, best friend, partner, and editor, Thomas Nickelsen, for his effort, support, and help dealing with all that was involved in this work "behind the scenes." I want to thank all my beautiful models, readers, and students; I hope you like the result of this undertaking. I would also like to express my appreciation to my Watson-Guptill team: Jenny Wapner, Lisa Westmoreland, Alisa Garrison, Jennifer McClain, and Chloe Rawlins, who saw me through this book.

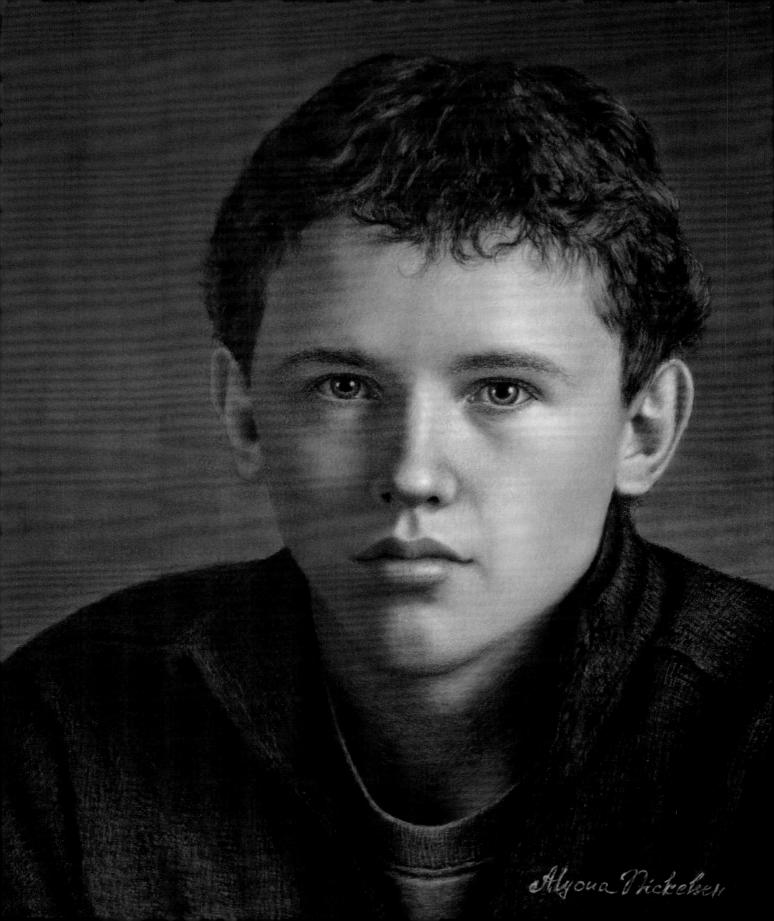

Alyona Nickelsen

CONTENTS

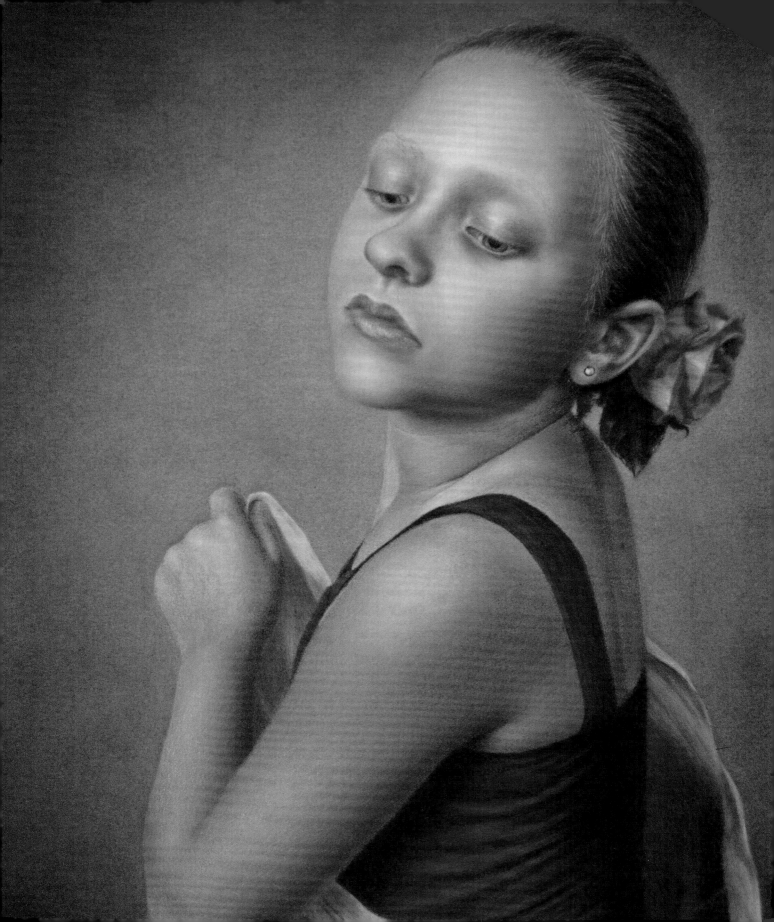

FOREWORD

In 2011, when I decided to start a colored pencil art magazine, I knew that I was going to need an expert in the field to represent this amazing medium. I chose Alyona Nickelsen. I was honored when she agreed to be the Q&A columnist for *Colored Pencil Magazine*, a column she was dedicated to for two years. She also helped with our *Colored Pencil Student* digest launch in 2013 when she agreed to provide art lessons for the first year of its publication.

In the time that I have known Alyona, I have had the privilege to see, firsthand, a depth of knowledge that I didn't even know was possible with colored pencils. She is not only an artist but an avid researcher, scientist, and pioneer. Until I met Alyona, I had never heard of an artist analyzing art materials under a microscope or measuring color depths with a colorimeter. I know of no one else who has the understanding of art masters and color theory the way that she does. It is no wonder that numerous top art supply manufacturers depend on her knowledge to improve their products.

Alyona's vast and virtually complete collection of colored pencils and colored pencil books would rival even the most passionate collector. All of this knowledge and her materials are the basis for Alyona's artwork, but the spirit of her work, I believe, comes from her life experiences. What many people don't know is that Alyona was raised in Communist USSR, where dreaming of what you can do by working hard and applying yourself is not something that was rewarded or promoted. As a young woman, she made it a goal to experience the American dream, and in 1999, she achieved what she set out to do and moved to the United States of America. In 2009, she published her first book, *Colored Pencil Painting Bible*. This book is credited with taking colored pencil art to an elevated level, and it inspired new artists to try their hand at what once was regarded as a sketching medium.

Alyona Nickelsen,
Mary-Ashlynne, 2014,
colored pencil painting
on acrylic gesso,
24 x 16 inches (Detail)

With this new publication, Alyona is again taking us to another plateau as she shows us not just that colored pencil can stand side by side with our more respected traditional mediums, but why it's even better! You will be intrigued by techniques that promise to cut your work time to a fraction of what it once may have been and with results that will be better than you ever thought possible. You will find new tips and learn about brand-new tools that she personally developed over the last several years. Get ready for a revolutionary way to use colored pencils!

I am honored to know Alyona and call her my closest friend and confidant.

—**SALLY ROBERTSON**, editor in chief,
Colored Pencil Magazine

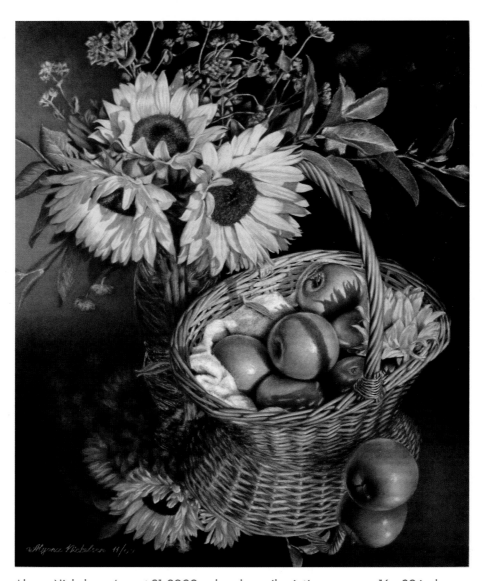

Alyona Nickelsen, *August 21*, 2009, colored pencil painting on paper, 16 x 20 inches

INTRODUCTION

"Eighteenth- and nineteenth-century investigators were impelled to search for ways of utilizing wax in a cold-application method not by ignorance of the molten wax technique, but because, from tales about the half-legendary Greek masters and from vague technical writings, a strong impression was received that the ancients had a second way to paint with wax and that this lost secret was the one used in work that required the highest degree of finesse."

—RALPH MAYER, *The Artist's Handbook of Materials and Techniques*

The colored pencils in my studio are amazingly resilient. They have successfully outlasted the many temptations presented by paints, pastels, inks, and other mediums and, umpteen years later, still hold the preferred position on my work table. I have used the vast quantity of accumulated knowledge about the properties of other mediums and incorporated the more useful ones to further advance and extend the benefits of the colored pencil painting process.

Through continuous research, experiments, and testing, the exceptionality of the colored pencil medium has become clear to me. Its precision and flexibility allows artists to achieve practically any desired effect. We simply need to understand its much overlooked properties and use them to our own advantage. As a result, even the sometimes cumbersome task of covering a large background is no longer a chore. If you know how, you can overcome such challenges in just a fraction of the time you may have come to expect.

In this book we continue the discussion started in *Colored Pencil Painting Bible* about the colored pencil painting process; however, this time it will be based on the example of the portrait genre. Since the publication of my first book, some of the techniques I use today have been updated or modified, some tools were added and others abandoned, and some ideas have been adopted or rejected. But the fundamentals of my approach remain the same: I continue layering colored pencils onto a white surface, producing finished artwork that resembles a painting rather than a drawing. We will be discussing all aspects of my practices in detail throughout the pages of this book.

You might notice that in the majority of "how-to" books, authors list and refer only to the brands that they personally use. Occasionally, some of the materials mentioned may not be available to readers in certain geographical locations. Of course, it is difficult to go through practice exercises and follow step-by-step demonstrations without having the specified colors/brands handy. Also, each pencil maker offers its own set of colors, and sometimes it is nearly impossible to find the appropriate color substitute from one brand to another in a typical art studio. I have taken all of these issues into consideration and devised two tools to overcome them: the Color Match and Color Compare tools.

You can read more about them in the first chapter of the book and access them in the Art Logistics section of my website, www.BrushAndPencil.com. There you can also find numerous concise and detailed videos, demonstrations of techniques, exercises, and the projects described here. (A picture may be worth a thousand words, but a video is definitely priceless.) To better accommodate my readers, I have made the reference images that are used for the projects in this book available for download as well.

The main focus of our conversation in this book is a realistically rendered portrait. Though there are many methods and styles that have been used to create portraits, I will be concentrating only on those that I personally experienced and favor.

Realistic representation of the human face and body has always been considered one of the most ambitious goals for an artist. The complexity and diversity of the human form can present daunting and seemingly overwhelming obstacles to success; however, as is true with all complex projects, the best way to tackle them is to divide them into smaller and simpler pieces. So, let's get down to brass tacks and solve this colored pencil painting conundrum one task at a time.

COLORED PENCIL REVOLUTION

An exploration of new working surfaces, materials, and tools

"Everybody is a genius. But, if you judge a fish by its ability to climb a tree, it'll spend its whole life believing that it is stupid."

—ALBERT EINSTEIN

THE GAME CHANGER

To state the obvious: Colored pencil is not paint, nor does it act like it; however, it can be used in a manner that will produce results and look virtually indistinguishable from a painting.

A large part of colored pencil's young life (its first manufacturing began sometime in the 1920s) was spent as an unremarkable writing/drawing tool for preliminary sketching and coloring. Its ability to deliver saturated color with a unique precision was only recognized about twenty years ago. At that time, "I can't believe this is colored pencil!" was a typical reaction to quality colored pencil work, which pretty much implied that the skills of the artist overcame the inferiority of the medium. Since then, the reputation of colored pencil has slowly grown beyond the status of a typical birthday-party magician—a talented and skillful guy who was invited purely for amusement purposes. Today, colored pencil is finally accepted as a serious medium of professional artists and as a welcomed participant/award winner in numerous and prestigious shows. As such, it takes its well-earned place in reputable galleries, attracting the attention of serious art collectors worldwide.

Alyona Nickelsen, *Jenny*, 2014, colored pencil painting on acrylic gesso, 18 x 14 inches

At least three key factors were catalysts in this transformation:

- A number of manufacturers continued the effort necessary to create professionally suited products and, thanks to free market competition, built an industry to match consumer demand.

- Unique properties of colored pencil have been discovered, recognized, and utilized by enthusiastic and experienced artists who share, teach, and advocate in the promotion of the medium.

- During the modern era of open source knowledge, information is within the reach of practically everyone. These days, it is actually possible to watch the progress of an artwork "over the artist's shoulder" via videos and online tutorials without ever leaving your own residence.

In this book, I will detail the second factor of colored pencil success—its unique properties and methods to achieve amazing results by utilizing them to our advantage.

The fundamental difference between a painting and a drawing is in its natural state—liquid in the first case and solid in the latter. However, the primary purpose of both paint and pencil is the same, to evenly disperse the pigment within the binder and then contain, deliver, and deposit it onto a surface.

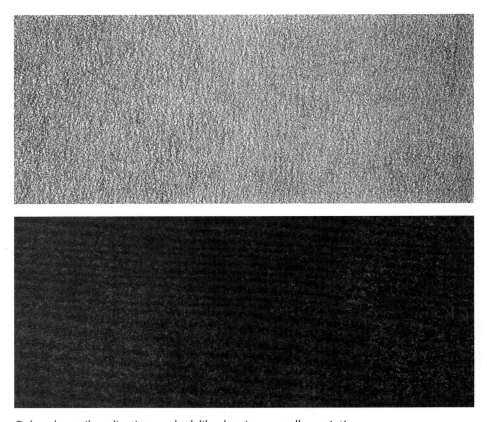

Colored pencil application can look like drawing, as well as painting.

The Painting Process

Let's take oil paint as an example. The pigment in oils is suspended within a carrier or a vehicle such as linseed, poppy, or walnut oil. Pigment is delivered to the painting surface and deposited with a brush. It is partially secured by being trapped between the crevices of the surface's "tooth," but mostly by adhering to it and to some extent being absorbed by it.

When paint is applied to a layer that is still wet, the new and existing paints are physically mixed together, producing a new hue or variation thereof.

When paint dries, it not only conceals pigment within a flexible transparent film but also creates a hard new surface that is available for a subsequent layer of paint. This allows two layers to be superimposed but not intermixed.

Oil paint can be used in a transparent manner with very little pigment (mostly carrier). Likewise, it can be used in an opaque way where the carrier is highly saturated with pigment. And, of course, there are innumerable states between the two. Sounds like a pretty beneficial situation for the needs of an artist, doesn't it? Indeed, oil paint enjoyed the titular position as the "king of the mediums" for centuries. (The earliest oil painting known today is dated circa seventh century AD.)

However, working with oils is not all moonlight and roses. There are numerous issues to deal with and pitfalls that can kill your productivity. For example, oil's tendency to darken or yellow with time has always been a major concern. It can also crack, peel, and blister when not dried properly between the layers. The common solution for this problem is to allow the surface to completely dry before applying

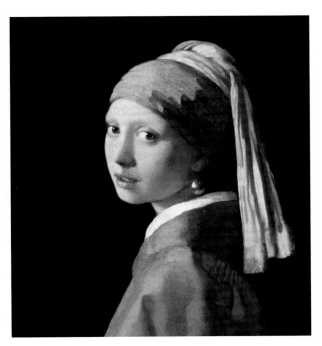

Johannes Vermeer, *Girl with a Pearl Earring*, c. 1665, oil on canvas, 17.5 x 15.4 inches. Courtesy of Mauritshuis Museum, The Hague

Example of severe oil paint cracking.

more paint. Drying time for each layer poses an issue all by itself, as this can take from days to weeks or even months, depending on the type of oil used and the thickness of the layer.

Because time is always of the essence in the life of any professional artist, the search never ends for a medium that offers the positive qualities of oils and negates the problematic ones.

It should be of no surprise that wax as a substance with exceptional qualities has been on the artist's radar for centuries. The vital task of preserving pigment within a stable binder comes naturally

to waxes, since they are malleable, inert, and hydrophobic. The oldest surviving artwork created with wax (through a process called encaustic) is dated circa first century BC. It is safe to say that encaustic medium must be considered as the closest cousin of modern colored pencils judging by the content of both. It is also a fact that encaustic has passed the test of time with flying colors.

The Drawing Process

During the process of drawing, pigment from colored pencil is deposited onto the surface due to the friction between the tooth of that surface and the pencil core. Surface tooth works like a file that shaves off the particles of the core together with the pigment encased within them.

Portrait of the Boy Eutyches, c. AD 100–150, encaustic on wood, paint. Courtesy of the Metropolitan Museum of Art, New York

Example of wax excelling in preservation of pigment with no cracking, blistering, or peeling.

The shaved particles are held more securely when the pencil core contains more wax. When there is less wax, the particles are attached to the drawing surface more loosely.

In addition, pressure from the pencil point drives the particles deeper into the crevices and, thus, helps to secure them to the surface. The more pressure is applied, the faster the surface tooth is filled with pencil medium.

The rigidity of the surface tooth determines the effectiveness of pencil deposition. Since cotton paper tooth is relatively soft, vigorous drawing, a heavy hand, numerous erasures, and the like can lead to paper fatigue—the flaking or peeling of its soft fibers—therefore, working on cotton paper requires a gentle touch, constant sharpening of the pencil point, and tight alignment of individual pencil strokes. This ensures that colored pencil medium fills most of the paper tooth voids prior to collapsing the "walls" of the cotton fiber. Hence, the

process is time-consuming and contributes to the tarnished reputation of colored pencil as a slow and tedious medium. It is also wasteful, due to the major loss of pencil core in the sharpener.

The adhesion of colored pencil medium to the surface is provided mainly by the property of wax to fit hand in glove within whatever protrusions it contacts. This holds wax in place and creates a firm base for the subsequent layers.

If the drawing surface is absorbent, as is the case with many traditionally used cotton-based papers, some content of the pencil core will seep into the surface with time. (A similar effect exhibits when working with oils on an unprimed canvas.) When nonabsorbent surfaces, such as sanded paper, are used in colored pencil work, wicking does not occur and artwork appearance will not be affected.

Subsequent applications of colored pencil do not mix with the previous layers but sit on top like a sandwich. When the surface tooth becomes

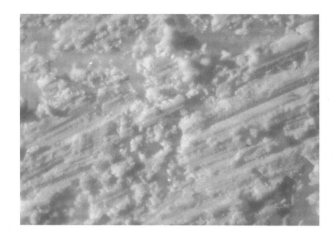

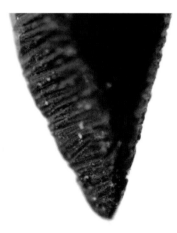

Micrograph of Prismacolor Premier China blue colored pencil point (10x). You can see the ridges created on the pencil point by the tooth of the surface during the drawing process. Wax particles have been shaved off and deposited onto the surface.

Micrograph of Prismacolor Premier canary yellow followed by a layer of scarlet lake and then by a layer of China blue. This illustrates the "sandwich effect" and reduction of friction in colored pencil layering.

saturated with colored pencil medium, friction between the existing wax and the pencil core is gradually reduced. This makes the deposit of additional pigment less and less significant.

These circumstances limit the layering process, narrow the available range of values, and make many techniques common to other mediums virtually impossible to use with colored pencil. Traditionally, colored pencil artists have found ways to work around these issues. Though we can see stunning results from such efforts, it would be very liberating to remove these restrictions.

The Colored Pencil Painting Process

Painting with colored pencils brings the best of both worlds—painting and drawing. It produces the richness and saturation of the surface with colors, which is a signature trait of a painting, within a completely controllable process, which is the prerogative of a drawing.

The unique properties of wax in the pencil core—softness, firmness, inertness, translucency, and water resistance—create a perfect environment for containing, delivering, and preserving pigment with precision that is naturally obtainable through the hard point of a pencil.

My own experimentation and research resulted in a combination of specific techniques and newly developed art materials that successfully resolved all roadblocks traditionally occurring in a drawing. At the same time, my methods involve the most effective innovations of the painting process that are pertinent to the created effect, not to the painting medium itself.

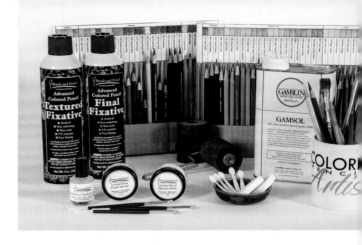

TOOLS OF THE TRADE

The creation of any fine artwork is affected by three major factors: an original design, the skills of the master, and the materials used. The properties of the latter largely impact the techniques and approaches involved, and the overall appearance of the end result, as well as its integrity and longevity. Therefore, most professionals are very particular about their "tools of the trade" and their specific qualities.

Manufactured and Custom-Made Supports

The working surface (or support) plays a pivotal role in the process of creating colored pencil artwork. Its color, durability, and textural qualities affect and dictate the approaches and methods that artists are able to use in their work.

The list of suggested ready-made and custom supports was compiled based on the following considerations:

- **ARCHIVAL QUALITIES** The pH level or acidity of the working surface affects the longevity of the artwork; therefore, all surfaces presented here have a neutral pH level (according to the manufacturer's specifications).

- **WHITENESS** The whiteness of a surface measures the light reflectance across all wavelengths of the full visible spectrum on a scale of 0% (perfect black) to 100% (perfect white). To ensure that artists utilize the entire range of values available to them, the surfaces listed here are only those that are closest to a perfect white.

- **EVENNESS AND TEXTURAL PATTERNS** The level of surface textural evenness affects the appearance of colored pencil application; thus, the surfaces in this list have an even texture with no visible patterns.

- **TOOTH SIZE AND DURABILITY** The included surfaces have a tooth size that varies from "fine" to "rigid," with a durability that allows successful handling of vigorous pencil application, heavy pressure, and other manipulations without the risk of surface fatigue.

- **ABSORBENCY** This collection comprises the least absorbent surfaces; thus, wicking of the colored pencil over time is avoided and deformation of the surface is prevented whenever liquid medium is involved.

SUGGESTED READY-MADE SUPPORTS

Sanded papers, such as Fisher 400 or UART of various grits, provide an excellent support for colored pencil work; however, their natural off-white coloration must be considered during the planning of a composition.

- **CANSON MI-TEINTES TOUCH SANDED PAPER** Acid-free, coated with fine-sanded primer, available in 353 gsm paper sheets and mounted on boards (4-ply or higher)

- **RICHESON PREMIUM PASTEL SURFACE** Acid-free, archival, available on 350 gsm paper, mounted onto hardboard and on Gator foam board

- **ART SPECTRUM COLOURFIX SUPERTOOTH BOARD** Neutral pH, acid-free, available in 500 gsm watercolor paper coated with clear acrylic primer that was mixed with a blend of silica particles

- **AMPERSAND MUSEUM SERIES PANEL PASTELBORD** Neutral pH, acid-free, available in $1/8$-inch (3 mm) hardboard coated with kaolin clay ground and textured with fine marble dust granules

- **PASTEL PREMIER SANDED PAPER** Acid-free, 100% cotton, 145 lb (310 gsm), available in white fine and extra-fine grit, double-primed and coated with aluminum oxide

IMPORTANT: Flexible surfaces, such as canvases or papers, significantly escalate the danger that the applied mediums will crack due to mechanical movement. This includes oils, acrylics, pastels, and so on, as well as colored pencil medium. To stabilize a flexible manufactured working surface, you can mount it on a sturdy backing. This is an easy solution that dramatically reduces the chance of damage in the future.

SUGGESTED CUSTOM-MADE SUPPORTS

Toothy acrylic primers, grounds, and gessoes that are currently available allow the artist to create sanded-paper-like support of a custom size and a desired whiteness that are budget friendly and easy to make.

- **ART SPECTRUM PASTEL AND MULTIMEDIA PRIMER** Nontoxic, permanent, quick-drying acrylic primer, can be tinted with acrylics, inks, watercolors, and gouache. Creates fine to medium tooth. Almost opaque in white color, transparent in clear color.

- **GOLDEN ACRYLIC GROUND FOR PASTELS** A 100% acrylic medium that consists of ground silica (sand) and a pure acrylic emulsion. It dries into a flexible film that is water and UV resistant; can be tinted with acrylic paints and mixed with other acrylic gels. Creates fine to medium tooth. Translucent, dries into grayish white color.

- **LIQUITEX GESSO** Dries into a flexible, non-cracking, nonyellowing film. Can be tinted with acrylic paints. Creates medium tooth. Dries transparent.

- **BLICK GESSO PROFESSIONAL** Pure polymer acrylic emulsion with a high percentage of titanium dioxide, calcite grit, and acrylic resin for maximum opacity and "tooth"; water resistant. Dries matte, flat, and flexible. Will not yellow. Creates medium tooth. Dries almost opaque.

- **HOLBEIN GESSO** This gesso is available in four textures: smooth, medium, coarse, and extra coarse. It dries to a matte finish, is lightfast, and can be tinted with acrylic colors. Coarse white creates medium tooth. Extra coarse creates rough tooth. Both dry to almost opaque.

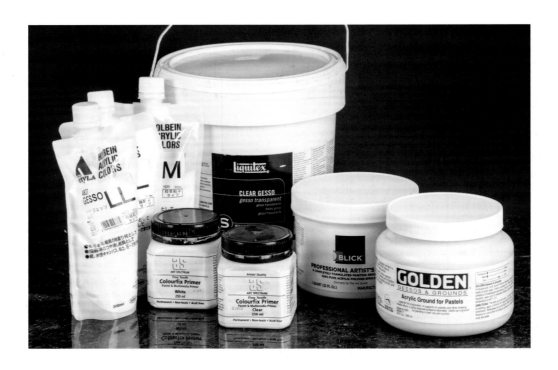

"Oil-" and "Wax-Based" Colored Pencils

In colored pencil painting, obviously, colored pencils are the main vehicle for pigment delivery onto a working surface. In recent years, artists have become more aware and frequently discuss the lightfastness of the pigments used in colored pencils; however, the actual properties of the colored pencil core itself are mainly ignored, are overlooked, and are not effectively exploited, though they play a major role in the choice of methods and techniques used. Of course, the fact that manufacturers do not disclose all ingredients contributes to this situation. Often, the information they do supply is extremely limited, stating only whether a pencil line is so-called oil-based or wax-based.

In general, except for secret ingredients that are well guarded by every manufacturer as proprietary information, colored pencil cores consist of these major parts:

- Body fillers and extenders (such as clay, chalk, kaolin, talc, calcium carbonate, etc.)

- Binders and hardeners (such as cellulose ethers, stearates, vegetable gums, etc.)

- Waxes (such as beeswax, paraffin wax, carnauba wax, Japan wax, etc.)

- Colorants (such as various organic and inorganic pigments and their combinations; fluorescent, pearlescent, and metal powder pigments; dyes; and so on)

Pigments and other components of the core are combined using various manufacturer-specific processes and then thoroughly mixed with the help of water to ensure an even dispersion. The actual properties of the pencil core are determined by the ratio between the fillers, binders, and waxes:

- A higher percentage of fillers makes pencils feel "chalkier." When working on toothy surfaces, the applied pencil particles do not hold on to the tooth very tightly and can be moved around easily using a coarse-bristle brush.

- When a higher percentage of binders is used, the core will be harder. This produces a crisper line and maintains the sharp point longer.

- With more wax present, the pencil feels softer and more buttery. Particles adhere better and more quickly fill the tooth of the surface.

Being familiar with the overall qualities of pencil cores from various brands can help artists choose the most beneficial methods for colored pencil

application and subsequent medium manipulation. The appendix lists the blending abilities of selected colored pencil brands.

The Ultimate Fixatives

The resurrection of wax as a major artist's medium did not occur overnight. It was first used as additives to other mediums and has slowly brewed on the hot plates of encaustic artists for quite a while, though, with little notice by the major art industry. Then colored pencil came to play and brought a new way to imitate the layering effect of oils in a clean and elegant form. It overcame oil's massive drying time and added the benefit of precision and control through its solid point. Unfortunately, the natural loss of friction during the layering process turned into a major obstacle for this medium's growth and popularity.

Colored pencil artists tried to remedy this issue and extend the tooth of the working surface with acrylic-based workable fixatives. When acrylic-based fixative dries it creates a thin flexible film. This provides some friction, so the artist can apply a couple more colored pencil layers; however, this is a very limited solution. Furthermore, acrylic fixatives have a tendency to shift the hues and alter values of the applied medium. They are also toxic, have a noxious odor, and their bonding with wax is questionable. For these reasons, I have never ceased looking for a better answer.

Advanced Colored Pencil (ACP) Textured Fixative and Advanced Colored Pencil (ACP) Final Fixative resolve the problem of limited layering. Unlike various acrylic derivatives that are common on the market today, these fixatives are nontoxic, nonyellowing, nondarkening, acid-free,

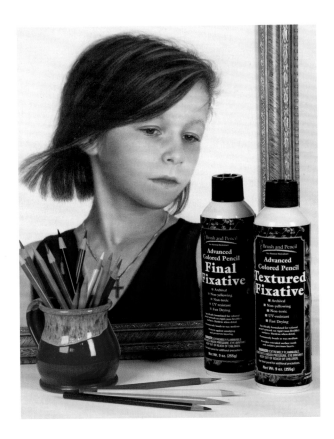

and have no odor. They create a natural bond with colored pencil medium and do not compromise the longevity or aesthetics of the resulting artwork. ACP Textured Fixative enables practically unlimited layering by adding durable tooth to the painting surface. Both fixatives dry and harden in minutes, isolate previous colored pencil layers, and make them resistant to subsequent water, alcohol, or odorless mineral spirits (OMS) application.

These new art materials provide a revolutionary change to traditional methods of colored pencil application, such as developing values from dark to light or creating bright highlights and details at the end of the rendering. These tools address and correct problematic aspects of the colored pencil medium and allow it to thrive in the fine art field.

Solvents and Liquid Blenders

In this book, the term *solvent* is not limited to its traditional representations (such as the turpentine used in oil paints). Instead, it refers to any substances that affect the binder of the colored pencil core. As we discussed earlier, all colored pencils do not consist of the same ingredients; therefore, some have different reactions to these substances than others. For some pencils, alcohol can work as a solvent, though others can only be blended successfully with OMS or turpentine.

The following is a partial list of the many solvents and marker-blenders available for colored pencil artists. Please refer to the appendix for the description of colored pencil brands and how they are affected by various solvents.

SOLVENTS

- Gamsol Odorless Mineral Spirits
- Natural Orange Terpene Solvent
- Weber Turpenoid Natural
- Rubbing alcohol
- Grain alcohol

MARKER-BLENDERS

- Copic Sketch Colorless Blender
- Letraset Colorless Blender Marker
- Finesse Colored Pencil Blender Pen
- Prismacolor Colorless Blender Marker

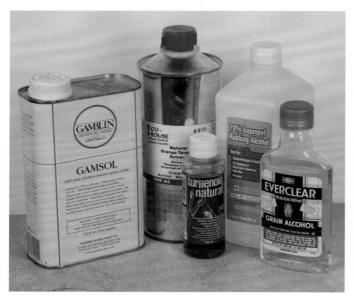

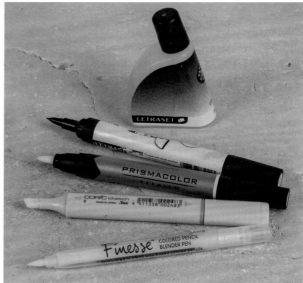

Dry Blenders

Because colored pencil is a dry medium, the traditional approach to blend colors depends on an optical effect rather than a physical one. To achieve the illusion of optical blending, colored pencil layers are superimposed and sit on top of each other, like a sandwich, where the bottom layer is visible through the top one. Different colors can also be juxtaposed, so they are connected together like patches in a quilt. The smoother the transition between two colors, the more convincing the illusion that they are merging. Since hard edges are inevitable "side effects" any time liquid solvents are involved, a few colored pencil manufacturers offer dry colored pencil blenders as an alternative.

DRY BLENDERS

- Prismacolor Colorless Blender

- Lyra Splender Colorless Blender

- Caran d'Ache Full Blender Bright

- Blick Studio Blender

- Derwent Burnisher and Blender

However, a high content of wax in the core of these blenders mostly just "pushes" the pigmented particles into the surface tooth instead of helping them to move freely from one point to another.

The core of colorless blenders offered by colored pencil manufacturers have properties similar to their pigmented pencils.

Powder Blender

Colored Pencil Powder Blender is great for creating seamless value transitions and color blending without liquid solvents. This tool allows you to use the minimum amount of medium for maximum coverage with no hard edges or shifts between the wet and dry states. Powder Blender is inert, nontoxic, and practically invisible when applied. It works as a dry lubricant for colored pencil and simply reduces the friction between colored pencil particles and the working surface.

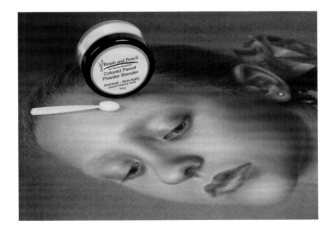

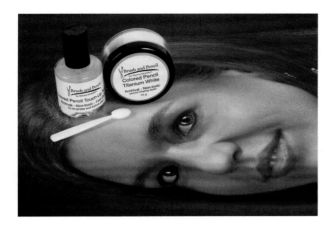

Highlighting Tools

Highlights are normally created in the final stages of the painting; however, this luxury has never been available for colored pencil artists in the past. At that point, the surface tooth is completely obliterated and the white pencil simply slicks off without leaving any impact. Making this situation even worse, the percentage of white pigment in the colored pencil core is so minimal that it is just not up to the task of creating the lightest value in the composition; therefore, colored pencil artists are forced to either reserve the white of the paper for the highlights or incorporate another medium, such as acrylic gel pens, to accomplish this task. Preserving the white of the paper for a highlight is an awkward and backward way to model the form, often leading to incorrect judgment of assigned values and misshaped results. On the other hand, the acrylics applied over wax layers have dubious bonding and uncertain longevity.

Colored Pencil Touch-Up Texture is an easy solution for this long-standing problem. When all layering is done and a highlight is needed, you can simply touch up that area and follow with white colored pencil. If even a brighter white is necessary,

use Colored Pencil Titanium White pigment. This is the most opaque white available on the market today and is the same pigment that is actually a part of any white colored pencil core, but in a higher concentration. A small sponge applicator is just the right tool for the job. You can further secure the applied pigment to the surface with a light coat of ACP Final Fixative.

You can also mix a small amount of Colored Pencil Titanium White with a few drops of Touch-Up Texture to create a paint-like mixture with a cream consistency. Use this for the brightest highlights in your work, such as what you would see in the eyes of the subject. After the highlight dries completely, the Touch-Up Texture in the mix allows you to work over it with colored pencils if necessary.

Water-Soluble Mediums

The properties of water-soluble colored pencils, pastels, and crayons resemble those of "wax-" and "oil-based" colored pencils by delivering pigment to the working surface in a controlled fashion. Then, with the application of water, their binder can be

dissolved and pigment spread across the surface. Similar to watercolor paints, water-soluble pencils create hard edges after they have dried. Application of water-soluble mediums can be reactivated with water. (The exception are Derwent Inktense lines, which become permanent after drying.) Each pigment's staining property determines the effectiveness of corrections and erasures.

The most popular lines of water-soluble mediums include:

- Faber-Castell Albrecht Dürer watercolor pencils (available in 120 colors); lightfastness information is disclosed on the pencil labels

- Caran d'Ache Supracolor Soft water-soluble pencils (available in 120 colors) and Caran d'Ache Neocolor II water-soluble pastels (available in 120 colors); lightfastness information is disclosed on the manufacturer's website, www.carandache.com

- Derwent Watercolour water-soluble pencils (available in 72 colors), Derwent Inktense water-soluble pencils and blocks (available in 72 colors); lightfastness information is disclosed on the manufacturer's website, www.pencils.co.uk

- Lyra Rembrandt Aquarell water-soluble pencils (available in 72 colors); lightfastness information is not currently provided by the manufacturer, www.lyra.de

- Cretacolor AquaStic (available in 80 colors); lightfastness is currently not provided on the manufacturer's website, www.cretacolor.com

When complete spontaneity is needed, watercolor is the medium to use. Transparent watercolor and its opaque version, gouache, allow colored pencil artists to incorporate unpredictable and unplanned passages in otherwise controlled application. Application of watercolor and gouache can be done with natural and synthetic brushes of all shapes and sizes, as well as with rollers for larger areas, such as backgrounds. Natural hair bristles hold watercolor longer and, therefore, allow longer passages. Synthetic brushes release medium more rapidly.

Remember, like any other wet medium, watercolors create hard edges after drying. To create a more gradual value/color transition and seamless coverage, watercolor and gouache can be applied using an airbrush. Corrections and erasures of applied watercolors and gouaches can be accomplished by lifting the medium with damp brushes or sponges, though the final result will depend on the staining properties of each individual pigment.

For use in colored pencil painting, any artist's grade brand with appropriate pigment saturation and lightfastness qualities will do the job. These include Holbein, Grumbacher, Da Vinci, and Winsor & Newton, among others.

COLORED PENCIL PAINTING STUDIO

There are only three ingredients for a colored pencil process that you must have: a surface to work on, the pencils to work with, and an artistic vision to share. Nothing else is required. You will want to pick and choose those little extras that make the entire process easier, more comfortable, and more efficient.

There is no such thing as a typical colored pencil studio. It can be anything from the paper pad with your pencils stuffed in a coffee mug at the corner of the kitchen table to a spare bedroom overtaken by art supplies crammed in the closet and tucked under the daybed to a purposely designated studio with all of your goodies in it. My own workplace

evolved through all these stages, and today I am blessed with the one that is set up to fit my own requirements, schedule, and work style. Feel free to choose and adapt personal solutions and ideas according to your own situation and needs.

Studio Lighting

As we have heard for years, the perfect light in artists' studios comes from north-facing windows placed high on the wall. Don't be discouraged, though, if you don't have a high ceiling, your windows face south, or you live in the Southern Hemisphere, where everything is different. "Perfect" northern light isn't much help to you if you are working long hours for a deadline or you must deal with "moody" weather and frequent light changes throughout the day. Stable lighting is an artist's best friend, and any kind of natural lighting is anything but stable; thus, I have decided that controlled artificial lighting is the best solution for me. In this manner, I can work on my projects day or night, rain or shine.

With a set of blackout curtains, I can completely block the light in my studio and quickly switch back to a natural lighting if needed. With a tool called a *lux meter* (or *foot candle meter*), I can measure the illumination of my working surface at a particular distance from the light source. Based on these readings, I can adjust lighting by moving the working surface closer or farther away from the light source, or by changing the properties of the lighting itself. I have found that a lux level of 1500–2000 is appropriate for my type of work.

ARTWORK AND LIGHTING

In an ideal world, the light where a work of art was produced and the light where it is displayed would be the same. The location, intensity, and color of the light in the studio greatly influence the artist's ability to judge, match, mix, and present colors; thus, differences in illumination can significantly skew the appearance of the final artwork. So, if you can, adjust the lighting in your studio to match the place in which your art will be displayed.

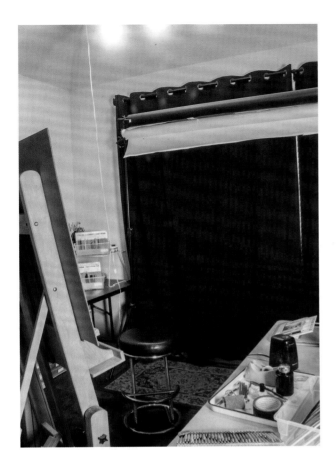

When choosing lightbulbs for your studio, consider the following light properties:

- **WATTAGE (W)**—measures how much power a bulb is using. One watt of power is usually enough to illuminate 2 cubic feet of space.

- **LUMEN (LM)**—measures the actual light emission from the bulb as perceived by the human eye. A total of 6000 to 8000 lm would be appropriate for a medium-size room.

- **LIGHT TEMPERATURE (K)**—measured in Kelvin, evaluates how cool or warm the light is. The higher the temperature, the cooler and bluer the light will be (matchstick flame, candlelight, and early sunrise are up to 2000 K; incandescent household lightbulb is 2500 to 3500 K; typical fluorescent light is 4000 to 5000 K; noon daylight is 5500 K; overcast light is 7000 K; north light is 10,000 K). My personal preference is 5000 to 5500 K.

- **CRI (COLOR RENDERING INDEX)**—measures the accuracy of the bulb to present a full spectrum of colors. The higher CRI is better. A perfect rating would be 100 (natural daylight). I look for bulbs with a CRI rating of 90 or higher.

When a light source is positioned high above the working surface, it doesn't blind you, does not create hot spots, and does not cast annoying shadows from your working hand.

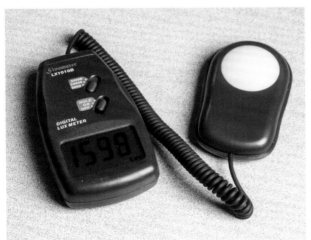

Lux meter (or foot candle meter).

Workplace

Primarily, I work standing in front of a large adjustable easel, though a detailed artwork often requires getting closer to the working surface. In those situations, it makes more sense to work in a sitting position. It seems that a comfortable chair with lumbar support would minimize back, shoulder, and neck stress and allow the artist to spend numerous hours sitting with minimal aches and pains; however, in an attempt to get closer to the details, you naturally lean away from all that support offered by the chair and your back will inevitably become tired within just a couple of hours. I needed an easel that could be moved toward me and allowed me to work long hours while leaning back in my chair.

After a lengthy search, I found a company (www.orbitalholding.com) that customized their existing product and created the Orbital Easel with Extender. It clamps to any flat surface of a table or a desk and extends toward you up to twelve inches. Though it does not come this way, my own easel has Velcro strips that allow me to attach various working board sizes. I frequently rotate my drawing during the rendering for a more natural hand motion. This is easily accommodated with the Orbital Easel, since it rotates 360 degrees and can be fixed by the twist of a knob to any position.

COLOR MATCH AND COLOR COMPARE TOOLS

Colored pencil manufacturers have been very creative with the naming of their pencil colors. It is common to find two absolutely different-looking colors from two pencil lines under the same name or two different names for the same color; however, if all manufacturers were to offer the same colors, it would be much more difficult for them to differentiate themselves in the open marketplace. That is, after all, how they compete and remain in business and profitable. So, each pencil maker offers its own set of colors, and it is sometimes really difficult to find an exact color substitute from one brand to another. For example, two colors with the same name, such as PC 932 violet from Prismacolor Premier and 120 violet from Caran d'Ache Pablo have different properties: violet from Caran d'Ache Pablo is slightly lighter in value, less intense in chroma, and slightly redder in hue. In another example, two colors with different names, such as Prismacolor Premier poppy red 922 and Lyra Rembrandt Polycolor pale geranium

lake 021 have only a slight difference in value but the same intensity and hue. In a third example, colored pencils Prismacolor Premier PC 1002 yellowed orange and Faber-Castell Polychromos 111 cadmium orange have the same value and slight differences in color intensity and hues.

As you can see, color matching is a difficult task for a typical art studio. Besides the fact that this process is cost-, time-, and effort-consuming, it is complicated in many other aspects. For example, two colored pencil swatches that were created using the same colored pencil but with unequal pressure and density can exhibit differences in value and intensity. Also, a hue comparison of two different colors based on a simple visual examination will not be sufficient to provide an accurate judgment of hue relationships (in reference to their positions on the color wheel). Additionally, measuring and data collection of all color swatches must be completed under stable and identical lighting conditions and must not be contaminated by light fluctuation.

Here are some very inconvenient but common situations for colored pencil artists:

- Some brands of colored pencils are unavailable

- The artist is running out of a color and is in need of a quick substitute from another brand

- A pencil line used by the artist does not offer a certain quality of a color

- It is necessary to switch between softer and harder pencils of matching colors

- The artist has a personal preference of a pencil line, but the tutorials and instructions being used are written for a different brand

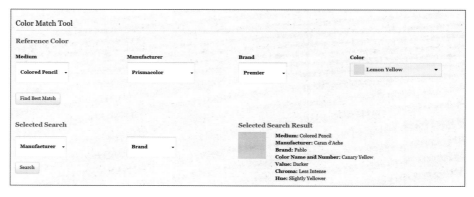

The Color Match Tool allows you to find the closest available match to a specified color among the most popular colored pencil brands. The purpose of the tool is to choose a similar color and show the differences in value, chroma, and hue.

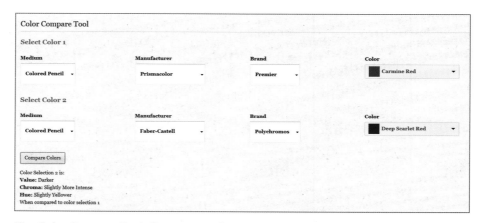

The Color Compare Tool allows you to choose any two colors and compare their value, chroma, and hue.

The Color Match and Color Compare tools are solutions to these problems. Extensive effort was put into the creation of hundreds of uniform color swatches, making hundreds of measurements under an identical light source, analyzing them using the latest technological advances in color measurements, and creating a unique software solution for color match and color compare between the many brands of colored pencils on the market. Occasionally, there is really no match at all; however, in the majority of cases there are approximate matches between colors with minor differences in some or all of their attributes. With the Color Match and Color Compare tools, you can find out if there are color matches and how different they are and in what aspects.

PRESENTATION AND CONSERVATION

I always felt that presenting artwork under glass was like making your guest sit on a couch covered with plastic; however, the curiosity of some "art lovers" who make sure that your artwork is not a photograph by scratching it with a fingernail can lead to a simply petrifying experience. (Yes, this is a true story from an exhibition in Beverly Hills.)

Typically, when presenting artwork without glass, colored pencil artists protect it with a few coats of acrylic varnish; however, often the true mission of varnish is not completely understood. Varnish should not be a permanent part of the artwork. When artwork is displayed under protective glass, besides shielding the surface from scratches, it works like a filter and accumulates all dust, dirt, and other harmful particles from the air to prevent damage to the artwork itself. With time, glass becomes dirty and needs to be either cleaned or replaced, so the dirt does not obscure the appearance of the artwork behind it. Varnish plays the role of protective glass, and so you can see how permanently adhered varnish to the surface of the artwork can turn into a nightmare for the restorer.

Any protective layers must be applied on top of an isolating layer, so they can be removed and reapplied or cleaned without damaging the underlying artwork. Of course, different mediums are susceptible to different materials in different ways, so this brings another task for the restorer—to determine what was used for creating the artwork: Is there an isolating layer and what kind? And what type of protective layer is applied? For the sake of the restorer's sanity, I would suggest that you make a habit of writing this information on the back of your artwork along with the year it was created. After all, you can see detailed information about the content and instructions for care firmly and discreetly attached to every piece of clothing you purchase. Your artwork deserves no less treatment than a T-shirt or a pair of underwear.

For the isolation layer, I recommend applying a few coats of ACP Final Fixative, allowing it to completely dry in between layers. Then, test the coverage with a lint-free white cotton cloth by lightly rubbing it against the surface of the artwork. Ensure that the color is not transferred onto the cloth. Allow the work to completely cure for no less than one week. The result is a hard glasslike surface that will provide reasonable protection against minor scratches; however, common sense should be used, since it is not glass and even varnished oil can be scratched. The surface will be water resistant but not waterproof, so hanging artwork in a humid area or splashing it with water is definitely not an option. Of course, you would not do that to an oil painting either. This layer will not alter the appearance of the hues and values as most of the acrylic-based fixatives and varnishes would. An ACP Final Fixative isolating layer will be resistant to odorless mineral spirits during a restoration process in the future; therefore, you can apply a varnish as a final protective and impermanent coating that can be removed with odorless mineral spirits when needed.

THE RULES OF THE GAME

The use of successful oil painting practices
with the colored pencil medium

*"You have to learn the rules of the game.
And then you have to play better than anyone else."*

—ALBERT EINSTEIN

HOW THINGS WORK

Time and time again, colored pencil not only proves to be extremely versatile but also surpasses other mediums (including oil paints) in ease of use, cleanliness, speed, precision, control, and stability. So I dare to say, "Yes, colored pencil can outperform paints in painting." To support such a bold statement, let's discuss the successful practices in oil painting and their implementation with the colored pencil medium.

There aren't many "how I did it" books written by the Great Masters. A good portion of our current knowledge about their methods and reasoning is based on the hearsay, rumors, memoirs, and unrelated notes preserved through generations of students, rivals, admirers, or simply bystanders. But, it is mostly derived from chemical, spectral, and many other kinds of scientific analyses (thanks to the wonders of modern technology) and wide interpretations by art scholars and field experts.

Knowledge of "how things work" was rare and precious in the days of the Masters, due to limited means of sharing. Today, we live in diametrically opposite conditions, with the Internet and instant communications at our fingertips. Unfortunately, in many new areas of interest, like colored pencil, the situation remains pretty much the same today as it was hundreds of years ago. The present era of informational pollution

Alyona Nickelsen,
Jordan, 2016, colored
pencil painting
on sanded paper,
11 x 13 inches

keeps us thirsty for relevant, reliable, and cohesive knowledge while we find ourselves trying to "drink" from the fire hose of data and do our best to interpret it.

Those who continue the centuries-old oil painting traditions follow the principles that were developed and based on the natural properties and limitations of paints. As colored pencil artists attempt to adapt useful oil painting methodologies, we need to differentiate between those that are applicable to us and those that are not.

For example, a well-known rule among oil painters called *fat over lean* advocates applying "lean" faster-drying oils (those with a lower oil-to-pigment ratio) first and then following with "fat" ones with a longer drying time (those with a higher oil-to-pigment ratio). Following this rule helps oil painters create artwork that is less prone to cracking (though as many experts will tell you, all oil paintings crack—it's just a matter of when, not if). Luckily for us, this vital rule for oil painters is irrelevant to colored pencil painters, since we work with a dry medium.

Pigment classification as "appropriate or not" for underpainting is another example of how painting rules based on the properties of oil mediums are obsolete for a dry medium such as colored pencil; therefore, it is more reasonable to consider the actual role of any stage in the painting process rather than relying simply on "how it was done in oil painting."

So far, colored pencil as an art medium does not have the luxury of being a subject for big-name-art-expert studies or even of being placed under serious examination. There are no meticulously organized catalogs of colored pencil artworks, classifications of techniques, or artists' registry; therefore, my

undertakings here to draw parallels with the "king of the mediums" (oil paints) are driven by intuitive understanding of the great potential hidden within the colored pencil core. These conclusions are based on my own studies and research, observations and interpretations, logical deductions, and years of practical experience.

I have no doubt that Leonardo da Vinci, Titian, Michelangelo, Raphael, Rubens, Rembrandt, Vermeer, and many other Great Masters of realism had one common goal in mind—they were all searching for the best way to present depth in their paintings and to create the illusion that canvas is not really flat. In this pursuit, they came up with their own methods and approaches that were passed from generation to generation of oil painters. Their solutions were based on the understanding of geometric and aerial perspectives, the range of values and their relationships in real

WHAT IS AERIAL PERSPECTIVE?

Aerial perspective is a term used to describe the rendering of objects that are at a distance from the viewer. The farther away the objects are, the lighter in value and bluer/grayer in color they appear. In addition, they will be reduced in size, their details will be less prominent, and the contours will be less defined.

life and within the composition, the properties of colors and our perception of light reflected and/or absorbed by the surfaces covered with pigments, the selective focus of the human eye, and the psychology of human nature.

One such approach was to take advantage of the way transparent and translucent paint layers allowed the light to penetrate them and to bounce back into the viewer's eye. This created contrast with the appearance of opaque paints and, thus, imitated the illusion of depth. The light reflected from the white of the canvas that was visible through a few translucent layers of paint, from the perspective of the human eye, seemed to be traveling a longer distance when compared to the light that was bounced from the highlight on, let's say, the nose of the model (which was painted opaquely at the very end of the rendering). This made the model's nose appear closer to the viewer and implied that, indeed, the canvas was not really flat.

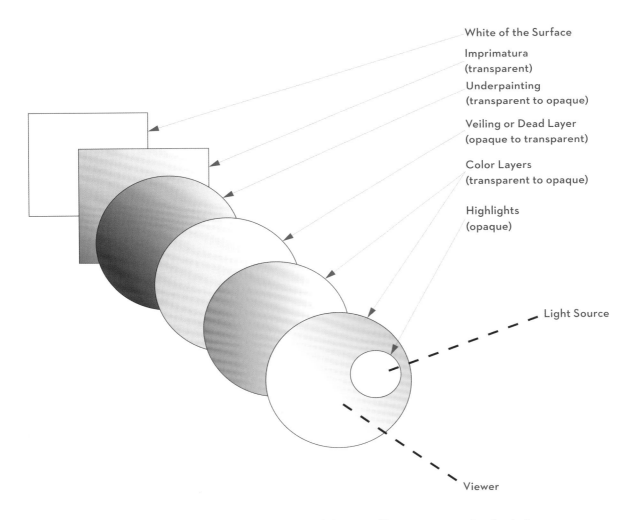

White of the Surface

Imprimatura
(transparent)

Underpainting
(transparent to opaque)

Veiling or Dead Layer
(opaque to transparent)

Color Layers
(transparent to opaque)

Highlights
(opaque)

Light Source

Viewer

Here is a simple schematic diagram showing each part of the typical layering process in oil painting.

WHITE SURFACE

The portion of the depth rendering that could be solved with the help of geometric perspective, anatomical proportions, and compositional arrangements was typically completed during the creation of the initial drawing. Then it was transferred onto the working surface and secured with ink.

Many Master painters opted to work on canvases or panels prepared with white primer. This choice served multiple purposes:

- To provide the widest range of values available in the pigment world

- To increase the luminosity of colors

- To divide the composition into as many planes as possible, making the white of the canvas or a panel function as their farthest spatial level

Some might ask, why use a white surface if it will be covered with the subsequent layers of paint? Why not use a toned or colored surface instead and save the effort and time? Yes, definitely, a colored or toned surface could be used, and many great artists did just that; however, the *maximum* depth that can be achieved in a painting is created when a white surface is chosen as a support.

White reflects the entire visible range of the light spectrum back to the eye of the viewer with minimum loss or absorbance. The white surface is not completely obscured by the subsequent layers and is visible in some areas more than others (such as lit backgrounds) indicating the farthest possible plane in the composition. Any manufactured toned or colored surface is entirely and evenly covered with pigments and, therefore, cannot provide this effect.

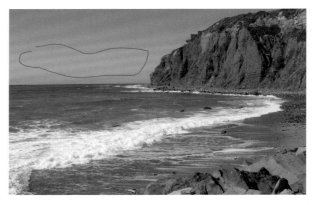

The white of the photo paper (above) as well as the white of the canvas (below) is visible through thin color layers, creating the impression of distance. Any coloration or toning of the white surface darkens its value and, depending on the color, causes some parts of the light spectrum to be absorbed, thus limiting the suggested depth in the painting and influencing the look of any transparent and translucent layers.

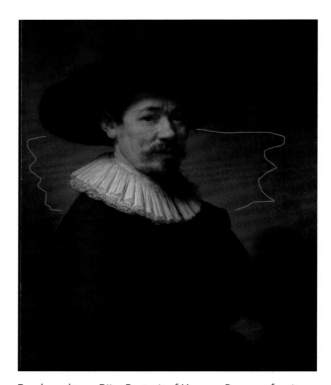

Rembrandt van Rijn, *Portrait of Herman Doomer, furniture maker*, c. 1595–1650, oil on oak panel, 29.6 x 21.7 inches. Courtesy of the Metropolitan Museum of Art, New York

Take a look at the farthest points (marked with red) in the seascape photograph and in the portrait painted by Rembrandt on the facing page.

IMPRIMATURA

By studying the Masters' work, we can see that they normally began the painting process by staining the white surface with a few transparent/translucent layers that consisted of mostly a paint binder with very small amounts of pigments such as umber, sienna, and ochre. This stage is called *imprimatura*, which actually means "what goes before first."

Imprimatura is the very first layer in the foundation, which affects the *entire* painting significantly. It is planned in advance, and the following factors are considered:

- The color of the working surface
- The location of the light source
- The intended tonality of the final artwork
- The color of the imprimatura itself

The Unifier

Imprimatura unifies the painting within a certain tonality (lightness/darkness), temperature of light (coolness/warmth), and the coloration of the piece (the overall hue).

The strength of the light and its proximity in relation to the subject determines the value of imprimatura or the tonality of the painting. For example, a composition with a subject lit completely needs a light imprimatura. When a subject is lit only partially, the imprimatura has a medium value.

With a subject that is spotlit, the imprimatura has a dark value; however, the darkest values of imprimatura are equal to the middle values of the final composition.

The temperature of light determines the temperature of imprimatura: cool light = cool imprimatura, warm light = warm imprimatura.

Some portion of the imprimatura layer can remain completely visible in the final painting; in the background, in the shadows, or partially visible through subsequent transparent or translucent layers.

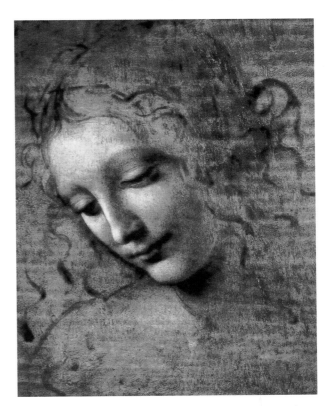

Leonardo da Vinci, *La Scapigliata*, c. 1508, oil on wood, 9.7 x 8.3 inches. Courtesy of Galleria Nazionale, Parma

An example of imprimatura in oil painting.

The color of the imprimatura affects the rest of the painting and should be chosen accordingly. Typical colors used are browns, grays, or earth shades that could be naturally incorporated and later become a part of the painting.

The "Separator"

Imprimatura begins the division of the composition into planes, due to its transparency/translucency. We can consider it as a preliminary separation of the painting into the background and the foreground. It implies that there is more depth behind it (a partially visible white surface), and anything that is painted on top of it is closer to the viewer (all following layers).

The "Killer"

Because values appear darker against a white background, it is easy to make the following underpainting too light and discover it later in the process when the background is already darkened. Thus, imprimatura darkens the values of the background right away ("kills" the white) and allows artists to judge more accurately how dark they should go with the underpainting.

Imprimatura can be successfully implemented in colored pencil painting by the use of transparently applied colored pencil medium (as described in the next chapter), water-soluble colored pencils, or watercolor. The drying time of imprimatura, as well as any other part of the colored pencil painting process, measures literally in minutes and can be completely discounted compared to the time it takes for oil paints to dry.

UNDERPAINTING

After the imprimatura has completely dried, artists transfer the initial sketch and secure it with ink so that it is visible through several transparent/translucent paint layers. We will return to this subject later in the book.

The next stage of the painting process is commonly referred to as *underpainting*. It is devoted to the development of the shadows and further divisions of the planes in the composition rather than to the lit areas, details, or textures. It can vary from transparent to opaque. The farther from the viewer

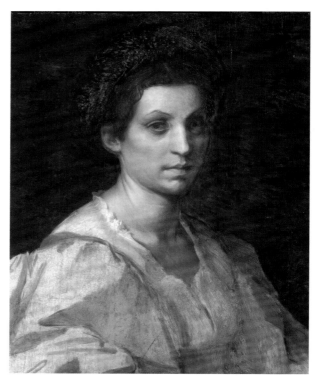

Andrea del Sarto, *Portrait of a Woman in Yellow*, c. 1529–1530, oil on panel, 25 x 19 inches. Courtesy of the Royal Collection, Buckingham Palace, London

The underpainting is still exposed in the shadow areas of this unfinished portrait

the shadowed area is located in the composition, the more transparent the underpainting is.

It is better to work from the farthest plane toward the viewer and gradually increase the opacity of the underpainting. This means rendering can be started at the rearmost planes, such as the sky in outdoor scenes or the farthest wall in an indoor composition, moving forward to portray the frontmost subjects at the end of the process.

How "Dark" Should You Go?

How dark should the underpainting be? The answer depends on what the artist is planning to do in subsequent layering. Every new layer is there not to correct the previous one but to build upon the net result. So, knowing and planning what to do next is vital. Here are a few things to keep in mind when deciding on the tonality of the underpainting:

- Colors look most lustrous when applied over white.

- The darker the underpainting, the duller and darker subsequent colors will look.

- Underpainting can be darkened, lightened by subsequent layers, or left "as is." So, naturally, if the artist is planning to glaze over the underpainting with darker colors, then it should be a tone or so lighter. If the artist is planning on working over the underpainting with lighter colors, it should be a tone or so darker.

- The multilayered transparent/translucent medium will look darker than a single opaque layer. This can be useful for going beyond the darkest available pigments and to extend the value range in the composition.

The darkness/lightness of the underpainting depends on the contrast in the composition and its overall tonality. More contrasted or a darker tonality needs darker underpainting. Less contrasted or lighter tonality requires lighter underpainting.

Dark to Light and Light to Dark

Approaches to underpainting vary from school to school and from artist to artist, but they could be divided into two general groups: *dark to light* and *light to dark*.

In the dark-to-light method of underpainting, the darkest values of the shadows are developed first and then followed with their local colors. This type of underpainting is done in semineutral browns, in grays, or in low-intensity reds, blues, and greens.

In the light-to-dark method, large shapes in the composition are covered with their local colors first, and the result looks like a collection of flat "paint by number" colored spots. Then, after the paint is completely dry, the forms are shaped and shadows are developed by glazing over with darker transparent colors.

The underpainting styles, whether dark to light or light to dark, can be successfully combined within the same rendering, depending on the effect that is needed.

The Color of Underpainting

The choice of color for the underpainting is a subject of personal preference and the general idea or mood of the painting. The color of the underpainting will influence the look of subsequent layers, as well as the final piece:

- Browns provide warmth to the shadows.

- Grays (grisaille) contribute to the shadow's coolness.

- Semichromatic underpaintings flavor the subsequently applied colors by projecting themselves from within. For example, life and energy by spicy reds, coolness and mellowness by dreamy blues, freshness and firmness by hearty greens (verdaccio).

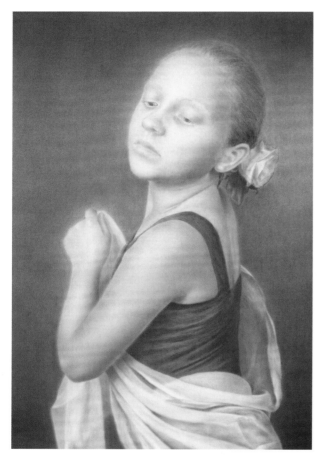

Alyona Nickelsen, underpainting for *Mary-Ashlynne*, 2014, colored pencil painting on acrylic gesso, 24 x 16 inches

This image was created with Faber-Castell Polychromos and Prismacolor Premier colored pencils using the dark-to-light method and a greenish brown color combination.

Alyona Nickelsen, underpainting for *Jenny*, 2014, colored pencil painting on acrylic gesso, 18 x 14 inches

This image was created with Faber-Castell Polychromos and Prismacolor Premier colored pencils using the light-to-dark method and a reddish orange color combination.

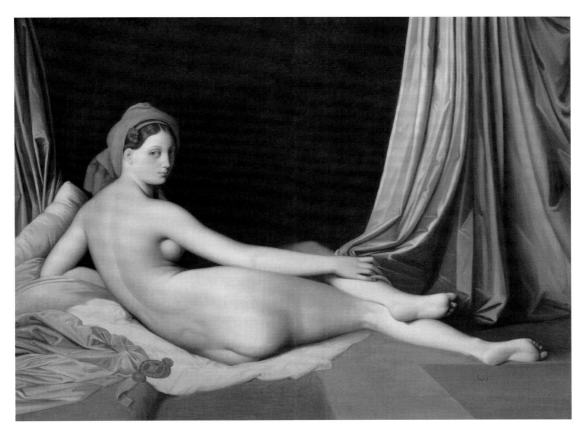

Jean Auguste Dominique Ingres and workshop, *Odalisque in Grisaille*, c. 1824–1834, oil on canvas, 32.8 x 43 inches. Courtesy of the Metropolitan Museum of Art, New York

Because underpainting is responsible for the shadowed areas of the composition, its temperature should be the opposite of the temperature of the light: cool light = warm shadows and warm underpainting, warm light = cool shadows and cool underpainting.

Underpainting modifies the subsequent application of local colors in the shadow areas by lowering the value and intensity of those colors. This creates a contrast with the appearance of the same colors in lit areas.

DEAD LAYER OR VEILING

The underpainting is usually followed by the so-called dead layer. This time the lit areas are the main consideration (though still without the minute details or textures). Despite its somewhat sinister name, this part of the painting process contributes greatly to the representation of life in the artwork. The dead layer is often misunderstood. Sometimes it is mistaken for part of the grisaille underpainting and sometimes it is even omitted altogether; however, this layer has two remarkable roles to play: as a crucial building block in the pursuit of three-dimensionality and as a means of safekeeping lustrous colors.

"3-D Builder"

In the many descriptions of the Masters' works, we often see the phrase "heightened with white"; not *lightened*, but *heightened*. This description is fairly accurate, since their works look very three-dimensional: protruding from the flat surface in the lit areas and receding deep beyond the canvas in the shadows. In short, the dead layer, which is sometimes also called *veiling*, takes part in the creation of this effect by covering the underpainting with white.

But wait, you may say, white is opaque. Wouldn't it obscure the underpainting? Yes and no. The dead layer doesn't obscure or affect the entire underpainting. It is applied only to the portion of the planes that are closer to the viewer than the farthest background.

The opaqueness of white varies depending on the pigment and the thickness of its application. For example, titanium white is more opaque than zinc white. A single layer of white has less hiding power when compared to the application of several layers.

The key for a successfully executed veiling is to create a layer that is *unevenly* translucent/opaque. Its most translucent parts will be at the far planes of the composition and in some portion of the shadows. Its most opaque parts will be in the lit areas and partially in the middle tones (but not necessarily at the foremost planes if they have a dark local color). In this manner, some parts of the shadow underpainting will not be obscured and will be visible through the translucent veil. The lit areas and middle tones will be covered with heavier opaque whites, preparing the groundwork for the subsequent application of the higher-intensity colors.

As we know, white among all pigments reflects light most, fully bouncing it back into the viewer's eye. The translucent white in the shadows will reflect light to a lesser degree compared to the opaque white in the lit areas and the middle tones. This factor of the "uneven reflection" of light creates the effect of depth in the painting and makes the impression that light travels unequal distances from the various parts of the canvas. The white of the pigment here establishes the various levels of depth that are somewhere in the midpoint of the composition—not as far as a background, but not as close to the viewer as the closest planes.

"Color Tuner"

Veiling "tunes," or regulates, the intensity of the subsequently applied colors. In real life, colors under light look more intense compared to the shadows. In painting, colors have the most luster when applied over a white surface; therefore, the intensity and prominence of colors superimposed over darker underpainting in the shadows is downplayed automatically. In the lightest areas, veiling with opaque white provides subsequently applied colors with the most brilliance and creates contrast to their appearance in the shadowed areas. As there is typically no obvious division between light, middle tones, and shadows, the transparent white is used in veiling to "marry" lit colors (applied on top of the opaque white) and shadow colors (applied on top of the underpainting) somewhere in the middle tones. This makes objects appear solid and more natural with some parts under the light and some in the shadow, which also enhances the impression of depth.

Alyona Nickelsen, underpainting and veiling for *Scott*, 2015, colored pencil painting on acrylic gesso, 11 x 14 inches

Created with Faber-Castell Polychromos and Prismacolor Premier colored pencils and titanium white.

COLOR LAYERS

Color layers are the actual bread and butter of any painting. All stages that have been discussed so far create only the preliminary base for the presentation of color. In this part of the rendering, artists not only state the facts that objects have a particular coloration but also continue the pursuit of the three-dimensional effect in the painting, orchestrate the hierarchy of focal points and accents, and refine the textural appearances of the surfaces.

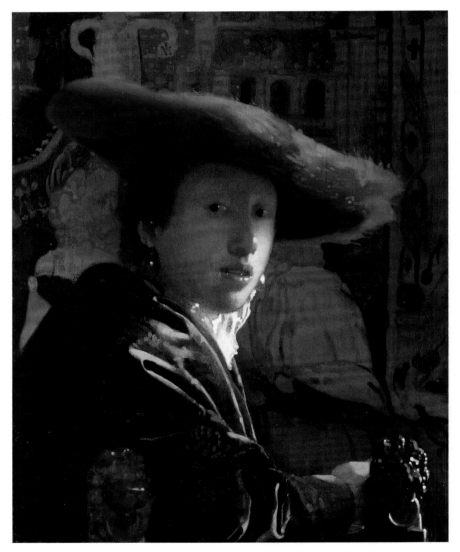

Johannes Vermeer, *Girl with a Red Hat*, c. 1665–1666, oil on panel, 9.1 x 7.1 inches. Courtesy of the National Gallery of Art, Washington, DC

Example of color application with glazing—the hat was underpainted with vermilion first and then followed by multiple glazes of madder lake.

Types of Color Application

Following the dead layer, local colors are applied and smaller details are modeled within the already established shapes and plane divisions. Colored layers are handled in various ways depending on the effect that is needed:

- In colored glazes for a shimmering effect of stained glass in the shadows

- By superimposing translucent color over white for maximum luminosity

- With opaque impasto of bright colors for strong accents and bold statements

- With meticulous gradation of optical grays for delicate modeling and seamless transitions

GLAZING—transparent color application; usually a darker color over a lighter one. This type can be easily implemented in colored pencil painting with the use of various solvents.

VELATURA—thin translucent or semi-opaque color application. This is the most natural type for a translucent colored pencil medium due to the content of wax and white pigment in the pencil core.

SCUMBLING—thin semi-opaque or opaque color application; usually a lighter color over a darker one. In colored pencil painting, it can be effortlessly created over a coat of ACP Final Fixative.

FROTTAGE—dragging thick opaque color over the established layer to create a pattern or textural effect. In colored pencil painting, the most effective way to create this is over a coat of ACP Textured Fixative.

Color Variations

Applying color emphasizes the pattern of shadows and lights established during the underpainting and veiling by modifying their temperature. To show lit areas as warm, such colors as yellows, oranges, and reds are allowed to dominate in the color mix. To indicate the coolness of the shadow, more blues, greens, and purples are added to the mix of those areas; however, often there is no distinct division between shadow and light in real life. When looking closer at shadowed and lit areas, we can discern hints of cool colors in the lit areas and warmth in the shadows. A translucent dry medium, like colored pencil, is a real asset in the re-creation of these effects because the colors do not actually mix together and, as a result, do not overpower each other.

It is better to begin color application in the shadowed areas and to proceed from there toward the lit areas, keeping shadows dark yet transparent. Starting from the middle values and moving into the lit areas, colors can then be applied more opaquely to contrast the transparency of the shadows.

Transparent glazing of darker colors over lighter ones creates a "warming effect." Velatura and scumbling "cool down" the overall temperature compared to the warm glazed shadows. They also decrease intensity of the previously applied color and create a "matting effect" to the texture. This is very useful when rendering skin tones.

Working with color over established and completely dry underpainting in oils is typically done in several phases, allowing layers to dry in between. In colored pencil painting, this process is much

more convenient, as it does not require drying time. During this part of the rendering, artists concentrate on modeling the topography of the surface and further enhancing the impression of three-dimensionality.

Final Touches

When the overall shapes have been developed, the spatial relationships have been adjusted, local colors established, and their temperature regulated, it is time to pay attention to minute details like color accents, the brightest highlights, and the texture of the surfaces.

Alyona Nickelsen, glazing of the shadows and scumbling of the lit areas for *Scott*, 2015, colored pencil painting on acrylic gesso, 11 x 14 inches

The number of details and accents should be dictated by the original compositional idea and should not detract from the focal point, such as the person's face. Surface textures should not be portrayed everywhere with the same precision. In real life, the details and textures are much less detectable at a distance, in areas that are out of focus, under extreme light, or in the darkest shadows. So, to simulate life in artwork, artists can downplay them as well in such areas and make them more pronounced in close-up areas, focal points, middle values, and borders between shadow and light.

The most brilliant color accents are painted last to prevent them from being mixed, since this would lower their intensity.

The brightest highlights are the most opaque whites in the entire composition and are the closest points on the portrayed surfaces to the source of light. They are also painted last to preserve their light values. Characteristic highlights are typically created with opaque application, and textures are indicated via the frottage technique.

Certainly, there is no better instrument for working on small details or refining edges than the hard point of a pencil.

Alyona Nickelsen, *Scott*, 2015, colored pencil painting on acrylic gesso, 14 x 11 inches

WORKING THE MEDIUM

Innovative methods and techniques for painting with pencils

"I haven't stopped painting or drawing—I've just added another medium."

—DAVID HOCKNEY

"Whatever the medium, there is the difficulty, challenge, fascination, and often productive clumsiness of learning a new method: the wonderful puzzles and problems of translating with new materials."

—HELEN FRANKENTHALER

ABRASIVE SURFACES FOR COLORED PENCIL PAINTING

A simple switch from traditional cotton papers to abrasive surfaces that are rigid, toothy, and nonabsorbent is a straightforward solution that resolves many problems of colored pencil medium and offers many additional benefits. Such is the case with sanded papers or toothy acrylic gesso applied to a sturdy (four or more ply) board. Colored pencil application on such surfaces is substantially faster and does not require constant sharpening.

Yes, working on toothy surfaces actually saves colored pencil medium and does so quite considerably, despite a common misconception that the toothier the surface, the faster it will "eat" the pencils.

I never liked the fact that we were "throwing out the baby with the bathwater" and inwardly cringed about the waste involved in the frequent sharpening of my pencils. The durable tooth of a sanded paper mounted on panels/boards or cotton paper mounted on a rigid surface and covered with acrylic gesso allows us to sharpen a

Alyona Nickelsen,
Elijah, 2013, colored
pencil painting
on sanded paper,
14 x 11 inches

pencil only the number of times needed to expose the core out of the wood casing. Then you can maintain the point during the actual layering process just by rotation.

This not only solves the "frequent sharpening disorder" but also speeds up the application process by a factor of at least five. The durable surface tooth "files" medium off the soft colored pencil core with even the lightest friction; thus,

it automatically sharpens the point and deposits the shavings into surface crevices during the layering process. You only need to "even out" the application afterward. With this remedy, the bane of colored pencil painting—covering a large background—is now quite simple and easily accomplished. One tremendous advantage is that it allows colored pencil artists to work on much larger-scale projects, such as "life-size" portraits.

The simple coverage of this 2 x 2–inch area of cotton drawing paper with Faber-Castell Polychromos rose carmine using the traditional approach took about two minutes and required that the pencil be sharpened three times to maintain a light touch and create this relatively even application of colored pencil.

I spent only about twenty seconds to cover the same area on sanded paper with the same pencil and did not need to sharpen it even once. I applied pencil lightly without caring much about the neatness of my strokes, because colored pencil medium applied on sanded paper can be effortlessly blended with a sponge applicator and Powder Blender.

DID YOU KNOW?

If you follow the rules of keeping your point sharp and sharpening every other minute or so while working on traditional cotton paper, maintaining a light touch, and placing your strokes tightly together, a colored pencil will last somewhere between half an hour and forty minutes, regardless of how good your sharpener or the pencil brand may be.

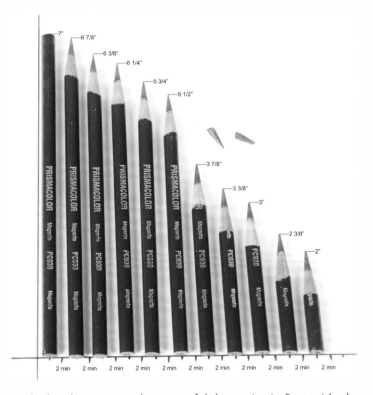

Here is a small example that demonstrates how wasteful sharpening is. Start with a brand-new unsharpened colored pencil (Prismacolor Premier magenta in this case). Then, work in the traditional manner on cotton paper with a light touch, maintaining a sharp point and placing strokes tightly together. Sharpen the pencil every other minute or so using a good electric pencil sharpener. As a result, you will see that your pencil did not last longer than about thirty minutes, even if you disregard broken points that could occur during the sharpening process (common to many popular brands on the market). So, to the original suggestion "keep your point sharp and sharpen every other minute or so..." we should add, "and waste the majority of your precious pencils in the sharpener."

APPLICATION: EVEN AND UNEVEN, DIRECT AND INDIRECT

For depiction of smooth surfaces, colored pencil medium must be deposited or spread evenly. The viewer should not see the gaps between the strokes or a difference between them. For depiction of textured or patterned surfaces, the opposite coverage is required.

Colored pencil can be applied directly or indirectly. *Direct colored pencil application* involves the actual point of the pencil core touching the working surface and leaving the mark.

To create a direct even application:

• Work with a continuous coverage (without lifting the pencil point off the surface between the strokes), rotate the pencil point to keep it sharp, and maintain the same pressure during the entire application.

• Avoid overlapped strokes.

• Place strokes tightly together.

An example of a direct even and uneven application of Prismacolor Premier indigo blue colored pencil on sanded paper.

An example of an indirect even and uneven application of Prismacolor Premier indigo blue colored pencil on sanded paper.

To create a direct uneven application:

- Lift your pencil point between the strokes, as the pressure always is a bit heavier at the point of the colored pencil "landing," or the "touch down," compared to the area where the pencil "takes off" from the paper surface.

- Allow strokes to overlap and accumulate more medium in some places as compared to others.

- Place strokes with some distance between them. The difference between the colors and values of the strokes and the working surface creates a contrast and, therefore, the impression of uneven coverage.

When *indirect application* is used, colored pencil is rubbed against a scrap of sanded paper to create a pile of shaved particles. Then colored pencil medium is transferred onto the actual working surface with a sponge or a brush to eliminate any well-defined pencil strokes.

The indirect method also can be used for even and uneven coverage following the same principles of application as described previously. Due to the increased size of the strokes created by brushes or sponges, it is easy to generate uneven application with soft edges that can be useful for blurry backgrounds or out-of-focus effects.

BLENDING METHODS

The role of blending is not only to even out the applied medium (i.e., to fill in the gaps between the brush or pencil strokes) but also to create gradations and smooth transitions between colors and values. Blending can be done when values

or colors are juxtaposed (for the optical illusion of colors merging into each other within one layer) or when they are superimposed (values or colors are merged by layering).

Traditionally, juxtaposing is controlled by the sharpness of pencil point, maintenance of light pressure, and placement of strokes tightly together to create even coverage. Though it provides a smooth transition between colors or values, it is an inevitably wasteful, slow, and tedious methodology. Physical blending (moving pigmented particles on the surface from one point to another) normally is ineffective, as colored pencil instantly "becomes one" with the tooth of the surface; however, solvents such as Gamsol odorless mineral spirits work very well with colored pencil medium and adequately remedy the need for physical blending.

Blending with Solvents

With the assistance of certain solvents, colored pencil particles can actually physically move from point A to point B on a surface to a certain extent. These solvents are available as liquids or as various types of blender markers, such as Copic Sketch Colorless Blender, Letraset Colorless Blender Marker, Finesse Colored Pencil Blender Pen, and Prismacolor Colorless Blender Marker, to name a few.

Each solvent has its own evaporation rate, which determines how long the application has to dry before proceeding further and how much solvent is needed for blending. For example, alcohol evaporates much faster than odorless mineral spirits (OMS); however, the absorbance of the surface also directly influences the behavior of solvents as well as the effectiveness of the blending process.

While it may seem that solvents evaporate faster from cotton-based surfaces, such as drawing papers and boards, this is an illusion; in reality, they are partially absorbed by the surfaces themselves. For example, blending colored pencil on cotton papers with alcohol is often ineffective compared to the nonabsorbent surfaces, due to the high evaporation rate of alcohol and high absorbency of cotton fibers. When solvents are applied to such nonabsorbent surfaces as sanded paper or acrylic gesso, you will notice that they remain on top until they have completely evaporated; therefore, the process appears to take a bit longer by comparison. To compensate, simply use less solvent to blend colored pencil when working on nonabsorbent surfaces.

Remember, it is not necessary to saturate the surface with solvent to accomplish your task. One or two droplets will penetrate the colored pencil layers and do the job. In this manner, you can soften the binder and move the applied medium on the surface with a blending tool; thus, you are "filling in the gaps" between the strokes, evening the coverage, and achieving a more painterly look. Note that when colored pencil is applied with lighter pressure, less of it is embedded into the depth of the surface tooth, which makes the blending process easier. For the most measured administering of solvents, you can use either water brushes or a ceramic pump dispenser with a sponge applicator.

There is a difference in the appearance of colored pencil when applied onto absorbent and nonabsorbent surfaces versus when blended with various solvents. Nonabsorbent surfaces allow solvents to disperse the colored pencil medium in thin layers, providing greater light penetration. This will reveal the true potential of the pigments in the colored pencil core. Conversely, absorbent surfaces limit this effect, and the colored pencil you apply remains in small "clumps" on the surface, making the application look darker and the color less intense.

Solvents can also alter the appearance of certain pigments in the pencil core; therefore, it is always a good idea to test the combination on a scrap of paper prior to use on the actual artwork.

Note that the values of the samples treated with solvent (opposite) appear darker when compared to the dry samples. When OMS "fills in the gaps," it reduces the contrast between the lightest value of the white surface and the darkest values of colored pencil pigment. That makes the overall appearance darker.

Keep in mind that the overall ability of a pencil to blend is affected by

- the properties of the working surfaces

- the content of the pencil core

- the density of colored pencil application

- the type and amount of solvents used

- the blending tools used

For example, softer pencils with more wax in their cores "grab" more firmly onto the tooth of surfaces such as sanded paper. Because of this, they are difficult to blend when sparsely applied. A single drop of odorless mineral spirits will quickly remedy this situation; however, pencils with more fillers than waxes can be easily blended on a sanded-paper surface with a coarse bristle brush and Powder Blender even when applied in a single sparse layer.

LEFT: Here, Prismacolor Premier peacock green colored pencil was applied with a light touch to a rigid, toothy surface. Strokes were placed close together to create a dense layer.

RIGHT: Odorless mineral spirits (OMS) were then applied with a barely dampened sponge and a gentle tapping motion. Solvent easily dissolved the binder and filled the small gaps between strokes with pigment, giving the application a more even look.

LEFT: In this example, the same pencil was applied heavily with strokes farther apart, leaving significant "gaps" between them.

RIGHT: As a result, some portion of the colored pencil medium was forced deeper into the tooth of the surface. The applied solvent dissolved the particles of binder that were closer to the surface first. Those that were embedded more deeply into the surface were affected to a lesser degree; therefore, the application still looks uneven, with strokes remaining visible.

THE "DANGER" OF SOLVENTS

Of course, as with all things, when working with solvents, use reasonable caution and keep your work area well ventilated; however, remember that exposure to some toxins is an everyday occurrence for modern humanity.

Antibiotics are toxins, but they are very selectively toxic and are effectively used to kill the microbes that would otherwise kill us. Antibiotics save millions of lives each year that would otherwise most certainly be lost.

Though we may try to avoid them, preservatives are used every day to keep foods fresh. These toxins help feed millions of people who might starve without them.

Chlorine is also a very toxic substance, but it is used extensively to clean municipal water supplies that would be undrinkable without it.

Obviously the word "toxic" should be heeded; however, the amount of solvents, such as odorless mineral spirits, occasionally used in colored pencil painting is minuscule when compared to the amount used in oil paintings. Anyone who has used nail polish remover has had a much greater exposure to toxins than would ever occur while creating a colored pencil painting.

Dry Blending

Any blending method that involves liquid inevitably creates hard edges. Dry blenders, such as Prismacolor Colorless Blender, Lyra Splender Colorless Blender, and Caran d'Ache Full Blender Bright, offer an alternative way to blend the colored pencil medium; however, due to a high content of wax in their cores, they tend to grip tightly to the tooth of the surface and, instead of physically moving pigmented particles around, they secure them in place under a clear waxy coat.

Blending "oil-based" colored pencils on sanded papers is easy, as their pigmented particles move more freely on the surface. Types of pencils that contain more wax in their core, such as Prismacolor Premier, Caran d'Ache Luminance, or Derwent Coloursoft, tend to "grab" the surface tooth more tightly. Powder Blender is an excellent tool in such cases because it helps to release the "grip" of the particles and allows them to move about more easily. The blending process also takes only a fraction of the time it would when compared to a more traditional approach.

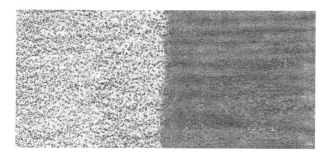

Prismacolor Premier magenta blended using a Prismacolor Colorless Blender Marker. A hard edge was created due to the use of liquid.

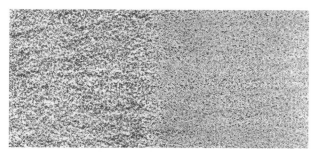

Prismacolor Premier magenta was successfully blended with Powder Blender. Pigmented particles were evenly dispersed on the surface with no hard or well-defined edges created in the process.

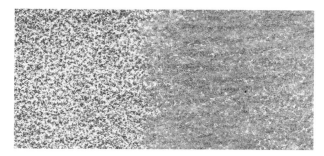

Prismacolor Premier magenta was blended here with Prismacolor Colorless Blender. Instead of being more evenly distributed on the surface, these pigmented particles were "cemented" to the surface tooth under a clear coat of colorless blender medium due to its high wax content.

In this example, identical rectangles of toothy, rigid surface were covered with Prismacolor Premier permanent red on the left side and Prismacolor Premier electric blue on the right. Blending the two colors, Prismacolor Premier magenta and electric blue, was easily accomplished by using a sponge applicator and Powder Blender. Note that the middle of the color swatch is now covered with a new uniform color.

LAYERING WITH ACP TEXTURED FIXATIVE

When colors are superimposed, or layered, colored pencil artists are faced with the well-known facts of limited possible layers and the development of values from the lightest ones toward the darkest; however, ACP Textured Fixative makes these restrictions obsolete and allows artists to apply a virtually unlimited number of layers and develop values from light to dark and from dark to light.

ACP Textured Fixative is also indispensable in the process of superimposed blending with solvents. Normally, solvents can easily destroy layering by mixing all layered colors together. This is not the case if colored pencil layers are isolated from each other with ACP Textured Fixative. Once the fixative completely dries, it hardens and becomes resistant to solvents like OMS. In the example below left, Prismacolor Premier Spanish orange

colored pencil was applied to all three squares of toothy sanded paper. The second and third squares were then covered with a light layer of Prismacolor Premier magenta. The colored pencil application was then blended with OMS on the third square. As you can see, solvent dissolved the upper layer completely and partially dissolved the layer beneath, creating a new color and destroying the layering.

In the example below right, after initial application of Prismacolor Premier Spanish orange, the surface was covered with two light layers of ACP Textured Fixative. After that, Prismacolor magenta was applied and blended in the same manner as in the previous example. The second layer was then blended with OMS on the third square, but in this case, the solvent did not disturb the layer beneath due to the isolation layer provided by ACP Textured Fixative.

ADJUSTMENTS, CORRECTIONS, AND ERASURES

Another well-known issue with the colored pencil medium when applied to cotton papers is that it is difficult to erase; however, when working on abrasive nonabsorbent surfaces, such as sanded papers, colored pencil application can be easily adjusted, corrected, or erased.

Colored pencil can be easily wiped off the abrasive surface when the particles are not yet firmly compressed into the crevices of the tooth. Modeling values in this manner is similar to the *bistre* technique, also called the *wipe-off* method, common in oil painting. This procedure involves wiping oil paint off the surface while it is still wet,

which, obviously, is subject to time limitations. Then the artist must allow the layer to completely dry before proceeding further. This is not the case with colored pencil, since we are not bound to such time limitations. Also, if Powder Blender was applied to the surface first, the erasing process is even more effective. When the artist is done with all the erasing and corrections, the colored pencil application can be secured with an application of ACP Textured Fixative.

It is easy to lift applied colored pencil from the abrasive surface with mounting putty, kneaded eraser, Scotch tape, or even wax paper.

Colored pencil can also be washed off the surface with the use of OMS or alcohol.

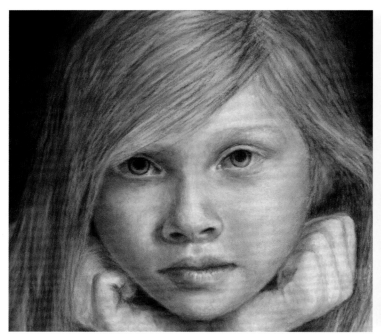
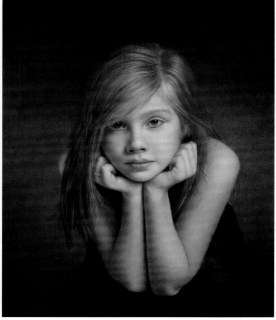

Example of underpainting in progress created with the wipe-off technique.

Alyona Nickelsen, *Emma*, 2016, colored pencil painting on sanded paper, 20 x 24 inches

Faber-Castell Polychromos burnt umber and Prismacolor Premier sienna brown colored pencils are easily wiped off the sanded paper using a sponge applicator.

Faber-Castell Polychromos burnt umber and Prismacolor Premier sienna brown colored pencils are brushed off with a short-bristle stencil brush.

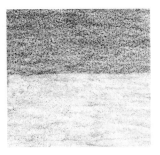

Faber-Castell Polychromos dark indigo and Prismacolor Premier indigo blue colored pencils are lifted with mounting putty.

Faber-Castell Polychromos dark indigo and Prismacolor Premier indigo blue colored pencils are erased with Scotch tape.

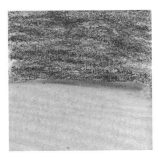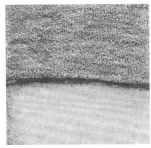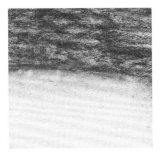

Faber-Castell Polychromos magenta and Prismacolor Premier magenta colored pencils are washed off the sanded paper with OMS.

Faber-Castell Polychromos magenta and Prismacolor Premier magenta colored pencils are washed off the sanded paper with alcohol.

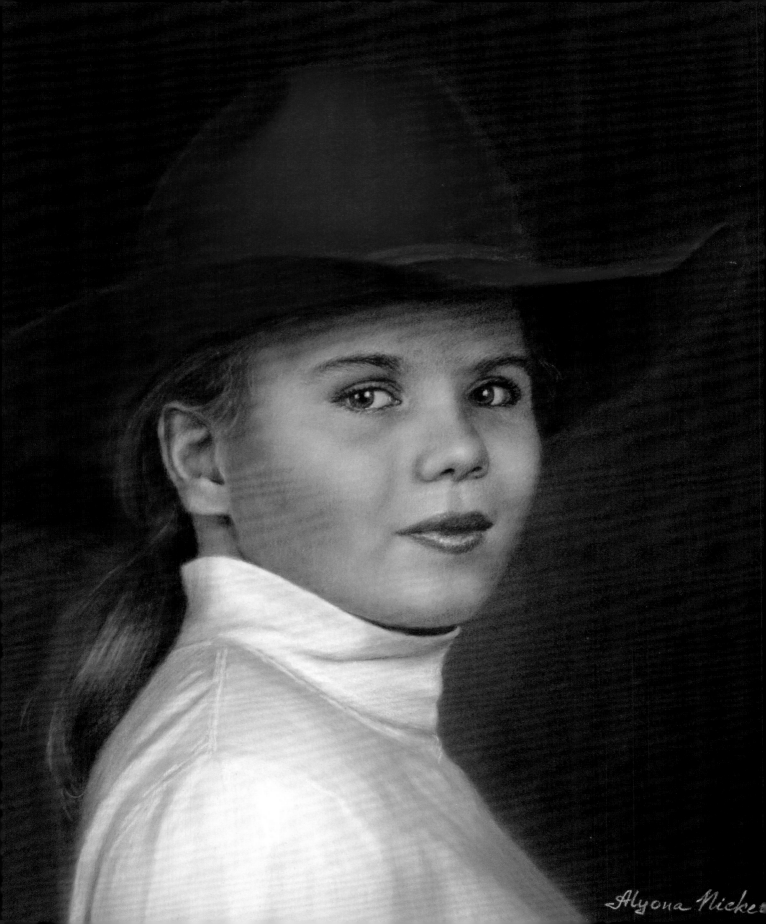

Alyona Nicke

CONTROLLING COLOR

Understanding the nature of color and the properties of pigments

"The laws of color are unutterably beautiful, just because they are not accidental."

—VINCENT VAN GOGH

"When I paint green, it doesn't mean grass; when I paint blue, it doesn't mean sky."

—HENRI MATISSE

COLOR AND PIGMENTS

Color is light. When there is no light, we do not see color. (So, philosophically speaking, is there color when there is no light?) For example, when we look at a red apple on a kitchen table or a red apple in a still life painting, the sensation of the color red is captured by the eyes, interpreted by the brain, and registered in the mind in the same way. The surface of the red apple absorbs all parts of the visible light spectrum except its red portion and bounces that back into our eyes, creating the sensation of red as interpreted by the brain.

Absorption and reflection of the light is caused by the properties of pigments that cover every apple's surface. The pigment that makes the apple on the kitchen table look red is called anthocyanin. It is odorless, flavorless, and a natural part of many fruits and vegetables. The pigment that makes an apple look red in a still life might be, let's say, cadmium red, something that you should avoid ingesting at all costs. Could we paint the apple with the anthocyanin pigment? Probably, but the color in

Alyona Nickelsen,
Madelynne, 2016,
colored pencil painting
on sanded paper,
16 x 18 inches

your painting would fade away as fast as the apple wilts and turns into brown mush. By comparison, cadmium red and other lightfast artist's pigments will last unchanged for ages. You should note that over the centuries many pigments were derived from plants, insects, and even human mummies. They were used not only for dyeing fabrics but also for creating paints and were often used in fine art. The disappointment with these pigments' poor longevity pushed scientific minds into a quest for more stable pigment colors. That search has continued ever since and today supplies artists with a plethora of new safe and stable alternatives.

In our attempt to match colors in life with colors in art mediums, we are actually searching for pigments with similar properties of light absorption and reflection in a never-ending attempt to create identical color sensations; however, even if we found the perfect color match, that factor is not enough to make a painted apple look like a real one. A sampled color of an object matched with a tube

of paint and applied to a round shape would end up looking like a round flat colored spot. To shape this painted red spot into a red apple, we need to mimic the nuances of hues, values, and intensity that are observed on the curved surface of the real apple under a particular lighting condition.

Natural surfaces, compared to those that are artificially made, typically are not perfect in their appearance. For example, the curvature of our red apple comprises endless minor bumps and dents. This causes its surface to absorb and reflect light unevenly. So by looking closer, we can spot numerous variations of the overall red color with some hints of oranges, magentas, blues, or greens here and there, which make the apple look lively and vibrant. Skipping such a vast collection of hues and painting an apple with just one red color from the tube simplifies the subject and creates a dull imitation of life.

The location of the apple in relation to the light source makes additional impact on the appearance of its brilliant red coloration. In the area where light first reaches the apple's surface, a highlight appears. There, the red color will be completely obliterated by light's intensity and the apple's skin will take on the color of the light itself. The more the surface curves away from the light, the less local color is influenced. As the strength of the reflected light gradually diminishes toward the halftones, the red increasingly reveals itself with its lighter versions in the areas adjacent to the highlight and the darkest ones in the core shadow. A weaker reflected light from a secondary light source "gently hugs" the shadowed area of the apple, contouring the shape and creating yet another set of red color modifications. The red in the shadow will be affected by the color of a secondary light source

Alyona Nickelsen, *Red Delicious Apple*, 2005, colored pencil painting on paper, 6 x 5 inches

as well as the colors of the nearby surfaces. The intensity of the local color will also vary throughout the object's surface. In the extreme lights and darks, the local color will have its weakest chromatic appearance, and in the halftones, it will be at its peak of intensity.

Overall, individual properties and the influence of light make surfaces appear to lack uniformity in hue, value, or intensity, just like our red apple. These variations in appearance are not random. They follow the laws of physics, have logic in them, and can indeed be successfully re-created in art.

Incorporating hue variations under light and in shadows creates a vibrant and lifelike appearance of the surfaces. For example, in the painting *Robert Rich, Second Earl of Warwick* by Anthony van Dyck, we can definitely recognize the overall color of folds as orange, but this local color has a bias toward yellows under the light and toward reds in the shadows.

Darkening and lightening of local color in relation to the source of light and engaging a wide range of values will shape the form and emphasize the feeling of depth. The masterful value manipulation of this local color produced a very convincing appearance of the folds in this work.

The variation of color intensity further advances the natural interaction of the surfaces with light. A lower chroma in the extremely lit and shadowed areas accentuates color richness in the middle tones, which was meticulously managed in this painting.

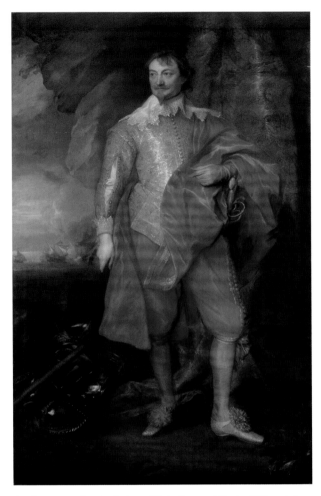

Anthony van Dyck, *Robert Rich, Second Earl of Warwick*, c. 1632–1635, oil on canvas, 81.9 x 50.4 inches. Courtesy of the Metropolitan Museum of Art, New York

A masterful use of color variation in depicting of the folds that emphasizes the feeling of depth.

Color-Mixing

Colors are rarely used "as is" directly from a tube of paint. Typically they are mixed from a selected palette of colors. Artists who work in liquid mediums, such as oils, have to be ever cognizant for the shift in appearance between wet and dry paints. The changes in color during the drying process can sometimes be significant. It takes experience and knowledge to "pinpoint" the exact proportion of colors while wet-mixing to get the correct final hue, value, and intensity of the result when dry. The number of mixes that are necessary to finish a project or some part of it should also be carefully considered. It would be difficult to replicate the exact mix later if a shortage occurs. On the other hand, no one wants to waste costly paints with a surplus of unused mixes.

Colored pencil artists often take for granted the fact that they are working with a WYSIWYG (what you see is what you get) medium. They experience no shifts in colors, values, or intensities due to the drying process. Actual color-mixing in a colored pencil painting does not happen on a palette but during the painting process directly on the working surface and can be conducted incrementally in light, thin layers; therefore, it is a completely controllable methodology with no waste of medium on the palette. As a "premixed" medium, colored pencil, besides offering the typical set of colors available in paints, also provides us with arrays of tints (color plus white), shades (color plus black), and tones (color plus gray). Of course, now and then we stumble upon some "creative" combinations of pigments with peculiar names that are difficult to decipher, but this is not a fault of the medium.

Rather, it is the sometimes questionable choice of a manufacturer; however, when manufacturers are serious about presenting their colored pencil line in a professional manner, we are often left with a luxury of choice that allows us to manipulate colors exclusively by layering single pigments or by incorporating ready and clearly labeled mixes.

The main task of color-mixing is to control and manipulate the medium so that it appears in the exact manner intended. In the process of color-mixing, we must remember and rely on the properties of colors. For example, white not only lightens the value but also lowers the intensity of the color mix and cools the temperature of that area. Black darkens the value and lowers the intensity of the color mix. Warm colors advance and cool colors recede. Mixing reds, blues, and yellows creates various neutral grays, and so on.

The typical act of color-mixing usually consists of "lifting" the area with white to show that something is protruding on the surface; warming it up, when necessary, with yellow or orange after it was cooled with white; darkening it with blue to "push" a certain area back; adjusting color balance with red, and so on. In other words, we have complete control of the color when we see what needs to be adjusted and know how to do it. Colored pencil does not force you to deal with shifts between wet and dry states. Colors are consistent within the core, and delivery of pigment is precisely managed by the pencil point and hand pressure.

To achieve a successful colored pencil painting, it is necessary to understand exactly what to expect from the layering of various colors. Here are a few important facts to remember:

- The intensity of the color mix is automatically lowered when the value of the original color is lightened with white.

- When mixed with white, some reds shift color dramatically toward "Pepto-Bismol" pinks.

- The intensity of the color mix is automatically lowered when the value of the original color is darkened with black.

- When yellows are mixed with blacks, the result is a greenish mix.

- The intensity of the color mix is automatically lowered when two different hues are mixed. The farther apart they are on the color wheel, the lower the intensity of the final color.

The following measurements were completed with a tristimulus colorimeter and are presented here as a percent of the highest value of 100% and the lowest value of 0% (the lower the number, the darker the color), and of the highest chroma of 100% and the lowest chroma of 0% (the lower the number, the less intense the color).

Original application of Prismacolor Premier permanent red: value = 43.5, chroma = 72.0

Prismacolor Premier permanent red darkened with black: value = 33.7, chroma = 37.2

Prismacolor Premier permanent red followed with a layer of violet: value = 35.8, chroma = 44.2

Prismacolor Premier permanent red lightened with white: value = 64, chroma = 40

Prismacolor Premier permanent red followed with a layer of dark green: value = 35.7, chroma = 38.2

Prismacolor Premier canary
yellow: value = 85.0, chroma = 89.1

Prismacolor Premier canary
yellow darkened with black:
value = 68.6, chroma = 62.3

Prismacolor Premier canary
yellow followed with a layer
of orange: value = 78.2,
chroma = 78.9

Prismacolor Premier canary
yellow lightened with white:
value = 90.3, chroma = 36.6

Prismacolor Premier canary
yellow followed with a layer
of violet: value = 64.9,
chroma = 50.4

The highest-intensity colors in paints or pencils are typically created from a single pigment. Does that mean that all secondary and tertiary colors have a lower intensity? Yes, it does. If secondary and tertiary colors are mixed from different pigments, they have a potentially lower intensity compared to colors that are derived from a single pigment. For example, color created from a single pigment, such as phthalocyanine green, potentially will have a higher intensity than the green derived from mixing blue and yellow pigments. (By the way, if such a green cannot be mixed from other colors, wouldn't it qualify by definition as a primary color, along with oranges and purples created from single pigments?) And of course, the addition of white, black, or any other pigment will decrease the intensity of that

paint or pencil: magenta will not be "magenta-ier" with the addition of other colors. The use of a single pigment by the manufacturer, however, doesn't necessarily guarantee the highest intensity of color, due to the specifics of manufacturing processes or different additives. The qualities of the pigments themselves play an important role in their appearance as well as their longevity. Although some pigments may be more attractive, their archival qualities will not be suitable for fine artwork. Since we have many choices in art supplies these days, it is up to us artists to make responsible decisions about which product to use. And, at the end of the day, it is our demand as customers that shapes the market.

Prismacolor Premier orange was manufactured using a mix of orange and white pigments and has a chromatic value of 78.6. Its archival qualities are not satisfactory.

Caran d'Ache Luminance orange was created using a single pigment and has a chromatic value of 71.2. This is a permanent color with an excellent lightfastness rating of I, according to the American Society of the International Association for Testing and Materials (ASTM) standards.

The fact that mixing any two differing colors results in a lower-intensity color makes it reasonable to reserve the most chromatic colors as unmixed and available for the areas that require them: the middle tones, focal points, or accents. The Color Match and Color Compare tools become extremely handy when there is a need to compare color properties and determine which colored pencil has higher intensity; therefore, with the exception of reserved chromatic colors, the rest of the composition will be subjected to color-mixing—modifying hues, lightening or darkening their values, and adjusting their intensity.

For more control in layering, it is better to begin color-mixing with lighter colors. For example, yellows have the lightest values on the color wheel and can be easily overpowered by the rest of the hues. Gradually add darker participating colors to the mix. It is also advisable to begin layering with more transparent colors and follow with those that are opaque.

Artists commonly darken color values and lower intensity using complementary colors. As we know, the locations of true complementary colors on the color wheel are opposite one another. When

mixed together, they darken the value and create a neutral gray; however, in reality, it is difficult to determine which colors are true complements. First, the complement depends on the type of color wheel that is used: twelve-color, ten-color, or other alternatives, such as Newton's asymmetric or Goethe's symmetric color wheels. Then it depends on how accurately a particular color of paint or pencil corresponds to its location on that color wheel. For example, a bias of green toward yellow or blue determines which red is its perfect complement—red that is leaning more toward orange or one that is leaning more toward purple. So, imperfectly matched complements create imperfect grays that are actually semi-neutrals containing just a hint of color, which makes them unique, what artists call "interesting grays" in the painting.

How well colors are mixed also influences the look of the resulting color. That can be either a gift or a curse in many mediums, depending on the effect you are seeking. For example, because of their fluid nature, liquid mediums have a tendency to unify the resulting color in a mix. It takes a great deal of effort to create the shimmering effect that occurs when two colors are juxtaposed. This look has

long been pursued by impressionists using dabs of unmixed paint and "quilting" them tightly together to create the optical illusion of shimmering lights and shadows. Fortunately for us, colored pencil effortlessly produces this effect. Colored pencil layers do not physically mix together but are in very close proximity to each other. The translucent nature of the wax medium allows us to see the colors that lie beneath them, naturally creating the same shimmer with little effort; however, if unification is needed, colored pencil can be easily blended mechanically with short-bristle brushes or chemically with solvents to produce the same painterly effect as liquid mediums.

Light dense layer of Prismacolor Premier permanent red.

Prismacolor Premier permanent red followed with light layer of dark green.

Prismacolor Premier permanent red and dark green blended with a short-bristle brush.

Prismacolor Premier permanent red and dark green blended with OMS.

Light dense layer of Prismacolor Premier canary yellow.

Prismacolor Premier canary yellow followed with a light layer of dioxazine purple hue.

Prismacolor Premier canary yellow and dioxazine purple hue blended with a short-bristle brush.

Prismacolor Premier canary yellow and dioxazine purple hue blended with OMS.

"MUDDY" COLORS

The more colors used in the mix, the lower the intensity of the final color. In the world of paint, some call such low-intensity colors "muddy," but this term is not an actual description of the colors. More accurately, it is a description of the artist's attitude toward them. They might better be called "unintentional low-intensity" colors, as they are usually created by overmixing and making too many adjustments or corrections; however, controlled color-mixing with the purpose of creating subtle nuances of low-intensity colors can hardly be called "mud."

The examples of low-intensity colors surround us in real everyday life. Look at your own hand. Skin tones can be considered as having muddy colors, since the subtlety of hues is often difficult to name and distinguish from one tone to another. Yet a masterful handling of colors in painting allows yellows, reds, and blues to mix together and create the illusion of living, breathing flesh. It takes a great deal of artistic ability to see the color first and then reproduce it by commanding the medium with the highest degree of virtuosity.

Color Under the Light and in the Shadows

Let's take a look at how we can apply and manage colors in lit areas and in the shadows. Traditionally, colors in the shadows are applied in the most transparent manner, and colors in the lit areas are applied thickly and opaquely. This makes a great

William-Adolphe Bouguereau, *Young Mother Gazing at Her Child*, 1871, oil on canvas, 56 x 40.5 inches. Courtesy of the Metropolitan Museum of Art, New York

A breathtaking use of low-intensity, "muddy" colors.

deal of logical sense, since the intensity of the color in the shadow in real life is much lower when compared to the lit areas. When dark underpainting is visible through the transparent layers of color due to superimposing and optical mixing, the intensity of the resulting color is lowered automatically in contrast to the same local color applied opaquely in the lit areas.

To better understand this, look at the following colors applied directly onto a white surface:

Now consider the following colors applied on top of an umber underpainting:

Faber-Castell Polychromos light yellow ochre

Faber-Castell Polychromos light yellow ochre

Faber-Castell Polychromos light yellow ochre and dark flesh

Faber-Castell Polychromos light yellow ochre and dark flesh

Faber-Castell Polychromos light yellow ochre, dark flesh, and white

Faber-Castell Polychromos light yellow ochre, dark flesh, and white

Shadow areas are commonly glazed over with a few thin, transparent colors to enhance their depth. To use this technique in colored pencil painting, we can isolate the underpainting with a light coat or two of ACP Textured Fixative. After it dries thoroughly, we can proceed with glazing. For blending, you can use Powder Blender or OMS.

In the following example, Faber-Castell burnt umber colored pencil was applied to the top two squares. The third square down was left as the original white of the working surface. The applied burnt umber was blended with a short-bristle brush and isolated with a few light layers of ACP Textured Fixative. In the first image, the application of burnt umber was followed with a thin layer of Caran d'Ache Pablo fast orange to all three squares; in the second image, they were glazed with vermilion, and with purplish red in the third. All colored swatches were then blended with a short-bristle brush and OMS. As you can see, the underpainting was not disturbed and the subsequent colors created transparent glazing. You can also see the difference in the appearance of glazed colors over the underpainting versus over the original white surface.

About White and Black

White is rightfully considered the most important and most used color on the artist's pallet. It takes part in practically all stages of rendering and participates in modeling of the form, lightening values, making colors opaque, and modifying hues.

The translucent nature of white colored pencil makes it perfect for veiling of the shadows and middle tones; however, how much opaqueness can colored pencil offer for veiling lit areas? To measure how much "hiding power" various white pencils have and how they perform in layering with the use of ACP Textured Fixative in between the layers, the whiteness of the working surface (acrylic gesso on white board) was measured and it happened to be 95% (100% being perfect white). Then, black ink was applied in a couple of washes, allowed to dry completely, and measured for its darkness. It measured 30% (0% being perfect black). After that, each white colored pencil was applied with normal pressure in several layers and sprayed in between with ACP Textured Fixative to extend the friction. Then each color swatch was measured. Here are the results showing how much each white colored pencil was able to restore the original whiteness of the surface (the higher the number, the more opaque the pencil is):

PENCIL	WHITENESS
Prismacolor Premier	92.5%
Caran d'Ache Luminance	91.5%
Faber-Castell Polychromos	90.5%
Derwent Coloursoft	90%
Derwent Artists	90%
Caran d'Ache Pablo	89.5%
Lyra Rembrandt Polycolor	87.5%
Soho Urban Artist	87.5%

So the obvious winner in the restoration of working surface original whiteness is Prismacolor Premier, as it reached 92.5%. This is, certainly, good enough to work on the shadowed areas, middle tones, and partially lit areas; however, if there is a need for the most opaque white, such as veiling in areas under intense light or rendering details, textures, and brightest highlights, there is always pure titanium white pigment. You can consider it as a spare part for the colored pencil, since it is actually a part of the colored pencil core. Titanium white pigment can be applied in layers with a brush or a sponge and secured with ACP Textured or Final Fixative. Titanium white beats even the original working surface in the preceding test with a 96.5% whiteness measurement.

In a traditional colored pencil layering, when the time comes to create bright highlights, the tooth of the surface is highly saturated with colored pencil medium at this point and the application of any additional colors would be practically impossible. The use of ACP Textured Fixative remedies such situations; however, when texture is needed only in small areas, a more precise application with Colored Pencil Touch-Up Texture is instrumental. Touch-Up Texture dries clear and creates additional tooth on the surface. We can also re-create the effect of the scumbling technique from oil painting by dragging lighter colored pencils across Touch-Up Texture.

IMPORTANT: We always need to remember the power of contrasting values: the same white will look much lighter when adjacent to or surrounded by darker values.

Toothy surface is completely saturated with Prismacolor Premier indanthrone blue colored pencil. Premier white colored pencil was applied to the right side of the sample. The impact is insignificant due to low friction between already applied colored pencil medium and the pencil core. White colored pencil simply slicks off the surface.

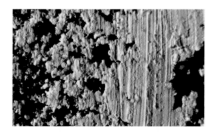

After Prismacolor Premier indanthrone blue was heavily applied onto a toothy surface, it was sprayed with ACP Textured Fixative. This created plenty of friction for a much more successful following application of Premier white colored pencil and its prominent appearance.

Micrograph of the applied white at 10x.

Micrograph of the applied white at 10x.

Artists who work on black paper know that colors look anemic when applied directly. Typically, underpainting with white would be required prior to color application; however, the tooth would be partially filled with white, so there is much less room left for actual modeling with color, and friction would be reduced, resulting in less prominent appearances of subsequently applied colors. This would also be the case in an attempt to apply intense colors on top of already established dark values. Advanced Colored Pencil (ACP) Textured Fixative allows you to apply chromatic colors directly onto a black surface or onto established dark values, revealing their true potential.

Some art instructors advise their students to ditch any black paint or pencil completely and to "use other" colors, as "they do a better job." This sounds like advising a right-handed person to amputate his or her left hand simply because "it doesn't work well in handwriting anyway."

Black has its own place and its own use in painting—lowering the intensity of colors, modifying hues, enhancing contrast, and darkening values.

Black is also a part of the pencil core in such colored pencils as Prismacolor Premier dark green, dark purple, Tuscan red, light umber, terra cotta, sienna brown, dark umber, marine green, chartreuse, pink rose, celadon green, jade green, periwinkle, greyed lavender, raspberry, black cherry, moss green, seashell pink, goldenrod, and many others. We would end up discarding the majority of this pencil line following such poorly conceived thoughts. It is much more beneficial to learn the right ways to use black than to simply disregard such an essential and valuable tool.

Prismacolor Premier colored pencils applied directly onto black paper.

Prismacolor Premier colored pencils applied after black paper was sprayed with a single layer of ACP Textured Fixative.

Utilizing Transparency, Translucency, and Opacity

The level of transparency, translucency, and opacity of mediums plays an important role in the imitation of spatial depth on a flat surface. It depends on the ability of the mediums to reflect or absorb light. Every portion of the medium content, such as pigments, binders, and additives, has its own ability to bend light. It is usually measured, calculated, and assigned its own refractive index (RI). The higher the refractive index, the more opaque the substance will look. For example, air has a refractive index of 1; for beeswax and candelilla wax, the RI = 1.43; for linseed oil, RI = 1.48; and for glass, RI = 1.5.

Pigments, natural and synthetic, are small particles of various hues, sizes, shapes, and textures, and they also reflect light in different ways. For example, for titanium dioxide, RI = 2.25, and it is the most opaque white pigment currently available. Zinc white's RI = 2 and, thus, the pigment is more translucent. It has less power to conceal than titanium dioxide.

When combined together, each ingredient of the medium affects its overall ability to reflect or absorb light and, therefore, makes it look more transparent, translucent, or opaque. The level of the medium's transparency or opacity can be changed and regulated. For example, when working in oils and there is a need for more opaque pigments, such as cadmium yellow, yellow ochre, cerulean blue, cobalt blue, burnt umber, and so on, to be used in a transparent manner, it can be accomplished by adding more oil to the mix. This will decrease the amount of pigment and make the result appear more transparent.

Transparency in colored pencils can be handled simply by spreading the medium over a broader portion of the surface in thin layers employing various methods, for example, using solvents. Pigments in colored pencils or any other mediums are dispersed in the binder but are not affected by the binder itself. (Dyes, on the other hand, are completely dissolved in the binders.) If solvents are involved in the production of colored pencils, the pigments must be insoluble by these solvents. When artists blend colored pencils with the help of solvents, they dissolve the binder of the pencil core but not the pigment itself. This is similar to dispersing sand in water, where particles of the sand may be closer together or farther apart but not actually dissolved in the solution.

Dry blending with Powder Blender helps immensely in spreading colored pencil medium in thin layers and makes the application appear transparent as well. Indirect application creates the most transparent colored pencil application.

You might ask, "Can colored pencil, a naturally translucent medium, look opaque?" The answer is yes. Layered application of pigment is the key. Look at the colored pencil core itself. It is solid and opaque. You cannot see through it, and light cannot penetrate it. The less light penetrates the surface (or the more it is reflected), the more opaque the surface appears. A layer of paint or colored pencil spreads pigment particles that are "connected" by a transparent or translucent binder, such as oil or wax, across the surface. The farther apart these particles are, the more gaps there are between them and the more light is able to penetrate the binder and make the application look transparent/translucent. There will always be more "gaps" within a single layer of medium than there would be in multiple layers.

With more layers, medium becomes more opaque; therefore, the colored pencil application can, indeed, appear opaque with a multilayering approach.

The amount of pigment in colored pencils greatly affects their covering power. The pencil core manufacturing process must provide the durability to enable the colored pencil to withstand the pressure during use and during sharpening. Pencil cores consist mainly of binder, and the average amount of pigment is only about 30%. In most cases, this is enough; however, a more prominent appearance of color or a more opaque application can be achieved and regulated not only by the number of layers but also by the size of the deposited colored pencil particles.

The larger the particles, the less light can penetrate them, the more opaque they look, and the higher the concentration of pigment accumulates at a given point. By increasing the friction between the working surface and the colored pencil core, we also increase the size of the deposited colored pencil particles. For example, compare how colored pencil looks when applied onto smoother surfaces, such as cotton paper (below, left), with its appearance when applied on toothy sanded paper (below, right).

The weak cotton fibers shave off smaller particles of colored pencil core, and these are spread more thinly within the layer. Light penetrates this application with ease. The rigid tooth of sanded paper performs a more aggressive shaving of the pencil core, the particles are larger in size, and they are located in closer proximity to one another. This keeps light from penetrating the layer, the application looks more opaque, and the color appears more intense.

Prismacolor Premier magenta applied to cotton paper with normal pressure has a translucent appearance.

Prismacolor Premier magenta applied to toothy sanded paper with normal pressure has a semi-opaque appearance.

Here is an example of how Faber-Castell Polychromos raw sienna can look transparent, translucent, or opaque in colored pencil painting.

Transparent application. A layer of Powder Blender was spread over the toothy surface. It was followed with a light layer of colored pencil and then blended with a short-bristle brush.

Semitransparent application. Pencil was applied in a light layer and blended with a short-bristle brush.

Translucent application. Colored pencil was layered with normal pressure and blended with a short-bristle brush.

Semi-opaque application. Colored pencil was applied with a heavier pressure and blended with a short-bristle brush.

Opaque application. Colored pencil was applied in two layers with normal pressure, sprayed between layers with ACP Textured Fixative, and then blended with a short-bristle brush.

In the actual layering (superimposing), a direct application of colored pencil layers creates a more transparent/translucent result, since the friction between the colored pencil core and already applied medium is reduced by the natural properties of wax. The application of colored pencil over ACP Textured Fixative can yield a more opaque appearance, since the fiction between the colored pencil core and already applied medium is increased. When colored pencil is applied over ACP Textured Fixative and then blended with solvent, the binder of colored pencil medium will be partially dissolved, and the pigmented particles will be spread thinly and evenly over the surface in a painterly way with minimum gaps between them, which reduces the opacity of application.

As you can see, colored pencil is a versatile and capable medium. Its appearance greatly depends on the color and properties of the working surfaces, and the application methods, as well as the solvents and blending tools used.

Here, the first swatch was made with opaque Winsor & Newton Designers Gouache raw sienna. The second swatch was made by applying one heavy layer of Faber-Castell Polychromos raw sienna. The third swatch was made out of three layers of Faber-Castell Polychromos raw sienna colored pencil with ACP Textured Fixative sprayed between the layers. As you can see, a single layer of colored pencil was not able to completely cover the black bar; however, it was completely obscured by three layers of the same colored pencil, and the effect is similar to the one created by opaque paint; therefore, the same colored pencil medium can appear transparent, translucent, or opaque depending on the way it is applied.

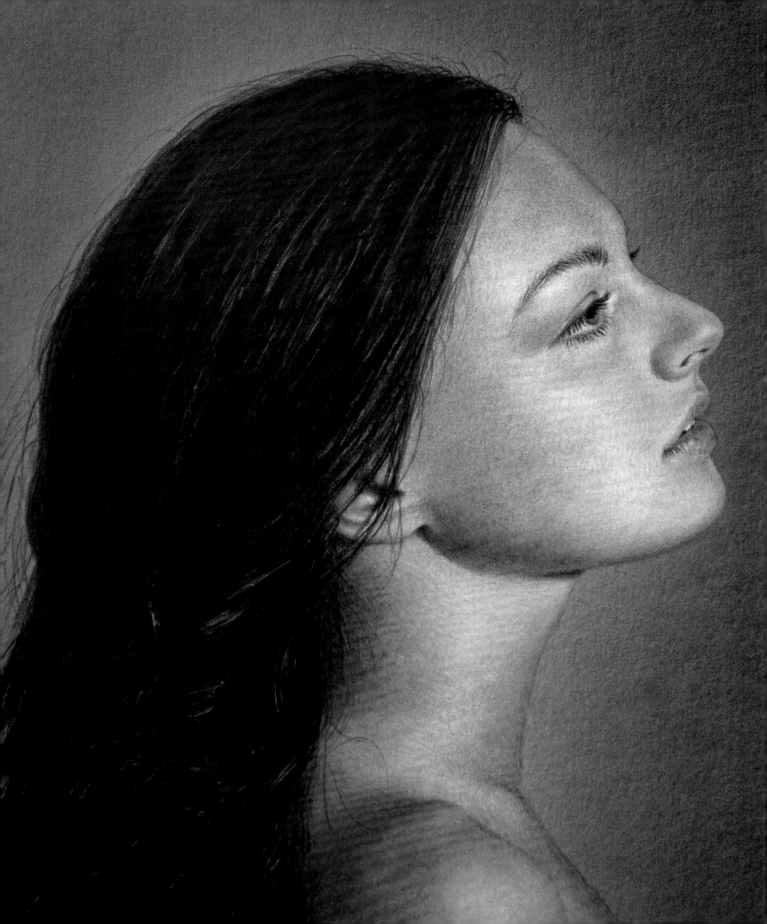

PORTRAIT FACTS AND FICTION

Ideas and solutions for composing a portrait

"The painter must always seek the essence of things, always represent the essential characteristics and emotions of the person he is painting."

—TITIAN

"A portrait is not a likeness. The moment an emotion or fact is transformed into a photograph it is no longer a fact but an opinion. There is no such thing as inaccuracy in a photograph. All photographs are accurate. None of them is the truth."

—RICHARD AVEDON

STEPPING STONES AND THE LEARNING CURVE

I got the "portraiture bug" way back in my early school days, as I clearly recall secretly doodling profiles of my classmates on the backs of notebooks. I have to admit, my early attempts at the portrait genre reflected my lack of knowledge in many aspects. At that time when I saw the image of a person who really impressed me in some way, I wanted to translate that feeling onto paper *immediately*. Typically, I used the first tool that was within reach—graphite pencil. Frankly, the result did not match even close to what I had in my mind and looked more like a caricature of my own vision. I clearly knew what it should look like but desperately needed to figure out how to implement it.

Alyona Nickelsen, *Anastasia* (based on a reference courtesy of PoseSpace.com), 2012, colored pencil painting on paper, 11.5 x 10.5 inches

This scenario is not that unusual. Our *artistic nature* allows us to intuitively recognize anything worthy of preserving in our work, be it a facial expression, a dramatic view, an intricate pattern of light, or a subtle color nuance. Our *human nature* may make our hands itch to draw or paint that vision right away. The possession of knowledge, how to control the medium, shape objects, mix and manipulate color, and the like would certainly make these urges more enjoyable and fruitful. Otherwise, we are doomed to remain frustrated with the results and have the feeling that "something is wrong with this picture." We may even be discouraged from

any new artistic endeavors at all. This is why it is so important for beginner artists to understand that they already have in their possession one of the key elements of creation: the vision or creative idea. The other two necessary ingredients, knowledge and experience, are obtainable only through self-discipline and dedication to learning.

I have personally discovered that the process of getting back to basics can be both very enjoyable and eminently rewarding. The feeling of pure accomplishment when you actually understand how to be in control of your materials and tools and can create *exactly* what you intended to show is unbelievable and encourages your progress like nothing else. I would highly recommend practicing simple still life setups that primarily consist of white objects placed against a white background or have a distinct predominant color with numerous variations of temperature and intensity.

The goal of such projects is for you to correctly present simple shapes under a chosen lighting condition and indicate spatial depth while controlling hue, value, and chroma. Exercises of this type will be helpful in your subsequent study of how to render the nuances of human flesh and how to convincingly re-create the much more complex topography of the human body.

Certainly, an in-depth knowledge of anatomy and proportions is on the wish lists of many colored pencil portrait artists. But how many of us have had the opportunity to spend years of training in the environment of a classical atelier or to learn the muscles and bones of the human body, as the late Leonardo, who once practiced on human corpses? Let's face it, the typical background of a modern colored pencil artist often involves only an anatomy class in high school or college,

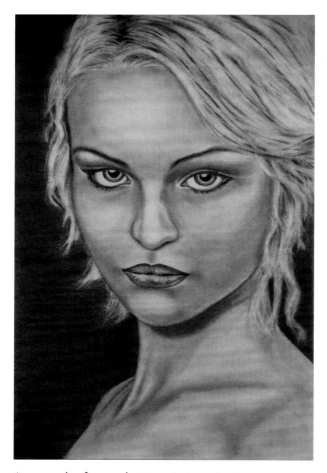

An example of my early attempts in portraiture.

the reading of a few books on the subject, and a workshop here and there.

So our discussion here will demonstrate how to achieve the best possible result based on the resources we already have, including our innate artistic ability to observe and analyze our own bodies and reference images. Remember that we human beings, though obviously very different from one another, have the same basic body structures. That said, I would recommend keeping a few good reference books handy. Books like *Classic Human Anatomy* by Valerie L. Winslow, *Anatomy for Sculptors: Understanding the Human Figure* by Uldis Zarins with Sandis Kondrats, and *The Artist's Complete Guide to Facial Expression* by Gary Faigin may be invaluable when you are dealing with something like a questionable view of a limb or shaping a wrinkled forehead.

Our primary agenda here is to design an appealing composition, secure it in a quality reference, and implement it through the colored pencil painting process. Sounds like a pretty tedious undertaking, right? Wouldn't it be much simpler just to create a photographic portrait? There would be no need to know how to control the colored pencil medium or how to shape facial features—everything is done accurately, in a split second with the push of a button; however, I think we would all agree that the image on our driver license or any membership card, which is the direct result of such photographic methods, could never be called a "portrait." The instant gratification of using a camera to produce artwork is merely an illusion. Working with a camera involves the same vital and key ingredients of other mediums: a vision or creative idea; knowledge of how camera, light, and photo equipment work; understanding of photo editing

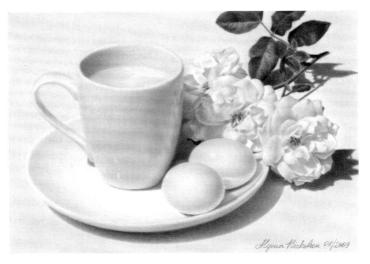

Alyona Nickelsen, *The Color of White 2*, 2009, colored pencil painting on paper, 8 x 10 inches

and manipulation (often involving multiple software programs); familiarity with computer and printer calibration; and actual hands-on experience working with the photographic medium and printmaking process. In just a few words, this is what is involved in producing artwork using the photographic medium.

In our work, however, even a quick snapshot can be helpful for the task of creating portraiture in any medium, including traditional ones such as oils, pastels, watercolors, and, of course, colored pencil. Photographic images are useful for retaining accuracy in likeness, capturing a fleeting expression, or even preserving a movement or a gesture. Photographs are simply invaluable for making portraits of children who have since grown up or for someone who is no longer with us, where observation from life is simply impossible. Our job as creative artists is to incorporate any helpful information the photograph offers, omit all the distortions or irrelevant details, and use it to relate our unique interpretation of the image while, at the same time, preserving the likeness of a subject.

HOW WE SEE OTHERS AND OURSELVES

Our self-perception comes from inside and is based on personal tastes, likes, and dislikes, as well as on intimate knowledge of our own feelings and circumstances; however, our view of others is based on limited knowledge about them from the outside, and so, naturally, it is different from their own perceptions. As the late author Michael Palmer once said, "Never compare your inside with someone else's outside." For example, if an employee is late for work, from the point of view of the employee the problem was the traffic. From the perspective of the employer, the blame is completely on the employee, who did not plan properly. We all perceive the same situation differently. The same is true of the way others perceive us. Someone might be concerned about the shape of their nose. But to someone else, the same feature may go unnoticed or may even be attractive. And vice versa, when we notice something that we like or dislike in others, they may have never thought about it and no one may have ever commented on it.

In *Dove Real Beauty Sketches*, a short film produced as part of the Dove Campaign for Real Beauty, several women were asked to describe themselves to a forensic sketch artist. The artist was not allowed to see the subjects. On separate occasions, strangers were asked to describe the same women to the artist. When the sketches were compared, the descriptions from the strangers were found to be more flattering and accurate. Sometimes we become obsessed with things that are not as important to others as we may think.

The image preserved in a single photograph might very well accentuate a characteristic that is not typical for the subject, or something that is generally characterizing that person in real life will not be as distinct in that image. Relying on just a single reference photograph provided by others will reveal a limited set of information. Personal interaction with the model, a series of photographic snapshots, a short video, or just additional description from relatives, friends, coworkers, and others can help to better understand who the subject is and reflect that information in the artwork.

PURPOSE AND STYLE

The style of a portrait is largely defined by its purpose. For example, it would be appropriate for a law firm to display a formal portrait of its founder posed against a simple background in a leather chair wearing a suit and a tie and looking straight into the camera lens. Typically, such a portrait would be considered "traditional" or "classical." For a family image that will be displayed in the living room of a home, a group portrait in relaxed poses against greenery in the background would connote a very natural environment. Its style could be called "casual." Overall, portraits can be categorized as

- Traditional
- Casual
- Candid
- Journalistic
- Glamourous
- Creative

John Singer Sargent, *Padre Sebastiano*, c. 1904–1906, oil on canvas, 22.25 x 28 inches. Courtesy of the Metropolitan Museum of Art, New York

The artist captured the cleric's thoughtful demeanor and conveyed his interest in nature. The style of this portrait can be considered casual or candid.

There is no precise formula for placing portraits into specific categories. Instead, it is the general feeling for what seems to fit and appears to be "right" for the occasion and location. Of course, there is also nothing wrong with stepping away from tradition, mixing and matching styles, or breaking the rules when it is aesthetically justified.

Typically, the style of the portrait is pretty much determined even before the artist touches the tools of the trade. The key components, such as a choice of the background, pose of the model, color scheme and tonality, props and accessories, are discussed and selected early in the process. They are either based on the decision of the artist or chosen by the client who is ordering the commissioned work. If this is a commissioned portrait, naturally, the client has the last word; however, to help clients with their choices, artists should make suggestions and

show portfolio samples that are appropriate for the occasion, explaining why this or that might work better for a particular situation. This also helps to make your customer more familiar with your personal style of painting regardless of the style of the portrait. The "hand of the artist" will remain recognizable through the body of work.

John Singer Sargent, *Edward Robinson*, 1903, oil on canvas, 56.5 x 36.25 inches. Courtesy of The Metropolitan Museum of Art, New York

The artist portrayed this person in a formal environment with referral to his career as an archaeologist and scholar. This portrait can be classified as traditional or classical.

EFFECTIVE LIKENESS AND ARTISTIC LICENSE

The issue of likeness is always a factor in portraiture as it is extremely difficult, if not impossible, for the artist to be completely neutral and absolutely objective. Regardless of the accuracy in likeness, the portrait will always indicate in one way or another the personal attitude of the artist—be it flattering or humiliating, admiring or condemning—since every portrait is actually the artist's vision of another human being. I refer here to the portrait as an artistic genre, not just a simple mechanical registration of the subject's appearance such as that created by a security camera.

The look of every human constantly changes because of such factors as age, weight gain/loss, and varying hairstyle/makeup. You can easily see this by sifting through the photographs of any family album. You will also notice that not only the color of hair, eyes, and skin tones but the look of the entire face of the subject can differ under various lighting conditions, angle of view, or as a result of inconsistent photo quality; however, despite all these variations of a person's appearance, somehow our brain is still able to recognize that person. The same phenomenon can occur when watching a brand-new movie starring a well-known actor or actress. Even with unusual makeup, costume, hairstyle, changes in mannerism, and voice modulation, you can still recognize the familiarity of a face. To do this, human vision relies on intricate processes that identify the unique shapes of facial features, as well as their proportional relationships.

Our eyes, eyebrows, nose, lips, forehead, cheeks, and chin are distinct, and their shapes play a significant role in creating the unique look of our faces; thus,

In these images, my son is still recognizable as the same person despite the changes that occurred due to the aging process.

the distinct shape of the lips can blow the cover of a person who had been disguised with the help of a wig and huge sunglasses. Also, our faces, in general, are symmetrically imperfect. Here is a fun little experiment that will help you see this effect in practice. Take a frontal photo of yourself or a person who you know very well, scan it, and open it with the graphic program that you normally use (Photoshop in my case). Now create an image that consists of two copies of the left side (one of them will be horizontally flipped) of the original photo and another one that consists of two copies of the right side (again, flip one of them horizontally). Then compare the three images.

As you can see, the color of the hair, eyes, and skin as well as the shapes of the facial features are the same, but the person is almost unrecognizable in the two new images. *Our imperfections define our uniqueness*, be it an uneven size of the eyes or not quite level eyebrows. As painter Édouard Manet once said, "There's no symmetry in nature. One eye is never exactly the same as the other. There's always a difference. We all have a more or less crooked nose and an irregular mouth." Complete

The original image on the left was divided in halves. The second image is constructed of two left sides of the original image. The third one is created by combining two right sides of the original image. Note that they look like completely different people.

undermining of our imperfections by the artist can wipe out the likeness. Exaggerations will lead to caricature. The trick is to conduct a delicate balance that preserves the likeness. Otherwise, we will end up with the overdone effect of Elvis Presley and Marilyn Monroe impersonators. The more the artist "fixes" things, the less the person is recognizable in the portrait.

Occasionally, the likeness of the subject is not required to be 100 percent accurate in a portrait. In this case, alterations are created purposely to distort the look of the model in a certain way depending on the reason. For example, if the model is used to represent a female in scenery as an illustration for the cover of a sci-fi novel, the particular likeness is not essential. When a male model is showcasing the strength of his muscles, likeness can play a sidelined role as well. There are plenty of requests for commissioned portraits to make a model look younger, thinner, or more flattered in some manner. Though the occasional "lucky accident" can be consciously retained as is, these deviations are done

by the artist deliberately. This can be called "artistic license"; however, these situations should not be confused with a poor justification of the artist's failure to achieve the likeness of the model.

BENEFITS AND PITFALLS

As they say: "You don't have to be a photographer to be a good artist, but you must be an artist to be a good photographer." If photography is used as a tool for creating art in mediums such as colored pencil, therefore, at least a basic understanding of the process is necessary. Of course, knowledge is the lightest luggage that you can carry throughout your life, so the more of it you have the better off you are.

Expensive photography equipment is not required to take useful reference shots. A camera that allows you to adjust settings manually, has a simple flash, and can be used with a couple of lenses will suffice as a "bare bones" photographic tool.

Here are a few issues to keep in mind when working with reference photographs:

- Understand exactly what information in the reference should be used and what can and should be adjusted in the artwork.

- Recognize how to obtain and preserve the necessary information with your particular set of photo equipment.

- Identify the distortions in the reference (all photographs distort).

- Supplement the information with different versions of the reference, color swatches, and notes so that you can modify the art appropriately.

- Accurately transfer and incorporate the critical information from the reference into the preliminary sketch.

Reference photographs do not need to be perfect, since they are not intended to be art forms by themselves. Their function here is merely to help efficiently secure information about the model or a composition for later use in other mediums, colored pencil for example; therefore, the reference photograph must be "read" and used selectively rather than blindly copied "as is."

Some content of the references can be tailored to your needs with photo-editing software; thus, it would be beneficial for you to become familiar with

Reference photographs are not perfect themselves and can significantly differ from the final artwork.

The reference can be adjusted in many ways using image-editing software, such as Photoshop.
Photograph courtesy of Sally Robertson

basic functions of that software, such as cropping and flipping the image, adjusting exposure and white balance, and altering contrast and saturation.

When the overall manipulation of the reference is satisfactory, you can transfer its critical information into the preliminary sketch by drawing freehand, using the grid method, or tracing. When drawing freehand, remember that accuracy in placement of facial features in perspective is vital to retain the likeness. The grid method can help you scale the sketch to the actual size of the final artwork. The issue with "tracing and cheating" has been debated ad nauseam. There is not even a consensus on the definition of the term, as the practice of "tracing from life" goes way back to the early fifteenth century and has been used in one way or another by many great artists since. This divides artists into those who categorically condemn it as a disgrace to the art world and those who are inclined to use whatever it takes in pursuit of excellence. As is always the case with any controversial topic, convincing either group to change its mind would be a tremendous waste of time and effort. So, I will just state my personal take

on this: *tracing of the reference itself contributes to final artwork about as much as a chalk outline does to solving a murder.*

The reference photograph can provide us with accurate information about the personal appearance of the model under specific lighting conditions and within specific surroundings, including

- The proportional relationships and shapes of the model's facial features.

- Fleeting expressions and momentary gestures.

- Specifics of an individual's figure in a particular pose.

- The transitory look of folds in clothing and the paths of patterns over them.

- Arrangements of hair and settlement of individual locks.

- The freshest appearance of such perishables as flowers or fruits.

- Subjects and matter frozen in action and motion, such as birds in flight or a water wave.

This type of information can be utilized in the artwork with assurance of accuracy as long as the reference was not distorted during its creation or software modification.

Due to the nature of lenses, all photo references contain optical distortions. These distortions create deformation of the image by stretching it, squishing it, or both (called "barrel," "pincushion," and "wave" optical distortions, respectively). Distortions are mostly noticeable at the edges of the frame in wide-angle lenses. In portraiture, optical distortions can cause the head to look larger than it is in reality and create the effect of bulging noses and tiny ears. One way to help avoid distortion is to not shoot your portraits with a wide-angle lens. To minimize distortion, use 50 mm lenses and above.

One common type of photographic image deformation is called "perspective distortion." It occurs when the subject is too close to the lens, which makes him or her appear too large or distorted compared to the background, with such things as large noses compared to the rest of the head, huge hands and feet compared to the rest of the body, and the like. Perspective distortion also occurs when the camera is not parallel to the plane of the subject closest to it. This will cause the horizon not to be horizontal, and vertical lines, such as building structures or trees, to appear to lean. To avoid this type of image distortion, place the subject in the center of the frame, keep the lens parallel to the subject, and move a few feet back. Of course, the resolution of the camera must be high enough to allow you to crop the image and still be able to enlarge it so that you can clearly see the details of the facial features.

The colors presented in the reference should be treated with caution since they will seldom be true. This is due to the calibration of the camera, computer monitor, and printer, as well as the properties of ink and paper when the reference is actually printed. If the true appearance of colors is important for the final artwork, artists should create a set of color swatches using the same medium as the final artwork and accompany it with informational notations (eye color, hair color, dress color, and so on) and the colors that must be used to create them. In this manner, the photo reference can provide the approximate coloration and the artist can easily adjust hue, value, and intensity based on the color swatches and notes to achieve maximum accuracy.

A good photo reference for portraiture must provide you with a clear view of the face and show the eyes in focus. You should also be able to see the details in the shadows and in the most illuminated areas. If it is not possible to achieve this with a single shot, you can create three versions of the same image—overexposed, normally exposed, and underexposed—so that you can see the details in the extremes of the value range.

The environment in which the model is placed greatly impacts the general look of the reference and the final artwork itself in several ways:

- Its darkness or lightness determines the overall tonality.

- Its coloration affects the colors in general, especially the shadow areas.

- The patterns and details of the background and the foreground can distract from the focal point or can add to the overall message.

As a general rule, the background and the foreground should not compete with the focal point of the portrait (the model). When you include busy patterns, bright colors, and numerous details, the composition can look unnecessarily cluttered. These items should be carefully orchestrated in advance to provide a harmonious relationship and a cohesive message.

A simple background with a few details is typically enough to give the portrait a complete look. Taking such references is easy, since any wall with an even coloration can serve as a background. For more complex backgrounds in a portrait, the following can be used:

- Attractive outdoor spots with greenery, water features, or architecture

- Indoor setups, including bookshelves, fireplaces, or window dressing

- Creatively designed backdrops and staged props

A BASIC PHOTOGRAPHY CHEAT SHEET

ISO
If your subject is still and there's plenty of light, lower your ISO (for example, to 100 or 200). Lower ISOs result in less grainy (noisy) images.

If your subject is moving or there is a deficit of light or you do not have a tripod, use a higher ISO (for example, 1600 or 3200). Just remember that higher ISOs result in images that are more grainy (noisy).

APERTURE
The smaller the opening of the lens (the aperture), the lower the amount of light that passes through the lens and the greater the depth of field (the area of sharpness from front to back) in a photo, meaning that the foreground and the background of an image will both be sharp. Smaller aperture openings have larger aperture numbers.

The larger the opening of the lens, the greater the amount of light that passes through the lens and the shallower the depth of field, resulting in a blurrier background in the image. Larger aperture openings are represented by smaller aperture numbers.

So for example, an aperture of $f/2.8$ creates a shallow depth of field (a blurrier background), $f/8$ creates a medium depth of field, and $f/22$ creates a deep depth of field (where sharpness extends from the near to quite far back into the scene.

SHUTTER SPEED
Use a slower (longer) shutter speed (such as 2 or 4 seconds) to imply motion, for example, blurring and softening the flow of moving water.

Use a faster (shorter) shutter speed (for example, 1/125 or 1/250 second) to freeze motion and make moving objects appear still.

Frans Hals, *Marriage Portrait of Isaac Massa and Beatrix van der Laen*, oil on canvas, c. 1622, 55.1 x 65.6 inches. Courtesy of Rijksmuseum, Amsterdam

The outdoor scenery enhances the relaxed and peaceful mood of this painting without detracting from the happy couple. The background and foreground are used to harmoniously frame the focal point.

Frans Hals, *Portrait of a Man, Possibly Nicolaes Pietersz Duyst van Voorhout*, oil on canvas, c. 1636–1638, 31.7 x 26 inches. Courtesy of the Metropolitan Museum of Art, New York

Though this local brewer is portrayed with a slight sense of humor, we can clearly see an overall positive attitude of the artist toward the subject.

An ordinary bed sheet, a few artificial leaves, and an artistic approach produce a stylish and enchanting image. Photograph courtesy of Sally Robertson

The way the model is posed and lit in the portrait reveals the artist's attitude toward that subject. Posing and lighting are extremely powerful tools for flattering and complementing or for derogating and ridiculing the appearance.

Frans Hals, *Malle Babbe*, oil on canvas, c. 1633, 30.9 x 26.1 inches. Courtesy of Gemäldegalerie, Berlin

An obvious negative attitude of the artist toward the subject is clearly presented in this grotesque portrayal of a woman. The inclusion of an owl hints to the old Dutch proverb "drunk as an owl" and associates her with fools and vulgar behavior.

Portraits are often commissioned by clients. So, naturally, your task is to make them like the results of the painting. The following are a few suggestions about lighting and posing to help models appear in a more flattering manner.

LIGHTING

It is hard to overestimate the importance of lighting in the painting. Light is the key element that sets the mood, determines tonality, accentuates focal points, and indicates the accents. It can pull compositional elements together and break them apart. Light in the painting can be a beautifier and exaggerator. Knowledge of how light works and how to control it is simply invaluable. Here are just a few general suggestions.

- The smaller the size of the light source, the sharper the shadows.

- The farther the light is from the subject, the smaller the size of the light source becomes. Therefore, the shadows will become darker and sharper as well.

- The highlights are the brightest areas of the lit surface. The strength of the light will diminish toward the shadow.

- To avoid confusing the viewer, use a single light source.

- If you are taking photos indoors and using flash, try to reflect the light off the ceiling or walls rather than pointing it directly toward the subject.

- Overcast days generate soft lighting without harsh shadows, which is great for taking portrait photos.

- For outdoor shots, it is best to illuminate the portrait with natural light just after sunrise or about an hour before sunset (the golden hour). At that time, light is diffused (softened) by atmosphere; it is pleasantly warm and creates dramatic shadows.

- To soften harsh shadows, place a reflector on the shadow side of the subject.

- For better head shots, use 100 mm to 135 mm focal-length lenses.

POSING

When deciding on the pose, first determine what type of portrait you are about to paint—traditional, casual, glamorous, and so on. Then, select an appropriate background, foreground, and accessories. Ask your subjects to wear clothing that would fit that type of portrait. Also, remember that you will be painting all those patterns, textures, and details. So beware.

Prior to the photography session, offer your subjects a facial tissue or a compact powder to remove any shine on the face. Shine is not attractive in the portrait and can obscure facial geometry. In addition:

- Do not crop the image at the joints of the subject.

- Frontal lighting flattens and widens the face. Three-quarter-angle lighting allows you to see the shapes of the face better; however, when turning the subject's face, make sure that both eyes are still visible, unless you have decided to paint a profile.

- Strong highlights in the eyes attract attention, as they are the focal point of the painting.

- You can make your subject look directly into the lens for strong eye contact or a bit off camera for a more contemplative look.

- People often worry about weight issues. To diminish the look of a double chin, ask the subject to stretch the neck toward you and slightly lower their chin.

- To create the appearance of a slimmer waistline, do not allow the arms to be placed alongside the body and do not pose your subject straight in front of the lens. Instead, twist them in a half turn.

- You can crop the image up to the waistline or conceal the waist with the arms.

- Do not allow your subject to slouch as it will increase the girth of the waistline and create an unattractive look overall.

- If hands are included in the photo, it is better to position them so that they are holding something; however, make sure they are relaxed and are not forming a strong fist.

- In standing poses, make sure that the subject's legs are not parallel to each other and that there is a space between them. This will help make them look thinner.

- High heels make feet look smaller. If you are portraying bare feet, pose them with their heel lifted to diminish their size.

- When photographing more than one person, make sure their heads are not at the same level.

These are just a few points to make the appearance of the model more attractive in the reference photograph. Remember, though quite a few things can be fixed in the image-editing software, you are always better off when the pose and lighting are captured correctly in the reference. First, it is faster and easier to change the pose or adjust the lighting and reshoot the image than it is to make laborious digital adjustments later. Also, reshooting minimizes the possibility of making the types of mistakes during digital editing that we have witnessed so many times on the covers of popular magazines.

A classical and contemplative male pose.

A casual and relaxed pose.

A dynamic and feminine pose.

A dreamy and romantic close-up.

An intriguing and mysterious close-up.

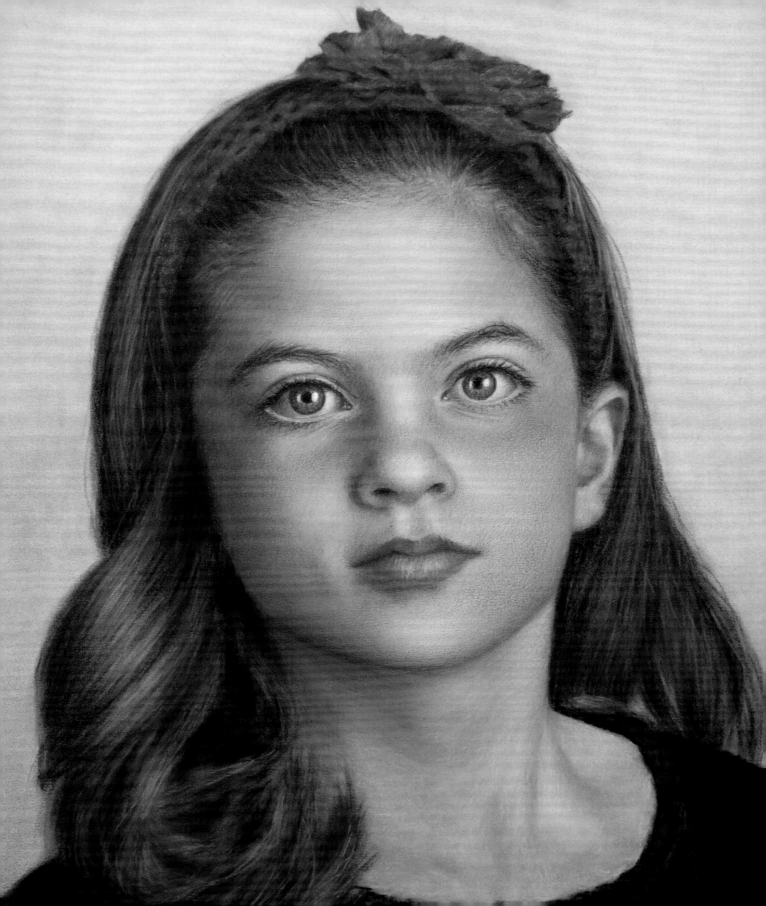

PRACTICING THE ESSENTIALS

Rendering key components of portraiture

"He who loves practice without theory is like the sailor who boards ship without a rudder and compass and never knows where he may cast."

—LEONARDO DA VINCI

"I have been impressed with the urgency of doing. Knowing is not enough; we must apply. Being willing is not enough; we must do."

—LEONARDO DA VINCI

LEARNING FROM THE BEST

Luckily for today's artists, we do not have to reinvent the wheel. There were plenty of smart, talented, and determined people before us who each put enormous effort into figuring out "how things work" in the two-dimensional world when portraying a three-dimensional one. The priceless discoveries they made are preserved in their masterpieces and accessible to us for the price of a museum ticket or, in the worst-case scenario, for the time taken while searching the World Wide Web. Any information about their knowledge that has survived has been carefully documented, copied, cataloged, and published, and is also available today to any and all who are interested. The value of such knowledge is solid, praised, and admired by many generations and, judging by the latest appraisals of da Vinci's or Rembrandt's originals, will not be diminished in the foreseeable future; therefore, with such a rich heritage, we have no excuse for failure. It remains our duty to put sincere effort into

Alyona Nickelsen,
Isabella, 2016, colored
pencil painting
on sanded paper,
15 x 12 inches

learning, discovering, and advancing our trade and craft for the next generation of artists as well as the art itself.

Learning from others does not mean accepting everything as is. It means understanding the concept presented, questioning it, and improving on it. Thinking "outside the box" generates new approaches and ideas; however, knowledge of "how things work" is always an excellent base that allows us to improve or even disprove a concept altogether.

The use of layering has provided oil painters throughout the centuries with the means to express depth in a two-dimensional painting (of course, in addition to all other aspects that a good piece of art must contain). Does this mean that this is the only formula for success? Can we skip a step or two and still achieve depth in our artwork? Certainly, nothing is written in stone, and practically all master painters brought their own solutions to the table; however, actually understanding the rules is the rule for breaking the rules.

In da Vinci's most famous and celebrated work, *Mona Lisa*, he demonstrates his ingenious solution to shadow projection, called the *sfumato* technique.

His method is still not well understood, even with the latest nondestructive image-analysis technologies. According to the X-rays of this painting, the thirty paint layers add up to only about 40 microns, which is roughly half the thickness of a human hair. Da Vinci began painting *Mona Lisa* circa 1503 and worked on it for about four years, though some think that the task continued for a decade or so. It is still considered unfinished, as he resumed work on

it again just prior to his death. No one knows why da Vinci worked so long on one painting; however, the fact that each layer of paint must dry completely before the application of the next would tend to justify such expenditures of time.

Though we lack an exact description of how *Mona Lisa* was created, in the writings of da Vinci that survived, he suggested using "black, umber, and little lake" for the underpainting of shadows; the combination of opaque pigments, such as "white, lake, and Naples yellow" for lit areas; and for glazing shadows, such transparent pigments as "azurite and

Leonardo da Vinci, *Mona Lisa*, oil on wood, c. 1503–1506, 30 x 21 inches. Courtesy of Musée du Louvre, Paris

lake." Looking at his unfinished painting *Virgin of the Rocks* from the National Gallery in London, we can see that his underpainting was followed by veiling to heighten the protruding areas of the faces, such as forehead, cheeks, nose, and so on, and to create contrast with darker shadows. Then, according to his notes, he continues with the color application: "After you have softened this first coat, or dead color, and let it dry, you may retouch over it with lake and other colors." A series of thin glazes of pure pigments alternated with thin scumbling over lit areas culminates in seamless transitions of shadows on the skin tones and a masterful blending of colors that we can see in his finished work.

I highly recommend artists visit as many exhibitions as possible and see the originals of master painters whose work and style is most appealing to you rather than viewing them on the computer monitor, even if they are high-resolution images. Actually seeing Titian's paintings allows you to truly appreciate the way he used the pinkish color of the ground to influence the appearance of human flesh. Looking at an original Rembrandt, you can really see the glowing effects of the rich deep reds in the backgrounds and admire the magnificently sculpted facial features. Though quality reproductions are helpful, the true brilliance of Bouguereau's "invisible brush" can only be fully experienced when standing in front of his work. Only by viewing the original oil paintings can you compare and understand the differences between the depth depicted with the masterful use of layering and the version displayed on a photograph or a computer screen.

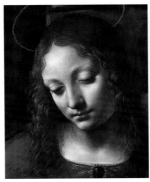
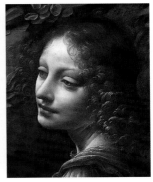

Leonardo da Vinci, *Virgin of the Rocks*, oil on wood, c. 1491–1499, 74.6 x 47.2 inches. Courtesy of National Gallery, London

FACIAL PLANES

The main goal of realistic portraiture is a depiction of the model in spatial perspective with areas of the face and the body under the light and in the shadow, closer to the viewer and farther away. It also includes correctly placing features of the facial surface, while keeping their accurate shape and continuing the impression that some parts of those shapes are lighter and some are darker, some closer and some farther from the viewer.

In oil painting, the detailed depiction of large shapes, such as the human head with its complex facial features, has been traditionally accomplished using something called the *general to particular principle*. Using this method, the artist renders the overall shape first and then portrays the details on its surface according to the perspective and lighting situation specific to the composition. Such properties of oil paint as the ability to form a hard surface after drying create perfect circumstances for this approach. It allows the artist to concentrate on shaping the head first and then addressing the shape of the nose, mouth, ears, and the like later. This property of oil also allows the artist to model the form from light to dark and from dark to light. That makes tasks such as indicating a lit detail over a shadowed area or creating a highlight on top of a shaped feature a fairly straightforward process; however, one huge disadvantage of oils is the long waiting period needed for layers to dry properly.

Colored pencil use has always been limited for these techniques. The wax in colored pencil does not form a hard surface when layered and, thus, does not allow the artist to work from dark to light. So, when detailing larger shapes, like the human head, colored pencil artists have been forced to work on everything at once and could only proceed by gradually darkening the values. Conversely, the only way we had to lighten the value was by erasing the applied medium. Unfortunately, this is not always easy. Traditional erasers simply "mush" up the surface of soft cotton paper, leaving murky colors behind. Mounting putty and Scotch tape have proven more helpful in this situation, though values still cannot be lightened as much as desired. As a result, colored pencil artists had to preserve the white of the surface for highlights and to shape entire objects together with their details all at one time. This often led to heads that have been misshaped overall by being "pushed in" or "pulled out" in the wrong places or to the wrong degree. In other cases with this method, heads looked like flat colored spots that resembled a human being about as much as a smiley face symbol resembles a real smile.

Using the correct layering methodology and ACP Textured Fixative, however, there is no real reason remaining for colored pencil artists to deal with this hardship at all. With new methods, colored pencil artists can work freely from light to dark and vice versa. We can concentrate on overall shapes first, laying a solid foundation for the details. Then, we can pay close attention to the location of facial features and assign the proper values to them.

LEFT: The "washed-off" appearance of facial features under more direct frontal lighting.

RIGHT: A clear division into facial planes with sidelighting and a three-quarter turn of the face.

As seen in the illustration on the preceding page, light and shadow reveal the structure of the head and divide the face into planes. Sidelighting creates more contrast; therefore, the division between the planes is clearer, making it easier to see the shape of individual features.

Certainly, the real facial structure is much more complex than this simplified model. For example, take a look at the superimposed lines in the illustration below that indicate the major areas of facial topography of the real person.

Our reference photograph is an excellent tool to guide us through such complexity. Imagine that you are looking at a topography map of a hill where the elevations are divided by black lines and colored in various shades of green (the lighter the green, the higher the elevation). The more closely the black lines are placed together and the fewer shades of green you can see on the map, the less detailed it is. Such a map was created by the set of lines that are based on careful measurements of the actual surface.

Similarly, we can "read" the reference photograph of a person as a map of facial and body landmarks and create an outline that contains accurate placements of all crucial marks or nodal points, such as the distance between the eyes, the width of the nose, and the length of the jawline. These markings will mimic the black lines of the topography map and indicate the boundaries of facial valleys and elevations. As there are no hard lines on the face, the placement of the lines and their frequency will depend on the artist's preferences.

The next step will be to assign the correct value during the rendering to indicate the true elevation or depth of the marked areas. For example, if, in the map, the peak of one of the hills was colored in dark green, we would read it as a crater on top of the hill. Similarly, if the tip of the nose in the painting has an incorrectly placed darker value, its shape would be altered and "pushed in."

A set of lines superimposed over a photo creates a "reference map" of the face and its features and demonstrates the true complexity of facial topography.

A grid is a very useful system for creating an exact outline. For centuries, it was a tool of choice and used by many prominent artists not only to enlarge an existing drawing but for accurate measuring and the actual drawing from life and live models—that is, "tracing from life." Typically, a simple frame was strung with dark threads that created a grid. Then it was placed in front of a composition or live model. The artist looked through a viewfinder at the object behind the frame. This was necessary to eliminate the distortion caused by the the binocular nature of our vision. (Look at your finger with one eye closed, then with the other eye. Note how the position of the finger "jumps" from one side to another. This factor is called *parallax* and is always considered by artists when making any sight measurements from life.) The artist placed all the necessary markings onto the paper with a corresponding grid.

You can draw grid lines on clear acetate, place it on top of the photograph, and secure it with artist's tape. Also you can use a graphic program, such as Photoshop: click View/Show/Grid, then capture the image with Print Screen, and print it to a comfortable working size (Photoshop doesn't have the option to print grid lines). You can adjust the distance between the lines as you need to by clicking Edit/Preferences/Grid.

Albrecht Durer, *Draughtsman Making a Perspective Drawing of a Reclining Woman*, woodcut, c. 1600, 3.06 x 8.44 inches. Courtesy of Metropolitan Museum of Art, New York

To produce the identical outline to the size of the reference photograph, draw a grid of the same size on tracing paper. Tracing paper is thin enough to transfer the outline afterward onto your drawing surface with Saral graphite transfer paper. It is also sturdy enough to withstand many erasings and corrections. For a larger size of outline, you can equally increase the distance between the grid lines.

To create the impression that the head has volume, we must accurately indicate which areas are under direct light, which are in a shadow, and which are between the two and to what degree. Of course, this involves assigning correct values to specific areas, as well as using the proper cool and warm variations of local colors. We also need to determine the correct depth of all the "ins" and "outs" of the face, otherwise, it is easy to compromise likeness in the portrait; therefore, shaping is probably the most difficult task we face. Since a photograph flattens the depth of the subject, we must rely on our own judgment to determine the degree to which we must "pull" the "outs" and "push" the "ins" to reconstruct the shape of the human head and restore the third dimension in our rendering.

We can all learn from the practices of the master oil painters, particularly Rembrandt, who had truly magical skills in the art of "sculpting" faces with paint. Upon examination, we discover that the best approach is "working up," or building the head from the farthest planes toward the closest in relation to the viewer. This helps us to better judge how much "lift" each area requires until it curves and turns into another plane. To maintain the illusion of light traveling the longer path to the "back" of the painting and the shorter one to its "front," shadows must be maintained as not only darker but also as more transparent/translucent when compared to the more opaque lit areas.

EDGE GUIDE

While shaping the face, it is easy to lose track of where the edges of facial features are and where one plane merges into another, especially when they are not very distinct in the first place. This is certainly one area that can lead to losing the likeness of the subject. For the sake of accuracy, many of the master oil painters relied on a very detailed preliminary drawing that was transferred onto the canvas or panel and secured with ink. This allowed the artist to see the edges through some portion of the painting process; however, after a while, the drawing was so completely obscured by layers of paint that the inked sketch offered little help.

Fortunately for colored pencil artists, I came up with a great tool that provides this functionality but in a much more useful form. I call it an "edge guide." The edge guide is an exact copy of the initial drawing, but it is created on a clear material such as tracing paper, clear acetate, or printer transparency. The idea is to securely attach this copy to one side

Edge guide attached to the side of the artwork.

of the working surface (typically, to the opposite side of the preferred working hand of the artist) and keep it there until the end of the rendering. This simple tool is an immense help to artists to provide an accurate reference for the edges of shapes and the directions of facial planes. No matter how opaque the layers become, the edge guide is still useful since it is not beneath the painting but is superimposed over it. Since colored pencil is a dry medium, there is no danger that wet paint will be smeared, as would be the case with paint mediums. The edge guide can be traced over the initial outline with markers on clear acetate, or it can simply be printed to the exact size from a scanned initial outline onto printer transparencies. Make sure that it is securely attached to the side with artist's tape and exactly matches the initial outline on the working surface.

BACKGROUNDS

Backgrounds are an integral part of any portrait and create enormous impact on the entire work. Their value and color not only influence the tonality and the mood of the piece but also impact the appearance of the foreground and the subjects themselves. Nevertheless, backgrounds are typically considered as a chore by colored pencil artists. And no wonder; backgrounds typically retain the majority of the area in the portrait and traditionally are rendered by a meticulous placement of tiny pencil strokes to create seamless value and color transitions. This method inevitably takes way too long to complete and way too much colored pencil medium due to constant sharpening. It is also a very "meditative" process, to put it mildly. If the artist is working on a tight schedule or has a commission to deliver, this would be an essential reason for resorting to other mediums or using other ways of speeding up the process, such as employing liquid solvents.

The following is a description of the most economical and the fastest method to create a background with seamless value and color transitions—without using solvents or involving other mediums.

1. Transfer the initial outline onto your working surface. Sanded paper works the best for this purpose. Use any brand of artist's masking film to protect the subject, and cut the edges using an X-Acto knife with a fresh blade. Work with the blade lightly, as masking film is very thin; however, the rigid surface of sanded papers makes this process much easier compared to the soft surface of the traditional cotton papers, when slightly deeper unintentional incisions leave a distinct mark that would be hard to camouflage during the rendering. With a large rounded sponge, apply a very light layer of Powder Blender to the entire background. Use the lightest value/color that you would like to make visible in your background using "oil-based" pencils. Work with pencils very lightly. The sanded paper easily shaves off the pigmented particles of the pencil core and they are deposited onto the surface, without being pressed into the paper tooth. This coverage literally takes a few minutes and doesn't require any pencil sharpening. Just rotate your pencil point to retain its sharpness.

2. Using the same large rounded sponge, blend the applied pencil. Try to work from the edges of the masking film toward the edges of the work to prevent accidental lifting of the film. Repeat the process if you would like to darken the value of that color. Spray ACP Textured Fixative in a couple of light layers to secure your application of pencil. Allow it to dry completely before proceeding.

3. Repeat the same process with a darker value or a different color of your background, and apply it in the areas of value or color gradation. Blend the applied pencil with Powder Blender to eliminate any edges between two colors, and again secure the application with a couple of layers of ACP Textured Fixative.

4. Increase the contrast of the background with the darkest colors of the selected pencils and apply them to the darkest areas, allowing the previous application to remain visible. If necessary, add touches of black to "push" your values even more. Blend the application with Powder Blender and secure with ACP Textured Fixative.

After the fixative dries, remove the masking film and proceed with the rendering of the subject. The edges of masked areas will be crisp; however, they can be softened easily during the rendering with a short-bristle brush.

SKIN TONES

Countless generations of artists have been intrigued by the elusive nature of human skin. Over and over, I return to my favorite master of portraiture: Rembrandt. I am instantly awestruck by his brilliant ability to blur the line between two and three dimensions—really between painting and sculpting. Standing literally about an inch away from the surface of his original painting reassured my understanding of his approach; working from the back of the composition toward the viewer, "pushing" back the shadows with transparency, and "pulling" lights out with the opaqueness of paint. The genius of Rembrandt's portrayal of skin is not only about using a limited set of specific colors or high contrast in values. It is also about manipulating medium such that skin appears as you would see it in person and in real life—not refined and artificial, but tangible and alive.

According to many writings about his techniques, Rembrandt did not have a single system or method. By experimenting and learning about the properties of the available materials, he constantly stretched

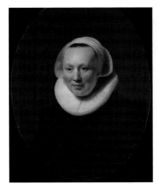 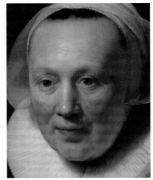

Rembrandt van Rijn, *Portrait of a Woman*, oil on wood, 1633, 26.75 x 19.75 inches. Courtesy of The Metropolitan Museum of Art, NY

their limits and manipulated them often in unorthodox ways. For example, contrary to the traditionally smooth finish of paintings, Rembrandt kneaded the paint applied to the surface until it thickened to the point that it could no longer be moved and had to be left to dry. Then, he would add another layer and continue sculpting with paint to create a textured, raised surface relief. Occasionally, his brushstrokes were perpetuated by thick impasto and often emphasized the plasticity of the skin that follows the facial structure beneath.

Of course, colored pencil is not paint, and applying it with thick impasto would be difficult, to say the least; however, the ability to allow continuous layers using ACP Textured Fixative provides us with possibilities Rembrandt did not have. We can lighten values and gradually "pull" lights out of the darkness of transparent shadows. Colored pencil layers are much more incremental when compared to the thick application of oil paint and do not require long drying times. In addition, their blending is not limited by thickening, as is the case with oils.

The same skin types can look dramatically different under a variety of lighting situations. Their colors are affected by the surroundings and mimic the complexity of the human anatomy beneath. Skin looks warmer as it wraps over a set of muscles, but when it gets closer to the bones it will look cooler. When blood vessels are near its surface, hints of reds are added for arteries or blues and greens for veins. Skin is translucent, very plastic, and its texture will vary depending on a person's age (smoother during childhood and rougher with advancing years), gender (delicate for females and coarser for males), or even lifestyle (subtle texture for exposure only to an office-like indoor environment and more pronounced or weathered texture for someone exposed to outdoor physical activities). Though skin colors themselves are fairly mute and low-key, when in contrast with an even lower-intensity color created by the shadows or washed out by strong lights, they can appear strong, bright, and vibrant.

Skin colors look more convincing in paintings when they are expressed as a compilation of various reds, yellows, and blues rather than a homogeneous single color that creates the impression of a paint job on a mannequin rather than real skin.

The overall lightness or darkness of skin tones is usually the factor you can use to divide them by groups; however, properties such as overall warmth or coolness should be taken into consideration as well. When lighter types of skin tones are painted, a significant quantity of white is used to model them, adjust the intensity of colors, and lighten the values. Since white naturally cools the applied color, an extra touch of yellows and oranges is needed to indicate a warmer type of light skin tone. When painting a darker type of skin tone, underpainting with warmer reds and yellows followed by darker glazes creates the effect of a warm inner glow. If cool dark skin tones are needed, a scumble with lighter colors will do the job.

SAMPLE COLOR COMBINATION FOR RENDERING LIGHT SKIN TONES

Base color is established with Faber-Castell Polychromos light yellow ochre.

Base color is modified with Faber-Castell Polychromos rose carmine and scumbled with Prismacolor Premier white to cool down the color mix.

Base color is cooled and darkened with Faber-Castell Polychromos phthalo blue for shadowed areas.

Base color is modified with Faber-Castell Polychromos rose carmine and darkened with Polychromos ultramarine for warmer shadowed areas.

SAMPLE COLOR COMBINATION FOR RENDERING MEDIUM SKIN TONES

Base color is established by mixing Faber-Castell Polychromos light yellow ochre and burnt sienna.

Base color is modified with Faber-Castell Polychromos rose carmine and scumbled with Prismacolor Premier white to cool the color mix.

Base color is cooled and darkened with Faber-Castell Polychromos phthalo blue for shadowed areas.

Base color is modified with Faber-Castell Polychromos rose carmine and darkened with Polychromos ultramarine for warmer shadowed areas.

SAMPLE COLOR COMBINATION FOR RENDERING DARK SKIN TONES

Base color is established by mixing Faber-Castell Polychromos ultramarine and burnt sienna.

Base color is modified with Faber-Castell Polychromos madder and scumbled with Prismacolor Premier white to cool the color mix.

Base color is cooled and darkened with Faber-Castell Polychromos phthalo blue for shadowed areas.

Base color is modified with Faber-Castell Polychromos madder and darkened with Polychromos caput mortuum for warmer shadowed areas.

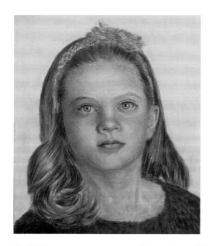

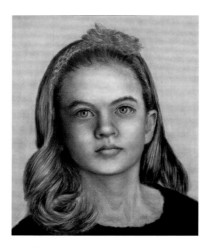

1. Skin tones were underpainted here with Faber-Castell Polychromos raw umber in the darkest areas and blended using a short-bristle brush and Powder Blender farther toward the middle of the face. The facial features were shaped using the wipe-off technique: values were lightened with a sponge applicator by wiping off the excessive amount of applied medium from the surface, and then the sponge was cleaned on paper towel to continue the process. More aggressive erasures were made using mounting putty and Scotch tape. After establishing the overall shapes, the values were darkened by adding Polychromos burnt umber and black to the darkest areas. The application was then secured with a few light layers of ACP Textured Fixative.

2. After the fixative dried, the underpainting was isolated from subsequent pencil applications. The lit areas of the face were developed further with Faber-Castell Polychromos white, Prismacolor Premier white, and titanium white. A more opaque application of white was applied to the lightest portion of the forehead and neck, as well as to the most protruding features—nose and chin. The applied white was blended using a short-bristle brush and sponges. At the end, this layer was also secured and isolated with ACP Textured Fixative.

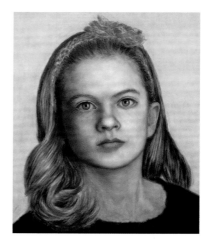

3. The color layer began with light glazing over the entire face using Faber-Castell Polychromos light yellow ochre and dark flesh. The isolating layers of

fixative allowed me to introduce and then blend low-key yellow and red to the skin tones without intermixing them with the underlying layers. This establishes the difference in color appearance over the underpainted shadows and the lit areas.

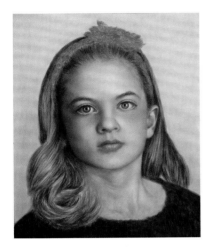

4. While the facial features are shaped, the reds and yellows in the skin-tone mix are deepened further with Faber-Castell Polychromos cadmium yellow, medium flesh, rose carmine, deep scarlet lake, and Prismacolor Premier jasmine and goldenrod. The topography of the face is gradually developed by lightening values with more Premier white and Polychromos white and reapplying more yellows and reds. This creates the impression that some portions of the face are not only lighter in value but located on different planes than others; thus, the impression of depth is reinforced. Note that every time white is added, it lowers the intensity of the color mix and also cools it. Premier light umber is then used to tone down the intensity of the color mix and darken the values.

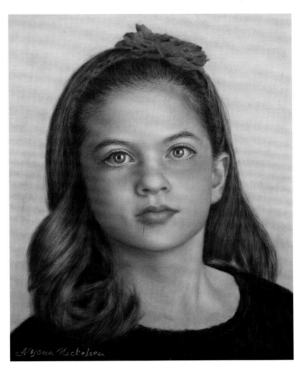

Alyona Nickelsen, *Isabella*, 2016, colored pencil painting on sanded paper, 15 x 12 inches

5. The cooler reds and yellows were introduced here by adding Faber-Castell Polychromos fuchsia, caput mortuum violet, Caran d'Ache Pablo purplish red, pale yellow, and Naples yellow. The most shadowed areas were touched lightly with Prismacolor Premier indigo blue and, closer to the lit areas, with Lyra Rembrandt Polycolor sky blue. This not only darkens the values but visually pushes those areas back, as blues tend to recede compared to the reds and yellows that advance in the painting. At the end, the skin tones were lightly scumbled with Polychromos white and Premier white to even out and smooth out occasional pencil strokes, to create seamless value and color transitions, to highlight the areas, to cool the overall color mix, or to lower its intensity when needed.

EXAMPLE OF RENDERING DARK SKIN TONES USING WATERCOLOR UNDERPAINTING

1. To begin, the skin tones were underpainted with a few thin watercolor layers using a mixture of gold ochre, a bit of burnt sienna, and a touch of alizarin crimson. Brushstrokes were applied following the facial features and topography of the body. This established a base color for the skin tones. In the areas under light, the underpainting leans more toward yellows, and in the shadows, more toward reds. Similar underpainting can be accomplished using layered colored pencils, such as Faber-Castell Polychromos light yellow ochre, light ochre, cadmium orange, madder, and burnt sienna, which were then blended using a sponge applicator and Powder Blender and secured and isolated with ACP Textured Fixative.

2. The development of the skin tones begins from the farthest planes in the composition forward, gradually combining yellows, reds, and blues to create a balanced mix of the base for dark skin tones. The pencils used are Prismacolor Premier sand and Faber-Castell Polychromos dark flesh and sky blue. Premier sienna brown was used to darken values further and to unify the colors when needed. Hair and brows were indicated using Premier black with short striking strokes following the direction of the hair growth.

3. The overall application does not appear as a single unified color, but rather as "patches" of color variations that follow the topography of the face. The skin tone is affected by the color, strength, and direction of light and contains low-intensity yellows, reds, and blues. The intensity of colors is lower in the shadows and under strong direct light. It is more prominent in the middle values.

4. With the addition of Prismacolor Premier yellow ochre, pomegranate, and Spanish orange, the modeling continues toward the middle values. The shadowed areas at the farthest side from the viewer were darkened with Premier crimson lake and indigo blue. The eyes and remaining facial features were articulated in more detail with the addition of Premier white and black, as well as the rest of the colors that were used in skin-tone development. This increases the contrast and refines the edges and smaller details.

Alyona Nickelsen, *Jesse* (based on a reference courtesy of PoseSpace.com), 2012, colored pencil painting on paper, 11 x 8 inches

5. The rendering was continued toward the viewer using the same selection of colors and adjusting the value of the color mix to maintain the appropriate contrast for a given lighting condition and in consideration of the light source direction. Facial features were refined further, and hair was darkened with more layers of Prismacolor Premier black and some touches of crimson lake and indigo blue. In the areas where coarse facial hair can be seen, some occasional pencil strokes of darker values were left intentionally unblended. The bright highlights and weaker reflected lights were created with Premier white.

HAIR

Hair in a painting can be a major attraction, as well as a total disaster when it looks flat, scrubby, heavy, solid, or helmet-like. While in real life there are quite a few tricks for salvaging an unfortunate hairdo, it could cause a real headache in a painting.

The problem is that quite often the shape of the hair does not follow the shape of the head in a given perspective. To properly "wrap" the hair over the top of the head, we need to detect the curvature of the head. This is easier to do with short or tightly arranged hair; however, when part of the head is hidden behind a heavy mass of hair, it is more problematic. So, it is always a good idea before working on the actual painting to mark on your outline the boundaries of the entire head.

Another issue is depicting the hairline so prominently that it makes the hair look like a poor-quality Halloween wig. With some exceptions, typically, the hairline consists of thinner hairs and doesn't have a distinct edge. Blurring it is an easy fix that improves the overall look.

Ask any hairstylist: if you need more volume for your hair, color it in layers. Hair looks more natural and fuller when its top layers are colored lighter and next to the roots it is darker compared to the main hair color. So, to avoid flatness of the hair in the painting, use contrast in values with the darkest colors at the roots, middle values in the middle, and lighter values closer to the surface. Underpainting hair with the intense colors of its middle values is helpful when creating a multilayered effect, which allows color to shine through the darker values. Underpainting light hair with its dark values first allows us to create greater contrast in the rendering.

It is important to pay attention to the shape and the strength of the hair's highlights, since they indicate where the light hits the surface of the hair first and has the brightest values.

Painting each individual hair would be an enormous task and an unnecessary undertaking, especially since the average number of hairs we humans have is more than 100,000; however, showing some individual strands of hair and some single hairs are necessary details to indicate its overall texture.

Such details, as well as the brightest highlights, should be addressed at the end of the rendering. Before adding single hairs, make sure that

- All areas adjacent to the hair are already painted (background, face, clothing).

- The overall flow of the hair is already established.

- Its shape does not contradict with the shape of the head.

- The hairline is in the right place and slightly blended with adjacent facial colors.

Use a harder type of colored pencils, such as Prismacolor Verithin, so they retain a sharp point longer and maintain a thin firm line under normal to hard pressure of application. In colored pencil painting, the surface at this point should be sprayed with ACP Textured Fixative to create enough friction so that sharp-pointed pencils can easily leave distinct marks. The strokes should follow the flow of the hair. Also remember that strokes normally have a heavy "touch down" and easy "take off." This means that when the pencil touches the working surface it leaves a more heavy deposit of pigment, and when we lift our hand off the surface, the mark has a thinner ending. This is a good method to remember when depicting any individual hairs: to land the pencil point at their base and to take off at their ends.

TIP FOR DRY UNDERPAINTING HAIR

The specifics of hair structure are easy to capture on abrasive surfaces, such as sanded papers, using just a flat stencil brush and Powder Blender. The idea is to use the wipe-off technique and to erase colored pencil off the toothy surface with a sweeping motion of the brush, following the directions of the major curves. When the stencil brush touches the surface, it creates a heavier impact; when the brush takes off from the surface, the pressure gradually decreases; therefore, when you press harder on the "touch down" with a brush, you will push the applied colored pencil deeper into the surface tooth and create darker value, blending some portion of pencil, but not destroying the overall shape of the curl. When you take the brush off while following the shape of the curl, the value created will be lighter and the edges will be softer at the end. Clean your brush on paper towel after each stroke and then dip it lightly in Powder Blender prior to the next stroke. This process works best with "oil-based" colored pencils such as Faber-Castell Polychromos, Caran d'Ache Pablo, or Lyra Rembrandt Polycolor. After you are done, secure your application with a couple of light coats of ACP Textured Fixative and allow it to dry completely before proceeding with veiling and color layers.

1. Roughly outline the overall direction of the hair flow and the shapes of the curls.

2. Use the darkest of selected colors to create your underpainting. This will allow you to maintain great contrast in the rendering and increase the impression of volume.

3. With a flat stencil brush, blend the curls starting at the darkest areas and moving toward the lightest ones with each brushstroke. It is also better to work beginning with the farthest curls from the viewer and moving toward the closest ones. Do not overblend. Follow hair shapes of each curl. Secure the application with ACP Textured Fixative before proceeding.

EXAMPLE OF RENDERING BLOND HAIR USING DRY UNDERPAINTING

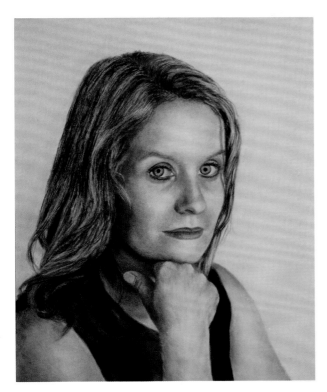

1. Underpaint hair with Faber-Castell Polychromos raw umber and in the darkest areas with burnt umber, dark sepia, and dark indigo. Blend the underpainting using a flat stencil brush and Powder Blender. Work from the darkest areas toward the lightest ones. Wipe your brush over paper towel after each stroke.

Secure your application with ACP Textured Fixative. Apply it in a couple of light layers, allowing them to dry completely between applications.

2. Using Faber-Castell Polychromos and Prismacolor Premier white, lighten the values of the lightest areas. Apply pencil strokes following the flow of the curls and placing them fairly close together, but without creating a solid coverage. Add touches of titanium white to the lightest areas. Lightly blend the applied whites with a coarse-bristle stencil brush. Secure and isolate this layer with a few additional coats of ACP Textured fixative, allowing each to dry completely.

3. Glaze the hair with Faber-Castell Polychromos light yellow ochre and touches of burnt ochre. Blend it in the same manner as before with a short-bristle brush and Powder Blender. Intensify color in the middle values with sharp-pointed strokes of Prismacolor Premier mineral orange and burnt ochre. Add touches of Polychromos caput mortuum violet to the darkest areas. Don't overblend the hair; allow some occasional strokes to identify its texture. Remember, there will be less details visible in the darkest shadows and in the lightest areas. The texture is most prominent in the middle values.

4. Continue working on the texture and indicate the separation of the curls into individual hairs with the use of sharp-pointed Prismacolor Premier light umber and dark umber, indigo blue, and black. Add individual strands of hair, and blend the areas of the hairline slightly more.

5. Spray the entire hair area with ACP Textured Fixative and let it dry.

Create highlights working with sharp-pointed Prismacolor Premier white. Make sure their shape is mimicking the shape of the hair curls and their strengths are shown according to the lighting in the image.

Alyona Nickelsen, *Carolyn*, 2016, colored pencil painting on sanded paper, 17 x 14 inches

EXAMPLE OF RENDERING DARK HAIR USING WATERCOLOR UNDERPAINTING

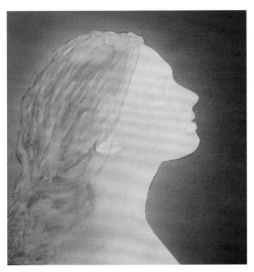

1. The colors of the background were established first before working on the hair itself. The overall color of the hair is dark and has a warm red undertone. It was underpainted with a few thin layers of gold ochre and touches of perylene maroon watercolor. This allows the undertone to shine through subsequent layers of colored pencil. We can use water-soluble pencils, such as Albrecht Durer light yellow ochre followed by Indian red to achieve the same effect blending them with water. During the application, some of the strokes overlapped, darkening some areas more and, thus, mimicking a natural look of value variation in the hair. The surface was then left to completely dry before proceeding.

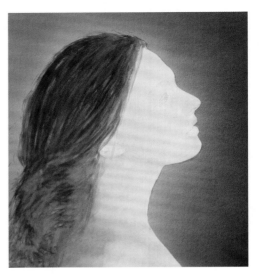

2. The work on the hair was continued with Prismacolor Premier burnt umber and touches of indigo blue. Strokes followed the flow of the hair and did not mix colors together too thoroughly to avoid the look of a solid mass. Instead, some yellows and reds from the underpainting were allowed to peak through.

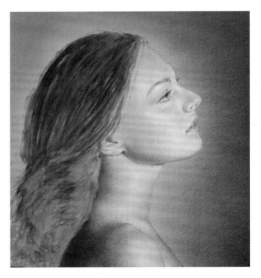

3. Before continuing with the details of the hair, the "facial and body topography" and skin tones were developed further.

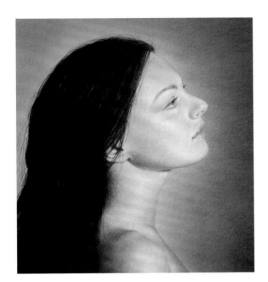

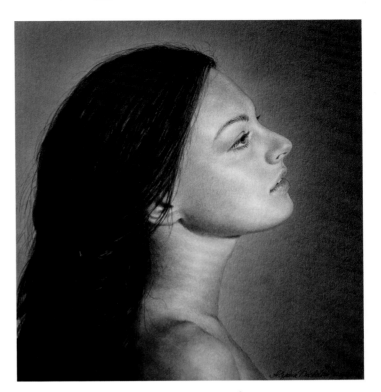

Alyona Nickelsen, *Anastasia* (based on a reference courtesy of PoseSpace.com), 2012, colored pencil painting on paper, 11.5 x 10.5 inches

4. Work continued here using sharp-pointed Prismacolor Premier indigo blue and black pencils with normal pressure, going over the entire hair and following its flow. The strokes were placed in close proximity to one another, but not too tightly together, thereby allowing some reds and yellows from the underpainting to remain visible. Switching to Prismacolor Verithin indigo blue, dark umber, and black allows the creation of individual hairs visible against the background and the skin tones. These pencils hold a sharp point longer and leave a thinner dark line compared to softer types of pencils like Prismacolor Premier.

5. At the completion of the rendering, the entire hair area was lightly sprayed with ACP Textured Fixative. This allowed me to regain enough tooth to create the brightest highlights with sharp-pointed white colored pencils.

1. Usually, a baby's hair is soft and thin. Its fine texture allows the skin to show through it. A very effective method for capturing this is to establish the skin tones first and then erase the largest strands of hair, reshape them with more contrast, and finally separate them into smaller sections with pencil strokes.

Here the skin tones were underpainted with Faber-Castell Polychromos dark Naples ochre and burnt ochre. Colored pencils were applied with a light touch, following the curves of the face and neck.

2. The skin tones over the hair area and next to the hairline were developed further with Faber-Castell Polychromos light flesh, medium flesh, rose carmine, sky blue, and then Prismacolor Premier sand, yellow ochre, and goldenrod. Pencils were still applied lightly, following the shape of the head.

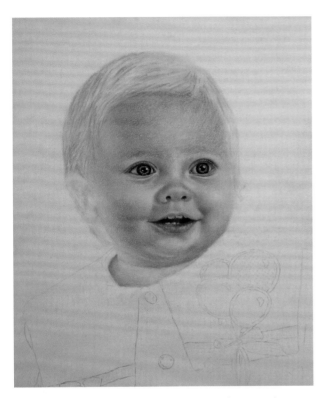

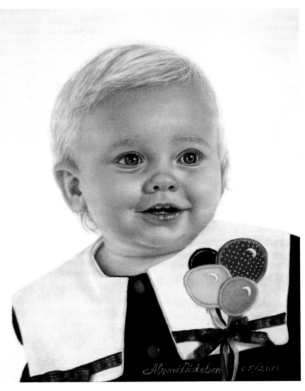

Alyona Nickelsen, *Rebekah Anne* (based on a reference courtesy of Sally Robertson), 2013, colored pencil painting on sanded paper, 14 x 11 inches

3. The overall hair flow was indicated using the wipe-off technique and erasing the large strands of hair with the edge of a sponge applicator and Scotch tape. Then the strands of hair were further shaped with sharp-pointed Prismacolor Premier white. This created the impression of skin tones that are visible through the fine and lightly colored baby hair. To preserve the established structure of the hair, the area was lightly sprayed with ACP Textured Fixative in a couple of light applications, drying completely between layers.

4. More color was added with Faber-Castell Polychromos Venetian red, pale geranium lake, and touches of Prismacolor Premier crimson red and mineral orange. Then the contrast was increased and hair texture indicated with sharp-pointed Premier light umber, dark umber, and touches of indigo blue. The hairline was further blended slightly with a short-bristle stencil brush and Powder Blender. The hair was sprayed with ACP Textured Fixative, and the brightest highlights were added with sharp-pointed Premier white.

FACIAL FEATURES

To begin any kind of conversation, we must first attract the attention of the person and then keep him or her focused on what we have to say. The successful composition of a painting is based on the same principle—have something to say, attract the attention of the viewer, and keep him or her focused as long as possible. For example, in portraiture, the story is, of course, about the model. High-contrast values or colors usually do a great job of attracting the attention of viewers. Well-defined edges and intricate details are useful means to keep the viewer focused on a particular area. Because the human eye can only be focused on one thing at a time, it makes sense to place the focal point of the portrait in the most comfortable spot for the viewer and define it with sharp edges, high contrast, bright colors, and intricate details.

I highly recommend that you look through anatomy books or simply in a mirror to refresh yourself with how the facial features are actually structured—that is, where the eyelids or corners of the mouth come together, how the nose transforms into the rest of the face, how the chin curves, and so on. Though we are all different and the shapes of facial features are very individual, their overall structure and the anatomical basics are the same for all humans, regardless of gender or race.

Eyes

In real life, we are typically attempting to establish eye contact. So, naturally, when the subject in the portrait is looking directly at the viewer, eye contact is made instantly; therefore, the eyes are our focal point. When the subject in the portrait is looking "off camera" or even turned away to some degree from the viewer, the focal point can be anything that artists would like to talk about first. Such a portrait will be more about the situation described in the painting rather than about the subject him- or herself. This makes it more like a still life with people.

Eyes and eyebrows are very expressive in the process of visual communication. A complex mechanism of muscles under the skin in that area allows us to influence the verbal message in numerous ways simply by lightly curving the brow or faintly squinting the eyes. Master oil painters understood the importance of the eyes in the portrait and commonly paid great attention to details of the eyes themselves and to the adjacent areas. Here is my attempt to copy the eyes of Bouguereau's *Gabrielle Cot* using the colored pencil medium.

1. Underpainting was done with Prismacolor Premier light umber and Faber-Castell Polychromos burnt umber. The applied pencil was blended with Powder Blender and a short-bristle brush and then sprayed with a couple of light coats of ACP Textured Fixative to create an isolating layer. Note that because of the natural location of the eyes on the facial planes and the specifics of the lighting situation in every portrait, it is very important to maintain the correct overall value of the eyes from the beginning so that they "belong" to the head rather than appearing to be pasted on top of it.

2. After the surface was completely dry, the veiling was created with Prismacolor Premier white and titanium white. This was followed with an additional light coat of ACP Textured Fixative.

3. Color layering was completed in a few stages with the following pencils: Prismacolor Premier sand, canary yellow, sienna brown, burnt ochre, burnt umber, light peach, crimson red, electric blue, indigo blue, and black; Faber-Castell Polychromos dark cadmium yellow, light yellow ochre, dark flesh, scarlet red, and burnt carmine; and Caran d'Ache Pablo vermilion and purplish red. Titanium white and Premier white were used to lighten the values, lower the intensity of the applied colors, and cool the temperature of the color mix. Layers were blended with Powder Blender and then secured with ACP Final Fixative. Final touches were performed at this stage to brighten highlights, sharpen edges, and refine details.

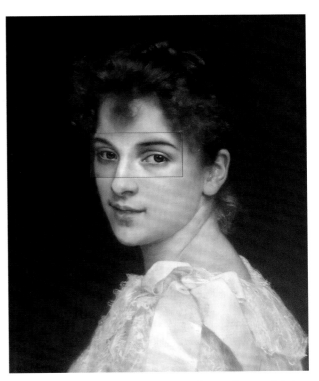

Alyona Nickelsen, *Gabrielle's Eyes* (after William-Adolphe Bouguereau's *Gabrielle Cot*), 2015, colored pencil painting on acrylic gesso, 4 x 8 inches

4. Here is the image of the detail rendering with colored pencil medium and superimposed over the reproduction of the original oil painting by Bouguereau.

1. The underpainting was done using Prismacolor Premier dark umber and Faber-Castell Polychromos burnt umber. The basic topography of the face was modeled using the wipe-off technique, sponge applicators, and Powder Blender. The lightest values were lifted with mounting putty and then blended with a short-bristle stencil brush and additional Powder Blender. Afterward, the underpainting was secured and isolated with ACP Textured Fixative applied in a couple of light layers. This created the natural division of the facial structure into planes (eyes "sit" deeper in the eye sockets, deeper in the facial plane), and indicated the shadowed and lit areas under a particular lighting condition (the angle of the pose situates the subject's right eye farther away from the viewer and in the shadow). The shape of the eyes makes them significantly open and the upper lid has a substantial size.

2. The veiling (dead layer) was created with the use of Faber-Castell Polychromos and Prismacolor Premier white applied in thin layers to articulate

the middle values and closer to the shadowed areas. Titanium white was used for the lightest areas to emphasize greater chiaroscuro effect in the rendering. The dead layer was secured and isolated with ACP Textured Fixative again.

3. The color layers began in the farthest areas from the viewer—the right eye of the subject. The underlayers were glazed with Faber-Castell Polychromos vermilion, rose carmine, and scarlet red. Applied colored pencils were blended using a short-bristle brush and Powder Blender. The color mix bias was directed to lean more toward cool reds in the shadow and toward warm yellows in the lit areas.

The brows, irises, and eyelid creases were reinforced with a sharp-pointed Prismacolor Premier dark umber.

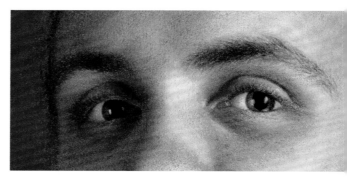

4. The modeling of facial features continued with the use of Prismacolor Premier and Faber-Castell whites for the "lifting" of the areas, and Premier light umber, dark umber, and indigo blue to "push"

them back. More chromatic passages of color were added in the middle values with Premier permanent red, burnt ochre, mineral orange, pumpkin orange, and canary yellow and Faber-Castell Polychromos dark cadmium yellow. The colors in the shadow were cooled and darkened further with the addition of Polychromos magenta and caput mortuum violet, and Caran d'Ache purplish red. The eyelid creases were deepened with Premier crimson red and more dark umber. The irises were darkened with Premier black and indigo blue. At the end, the lit portions of skin tone were lightly scumbled with Polychromos white and the eyelids touched up with Premier white. The pupils were treated with Colored Pencil Touch-Up Texture, and the touches of titanium white were applied to indicate the brightest highlights.

EXAMPLE OF RENDERING ASIAN EYES

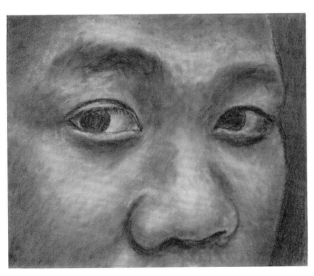

1. The underpainting was done with Faber-Castell Polychromos burnt umber and blended with a sponge applicator and Powder Blender. The darkest values were articulated further with Prismacolor Premier dark umber.

The topography of the face was created by wiping off the applied pencil using sponge applicators and Powder Blender. At the end of the process, the underpainting was secured and isolated with ACP Textured Fixative.

The shape of the subject's eyes makes them look slightly slanted with a visible narrower upper eyelid and heavier lower one. Note that the angle of the face turn, the shape of the nose bridge, and the light in this composition do not place the far eye into a deep shadow. So, the value contrast between shadowed and lit areas is fairly mild.

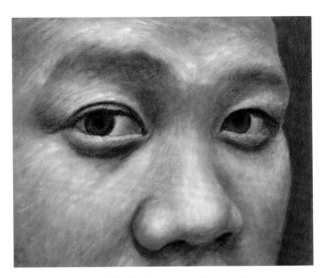

2. Faber-Castell Polychromos white and Prismacolor Premier white were used for the veiling, followed by touches of opaque titanium white in the lightest areas.

The deepest shadows, eyelid creases, pupils, iris edges, and eyelashes were touched up with Premier black.

The application was sprayed again with ACP Textured Fixative to isolate this layer and allowed to dry completely before proceeding.

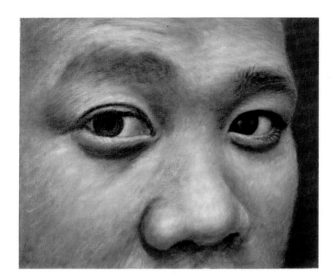

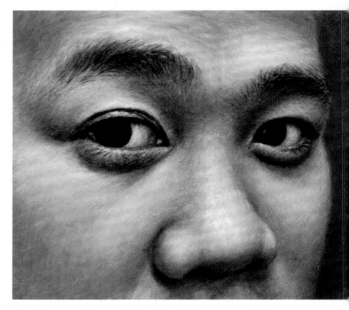

3. The color layer began at the point farthest from the viewer's eye by glazing Faber-Castell Polychromos rose carmine, cadmium yellow, and burnt ochre over skin tones, then blending with a short-bristle stencil brush and Powder Blender. The irises were darkened with Prismacolor Premier dark umber and touches of mineral orange and burnt ochre in the lit areas. Note that where the glazed yellows were superimposed over areas with black in the underpainting, a greenish hue was optically formed.

4. The modeling of the facial features and the skin tones was continued with the application of Prismacolor Premier jasmine, goldenrod, mineral orange, burnt ochre, and light umber. Shadows were lightly touched with Premier crimson lake, indigo blue, and dark umber. The lit areas were slightly cooled with Caran d'Ache purplish red. The elevated areas were lightened with Premier white and then adjusted with some touches of previously used colors, so they appear to "belong" to a different facial plane and have lighter values but of a similar coloration.

The whites of the eyes were shaped further by touching with some reds and yellows that were then blended and scumbled with Premier white. The corners were deepened with Premier dark umber. All the skin tones were slightly scumbled and the irises highlighted with Premier white.

Lips

In addition to forming sounds, lips are also a very expressive tool in real-life communication—a hint of a smile can work as a powerful supplement to a verbal message, enhancing or even contradicting it. Lips are a serious player in the complex game of facial expressions. So, unsurprisingly, they attract attention and deserve it no less than the eyes.

EXAMPLE OF RENDERING FEMALE LIPS AND LIGHT SKIN TONES

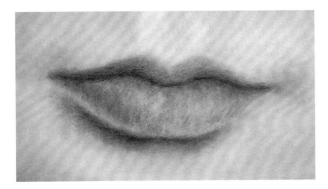

1. Lips do not have hard edges nor do they have superbright and distinct highlights, unless they are covered with lipstick. If they are, their contour will be more pronounced, and the surface becomes smoother and more reflective.

The underpainting here was created with Faber-Castell Polychromos raw umber applied lightly following the curves of the shapes. Applied pencil was blended with Powder Blender using a short-bristle stencil brush and the wipe-off technique, and then values were lightened with a small sponge applicator. At the end, the entire area was sprayed with ACP Textured Fixative and allowed to dry completely.

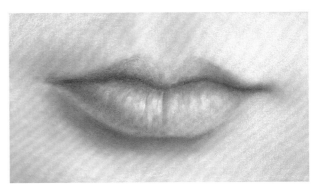

2. The dead layer was accomplished using Prismacolor Premier white, Faber-Castell Polychromos white, and titanium white. The shapes were developed further, and the lit areas were accentuated. Values were darkened with Polychromos burnt umber and dark indigo. At the end of the process, the entire area was sprayed with ACP Textured Fixative.

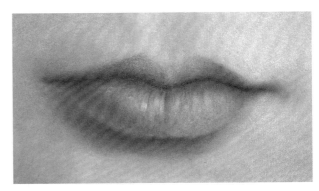

3. Warm reds and yellows were applied lightly and glazed over the shadowed and lit areas. Note that colors appear different over the underpainting than they do over white. The applied pencils were blended with a short-bristle brush. The pencils used were Faber-Castell Polychromos rose carmine, and Caran d'Ache Pablo vermilion and fast orange.

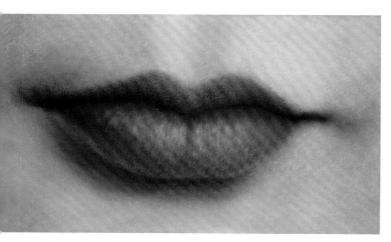

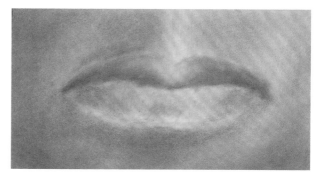

4. Values were adjusted with the addition of Prismacolor Premier dark umber and crimson red. The cooler reds were introduced with Caran d'Ache purplish red. The warm reds were emphasized with Premier permanent red. Skin tones were warmed with Premier jasmine and Faber-Castell Polychromos burnt ochre, blended with Powder Blender and scumbled with white pencils to smooth out strokes and color transitions. The entire area was sprayed with ACP Textured Fixative, and after it dried, a few touches of white were added to create highlights on the lips.

1. Lips and adjacent skin tones were underpainted with Faber-Castell Polychromos burnt umber, blended with Powder Blender, and modeled using the wipe-off technique with a sponge applicator. Then it was isolated with ACP Textured Fixative.

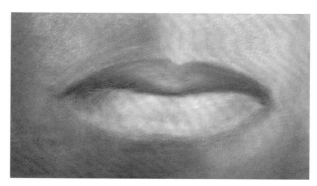

2. The dead layer was made with Faber-Castell Polychromos white and Prismacolor Premier white and titanium white. The layer was isolated with ACP Textured Fixative.

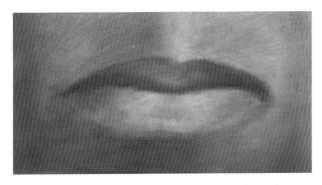

3. Underlayers were glazed with Faber-Castell Polychromos rose carmine and magenta in darker areas and in shadows, and with Caran d'Ache Pablo vermilion and Polychromos burnt ochre in the lit areas.

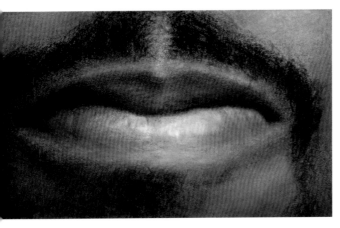

4. The skin tones were developed with Faber-Castell Polychromos burnt sienna, and Prismacolor Premier goldenrod and dark umber. Shadows were darkened with Polychromos dark indigo, and touches of color were added with Caran d'Ache Pablo purplish red and Premier permanent red. The darkest creases were deepened with Premier crimson red. The skin tones were lightly scumbled with Premier jasmine. Facial hair was developed with Premier black and indigo blue. The highlights were created with Premier white and titanium white.

Nose and Chin

The nose and the chin typically remain static during visual and verbal communication. They react to the activities of the muscles mostly during more extreme facial expressions. For example, when brows are pulled closer together forming wrinkles between them, it triggers the movement of the nostrils and the tip of the nose. When corners of the mouth are extremely angled down or up, the skin over the chin area is stretched; however, the nose and the chin are the most protruding areas of the face, and their values greatly contribute to the illusion of volume in the portrait.

Two great masters of oil painting, Leonardo da Vinci and Rembrandt, were brilliant in their own ways when portraying three-dimensionality on the canvas. Da Vinci carefully built the form working from the back of the composition to the front and using numerous thin layers of paint to counterpoint the transparency of the shadow and the opacity of light. Rembrandt, also working from back to front, kept the shadows transparent and used the thickest possible impasto of opaque paint to sculpt the lights in his work. One of his contemporary critics and a former student, in a not too favorable remark, said of him that the portrait he painted could be lifted by the nose of the sitter. Though very different approaches, they are based on the same principle: it is the contrast between transparent shadow and opaque light that creates the illusion of depth.

Colored pencil layering with the use of ACP Textured Fixative enables us to employ the same principle used by masters in a controlled manner and without waiting endlessly for layers of oil to dry.

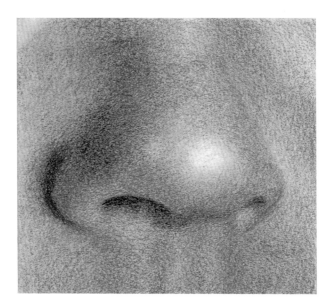

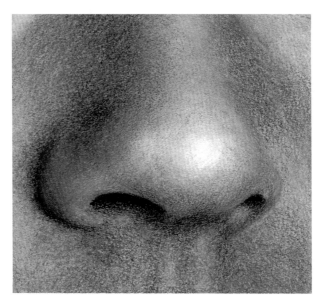

1. In the underpainting, the shape of the nose was modeled from the "point of view" of the shadow using Faber-Castell Polychromos burnt umber and Prismacolor Premier light umber toward the lightest area and gradually darkening values. All the significant protrusions were formed by lightening values and lifting applied pencil with a sponge applicator and Powder Blender. The edges of the erased areas were then blended using a short-bristle stencil brush. The nostrils and the most severe cast shadows were darkened with touches of Premier indigo blue and dark umber.

The underpainting was secured and isolated with a couple of light coats of ACP Textured Fixative and allowed to dry completely.

2. The protrusion of the nose was further emphasized with the application of Faber-Castell Polychromos white, and Prismacolor Premier white and titanium white to lit areas working toward middle values. The shadows were kept dark and transparent and practically untouched by white, which is a natural opacifier. The applied whites were blended with a sponge applicator and short-bristle stencil brush, then also secured and isolated with ACP Textured Fixative.

This stage provides a clear division between shadows and lights and enhances the impression of depth in the rendering.

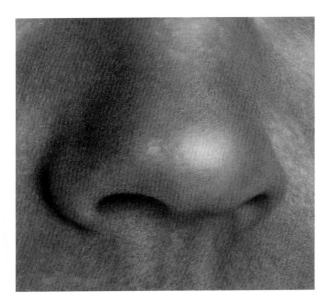

3. The colored layers began by glazing shadows and lit areas with warm Caran d'Ache vermilion. The applied pencil was spread with the use of Powder Blender and a short-bristle stencil brush. At this point, the shape of the facial features, the obvious protrusion of the nose, and the color variation created by vermilion superimposed over the underpainting, and versus the white, are clearly visible.

4. Colors here were cooled with the addition of Faber-Castell Polychromos magenta, and the shadows were deepened with Prismacolor Premier indigo blue.

A few touches of Polychromos scarlet red and pale geranium lake plus Premier sand and canary yellow add vibrancy to the skin color in the middle values. Pencils were applied holding them almost parallel to the surface, allowing some patches to be deposited more opaquely for the textural details of the skin.

Premier white was used when the intensity of color mix needed to be toned down. With indirect application, the values were slightly darkened using Premier indigo blue and Polychromos burnt umber.

Highlights were created with Premier white and titanium white in the brightest areas.

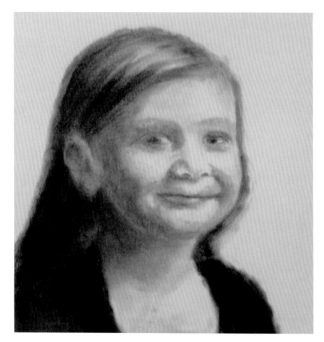

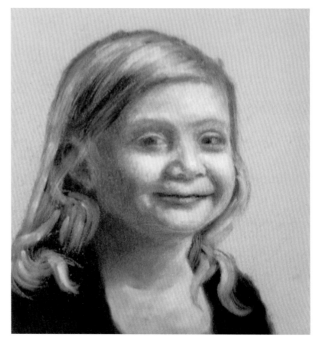

1. A contrasting pattern of values emphasizes the illusion that the nose and chin are closer to the viewer. At the beginning, the shape of the head and its position in relation to the light source were rendered in very general terms and without concentrating on the details until the later stages of the development.

The underpainting was created here with Faber-Castell Polychromos burnt umber and black for the darkest values. The lighter values were lifted off with a sponge applicator, and the edges were blended with a short-bristle stencil brush.

The underpainting was secured and isolated with ACP Textured Fixative applied in a few light layers and allowed to dry completely.

2. The veiling was performed with Faber-Castell Polychromos white and Prismacolor Premier white around the middle values. Titanium white was applied in the areas on the lit side of the nose and chin. This heightened the location of these facial features even more compared to the dark, yet transparent underpainted shadows of the face that are visually "pushed back."

The layer was again isolated with a few layers of ACP Textured Fixative.

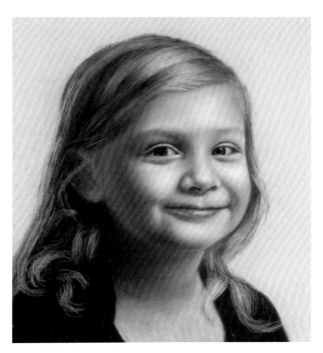

3. Here attention was paid to the more minute topography of the face and the specifics of the individual features.

The color layers were developed over the underlayers, maintaining the most intense colors in the middle values; lower-intensity light values in the lit areas; and lower-intensity dark values in the shadows. This provides further accentuation of the division between shadowed and lit areas of the face, enhancing depth in the rendering.

Skin tones were rendered with Caran d'Ache Pablo vermilion; Faber-Castell Polychromos burnt ochre, rose carmine; pale geranium lake, and dark cadmium yellow, and Prismacolor Premier burnt ochre, mineral orange, jasmine, and white.

The "oil-based" and "waxed-based" colored pencils were applied in turns. This approach enhances the ability of colors to mix or blend and to stabilize the entire application on the working surface. "Oil-based" pencils make "wax-based" pencils more "fluid" on the surface when mixed and vice versa—"wax-based" pencils secure "oil-based" ones to the surface.

4. The warm skin tones were cooled down with the addition of Caran d'Ache purplish red; Faber-Castell Polychromos fuchsia, magenta, and caput mortuum violet; and Prismacolor Premier pomegranate and crimson lake. Contrast was increased with touches of Premier indigo blue and dark umber in the deepest shadows. The face was slightly scumbled with Premier white to create a very smooth appearance and then blended further with Powder Blender. The brightest areas on the nose and the chin were highlighted at the end with titanium white and secured with ACP Final Fixative.

Ears

Because of the ear's location in relation to the eyes (on a different plane and to the rear of the head), they are often shown somewhat simplified and out of focus. This helps to emphasize the illusion of depth. Such an approach is certainly justified, as it helps to move the attention of the viewer to the focal point; however, the overall shape of the ears and their general topography must be kept to its true appearance and must remain anatomically correct, otherwise it will take a toll on the intended realism.

**EXAMPLE OF RENDERING
FRONT VIEW OF THE EAR**

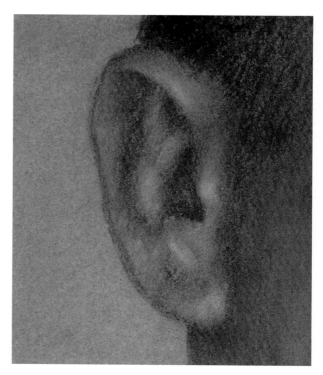

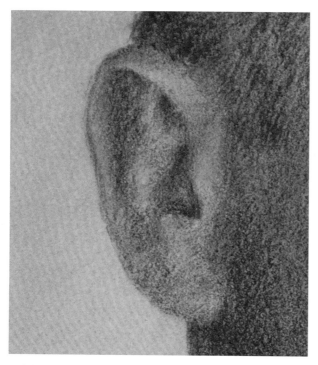

1. The underpainting was created with Faber-Castell Polychromos burnt umber and blended with Powder Blender. This indicated all the receding and indented areas of the ear.

2. The underpainting was isolated with a couple of light layers of ACP Textured Fixative. Then veiling was produced with the use of Prismacolor Premier white and titanium white. This articulated all the elevations of the ear.

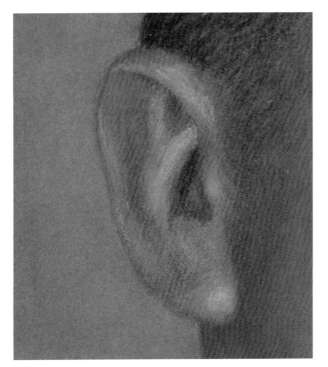

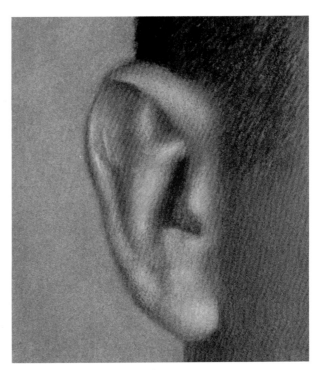

3. The previous layer was isolated with the use of ACP Textured Fixative and followed by the application of Faber-Castell Polychromos light flesh, medium flesh, dark flesh, carmine, and light yellow ochre; and Prismacolor Premier sand, yellow ochre, pumpkin orange, Spanish orange, permanent red, crimson lake, dark umber, and indigo blue.

4. At the final stage, the application was blended more with the use of Powder Blender, edges were adjusted (sharpened or blurred, according to the composition), and highlights were reinforced with more of Prismacolor Premier applied over dried Colored Pencil Touch-Up Texture.

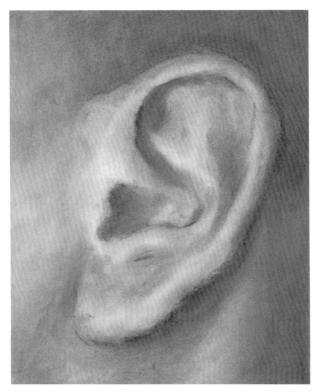

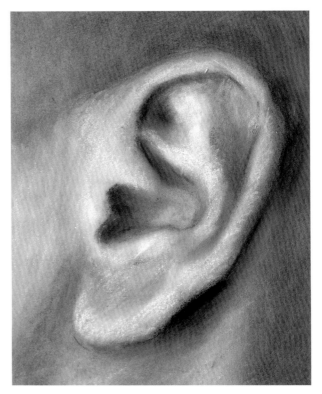

1. The underpainting was made with Faber-Castell Polychromos burnt umber and blended with Powder Blender. The shape of the ear was modeled using the wipe-off technique and a sponge applicator. The entire layer was secured and isolated with a couple of light sprays of ACP Textured Fixative.

2. The underpainting was followed with the dead layer, using Faber-Castell Polychromos white, and Prismacolor Premier white and titanium white on the elevations and lit areas. The darkest values were deepened with Polychromos burnt umber, dark indigo, and black. Again, the application was blended with Powder Blender and then secured and isolated with ACP Textured Fixative.

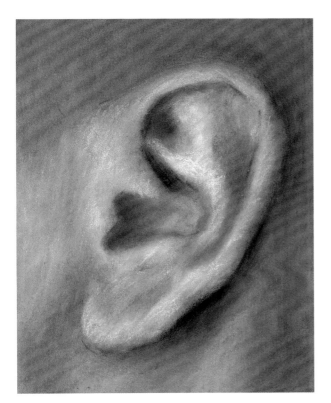

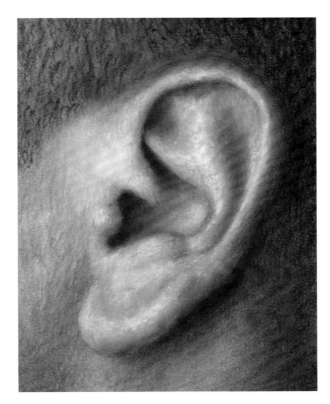

3. Color layers began by glazing with Faber-Castell Polychromos rose carmine, and Caran d'Ache reddish orange and vermilion.

The applied colored pencil was blended with Powder Blender. This created the necessary difference between colors applied over the underpainting and over white.

4. Modeling of the ear was continued with Faber-Castell Polychromos scarlet red and burnt sienna, and Prismacolor Premier crimson red, sienna brown, and touches of canary yellow. The shadows were deepened with Polychromos dark indigo and black, and Premier dark umber and indigo blue. The hair was rendered with Premier dark umber, indigo blue, and black.

A few touches of Caran d'Ache Pablo purplish red were added to create more intense color passages in the middle values. The highlights were created after application of Colored Pencil Touch-Up Texture in the most elevated areas and using titanium white. The edges of highlights were slightly blended and touched with hints of surrounding colors so that they would look natural.

Hands and Feet

When hands and feet are included in the portrait, they not only solve the compositional arrangement but also bring additional meaning to the message being communicated.

Though essential to certain casual and creative compositions, the human foot can be difficult to render. This is especially the case when portraying feet of babies and young children, as the features are all soft, rounded, and have fewer distinct characteristics.

It is important to plan ahead and work out the sizes, shapes, and foreshortenings beforehand to retain the proportional relationship and anatomical accuracy needed for realism.

EXAMPLE OF RENDERING A HAND

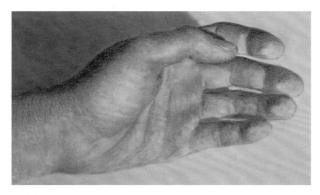

1. The underpainting was created with Faber-Castell Polychromos burnt umber and dark indigo, and then blended with Powder Blender. The shapes were modeled by wiping the applied colored pencil medium off the surface with a sponge applicator and a short-bristle stencil brush. The underpainting was then secured and isolated with a couple of light layers of ACP Textured Fixative.

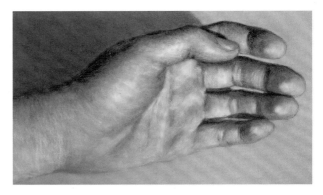

2. The hand was shaped further and its features were heightened in the dead layer that was created using Faber-Castell Polychromos white and Prismacolor Premier white. The lightest areas were indicated with titanium white. Then the entire rendering was isolated with ACP Textured Fixative.

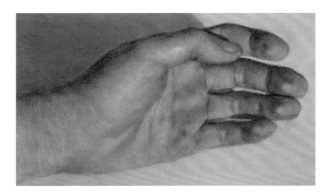

3. The application of color layers began with warmer reds and yellows: Caran d'Ache vermilion, and Faber-Castell Polychromos rose carmine, burnt ochre, and dark cadmium yellow. Colored pencil then was blended with Powder Blender using a sponge applicator and a short-bristle stencil brush. Due to the translucent nature of the colored pencil medium and the glazing method of application, the underlayers were not obscured but emphasized the difference between color appearance over underpainting and over white.

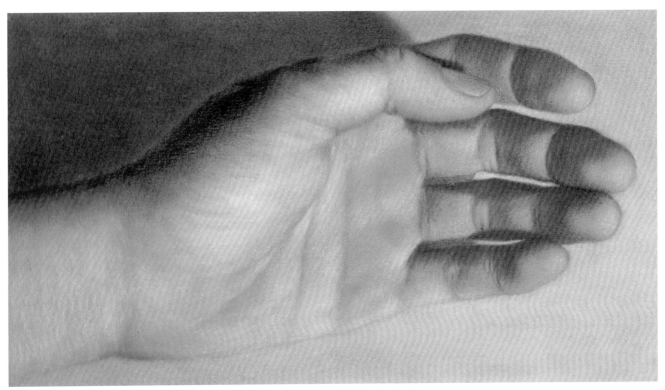

4. The shaping of the hand was continued with a semi-opaque/opaque application of Prismacolor Premier over the lit areas using sand, jasmine, goldenrod, permanent red, and burnt ochre, and in a more translucent manner with Faber-Castell Polychromos fuchsia, magenta, and caput mortuum violet over the shadows and partially over the middle values. This maintained the overall warm temperature of colors under the light and cool temperature in the shadows.

The skin tones were scumbled lightly with Premier white, and the contrast was "pushed" further with the use of Premier dark umber and indigo blue. A few touches of Caran d'Ache purplish red and Premier crimson red added some color to the deepest creases and shadows. The less prominent highlights were created with Polychromos white and the brighter ones with titanium white. The entire rendering was secured with ACP Final Fixative.

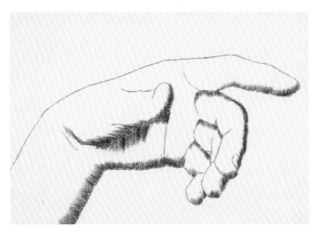

1. Note how little colored pencil medium was used with this technique to create the underpainting. Faber-Castell Polychromos dark indigo was only lightly applied to the darkest areas of the hand.

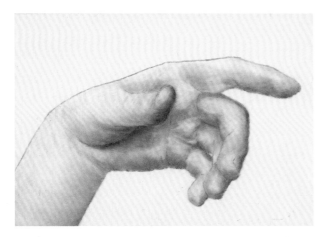

2. Applied pencil was spread with a short-bristle stencil brush further into the rendering. Since no sharpening was involved, there was practically no loss of the medium—every bit of colored pencil was redistributed across the area and secured with ACP Textured Fixative.

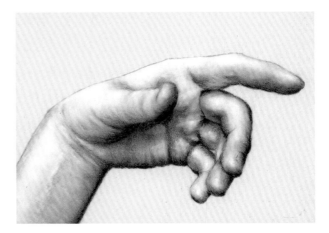

3. The dead layer was created with Faber-Castell Polychromos white and Prismacolor Premier white, as well as titanium white. This heightened the protruding shapes and enhanced the three-dimensional appearance of the hand. The layer was isolated with ACP Textured Fixative.

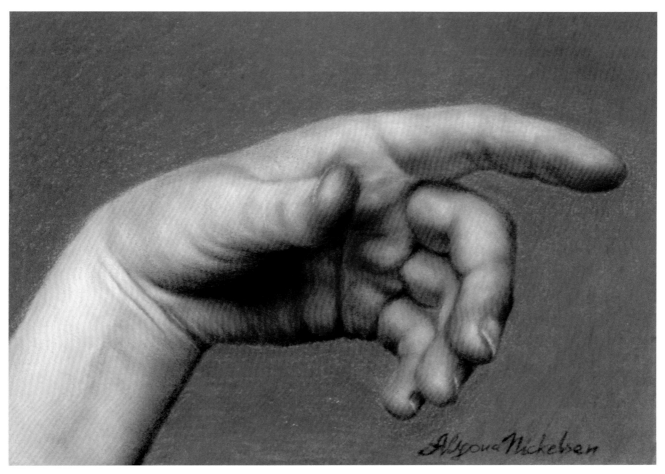

4. The color layers were created using Faber-Castell Polychromos rose carmine, deep scarlet, fuchsia, magenta, dark cadmium yellow, and burnt ochre, and Prismacolor Premier mineral orange, burnt ochre, permanent red, and crimson red. The contrast was increased with the use of Premier indigo blue, dark umber, and touches of black in the darkest areas.

The background was created with Polychromos cool grey V and blended with Powder Blender. The skin tones were lightly scumbled with Premier white. The highlights were accentuated with touches of titanium white.

DA VINCI'S AFTERTHOUGHT

From the first look at this artwork, it seems that the proportions of the woman's hand holding the animal in *Lady with an Ermine* are a bit off, to say the least. So why did a master painter like Leonardo da Vinci, with the brilliant mind of an engineer and a superb understanding of anatomy, decide to depict an enlarged and more masculine hand in the portrait of a delicate young lady? From recent scientific investigation, apparently the position of the hand and the animal itself were afterthoughts. This was the third attempt in painting the image of Cecilia Gallerani, the mistress of the Duke of Milan, Ludovico Sforza, who also was da Vinci's patron. The latest developments in imaging technology have revealed that originally the woman had a much smaller hand and there was no animal at all. In his second attempt, da Vinci enlarged her hand to a seemingly appropriate size, but the animal turned out to be a squirmy-looking, thin gray creature. In his final take on this portrait, Leonardo beefed up the muscles of the ermine and changed his coat to white. This addition was apparently a wink to the Duke's nickname "white ermine." But the hand of the lady ended up disproportionally enlarged for some still unknown reason. Obviously, these changes did not diminish the overall appearance of the work and actually added a special charm to it. It goes to show that in skillful hands even an afterthought can become a masterpiece.

Leonardo da Vinci, *Lady with an Ermine*, c. 1482–1483, oil on wood panel, 21.6 x 15.9 inches. Courtesy of Wawel Castle Museum, Krakow

EXAMPLE OF RENDERING A FOOT

1. After the accuracy of foreshortened shapes was verified and secured in the initial outline, the basic map of darks and lights was established and the underpainting created using Faber-Castell Polychromos raw umber and burnt umber.

2. The applied pencil was blended with Powder Blender and a sponge applicator following the direction of the curves. Then the surface elevations were indicated with Prismacolor Premier white.

3. The surface was lightly sprayed with ACP Textured Fixative to isolate the underlayers and to extend the surface tooth. The skin tones were developed with Prismacolor Premier light peach, scarlet lake, Spanish orange, mineral orange, and burnt ochre, and Faber-Castell Polychromos sky blue, rose carmine, and dark cadmium yellow. Applied colors were blended again with Powder Blender to achieve smooth color and value transitions.

4. Values were darkened further and shapes were defined with Prismacolor Premier dark umber and crimson lake, and Faber-Castell Polychromos caput mortuum violet.

Both highlights and reflected lights were indicated with Premier white and touches of titanium white. The entire rendering was secured with ACP Final Fixative.

HOW TO KEEP FRIENDS AND MAKE CLIENTS HAPPY

Hands-on examples of painting a colored pencil portrait

"Every time I paint a portrait I lose a friend."

—JOHN SINGER SARGENT

THE ART OF "KNOWING"

Making others happy is never an easy endeavor. This is especially true when you are presenting your own vision of their likeness through the frame of a portrait painting. It is within this delicate interaction where the most vulnerable areas of one's self-image can be bruised (though unintentionally) by the hand of the artist. Certainly, an accurate rendering of the customer's features helps to avoid comments like "Is that really how you see me/him/her?" and, instead, receive the more satisfying "It looks just like me/him/her"; however, the most cherished and praised portraits are those in which the artist was able to capture the very essence of the individual. This results in a favorable impression on those who are familiar with the model, as well as on those who have never met the subject but can really connect with this person through the painting even centuries later.

So, what exactly does it mean "to know" a person? Does it necessarily involve meeting with people in real life, or might some type of virtual interaction be sufficient to claim that you "know" someone? Often we live or work together in close proximity and engage in casual conversations but actually have very little knowledge about one another; however, in this time of rapidly evolving technology, long-distance relationships are often the new normal. Many of us become close

Alyona Nickelsen,
Ryan, 2016, colored
pencil painting
on sanded paper,
14 x 11 inches

137

friends or even soul mates long before we meet in person. In any case, truly knowing someone is never absolute or complete. Knowledge of others is only our subjective opinion, based, formed, and limited by the facts and experiences that we have available. So, when we engage our talents to create someone's portrait, we are really attempting to translate our mental view of the model into an image in the portrait.

This portrait of my late mother is based on the photograph that I took while she was undergoing chemotherapy. Her hair was about to fall out, her neck was swollen after surgical insertion of a port-a-cath, and she felt pretty miserable overall. Taking pictures was really the last thing on her mind. The resulting portrait was not as much about being true to the details of the photo reference, but more about my own vision of my mom. I painted her portrait after she was no longer with us. The process actually helped me somewhat to cope with my loss.

Frank Gerrietts was a brilliant artist, a wonderful human being, and my "long distance" Texan friend. We spent hours and hours on phone conversations between Southern California where I used to live and Texas where he was. We knew quite a bit about each other's views on art, politics, religion, and life in general—but had never met in real life. Once he emailed me a small blurry picture of himself so that I could "place a face" behind the voice during our many fiery debates and heart-to-heart talks. When I relocated to Texas and we were determined to finally meet, life brutally crushed those plans, leaving me with only a small blurry photograph. I turned that unlikely image into a portrait of my good friend, Frank, whom I never met in person.

Artists who accept commissions are often asked to create portraits based on reference photographs supplied by clients. This can occur when the client's location is at a significant distance geographically, when the portrait is of a now-grown child, when it is a surprise gift, when the person is already deceased, or simply when a client doesn't have time to come to the studio for a photo session. In any case, the artist's task is the same: to create a truthful representation of the individual and create an impression of his or her true personality. So, getting as much information as possible from the client about the subject is always a good idea. For example, is this person usually happy, cheerful, mellow, grumpy, and so on?

Overall, people are attracted to positivity and sincerity in life: in personalities, reactions, comments, and approaches. The same is true in seeing a portrait of themselves or loved ones; however, an overboard saccharine positivity can destroy the sense of truth, while overloaded, unadorned truth can sound unnecessarily bitter and hurtful. When creating a commissioned portrait or a painting of a friend, the artist is typically attempting to please the customer. So, one rule of thumb to keep them happy is to find some positive aspects in the subject's features and complement them by arranging the pose and lighting the portrait in the most flattering way possible. This will keep the overall experience positive and will help to minimize the balancing act between being blunt and being polite.

Alyona Nickelsen,
In Memory of My Mom,
2012, colored pencil
painting on paper,
11 x 8 inches

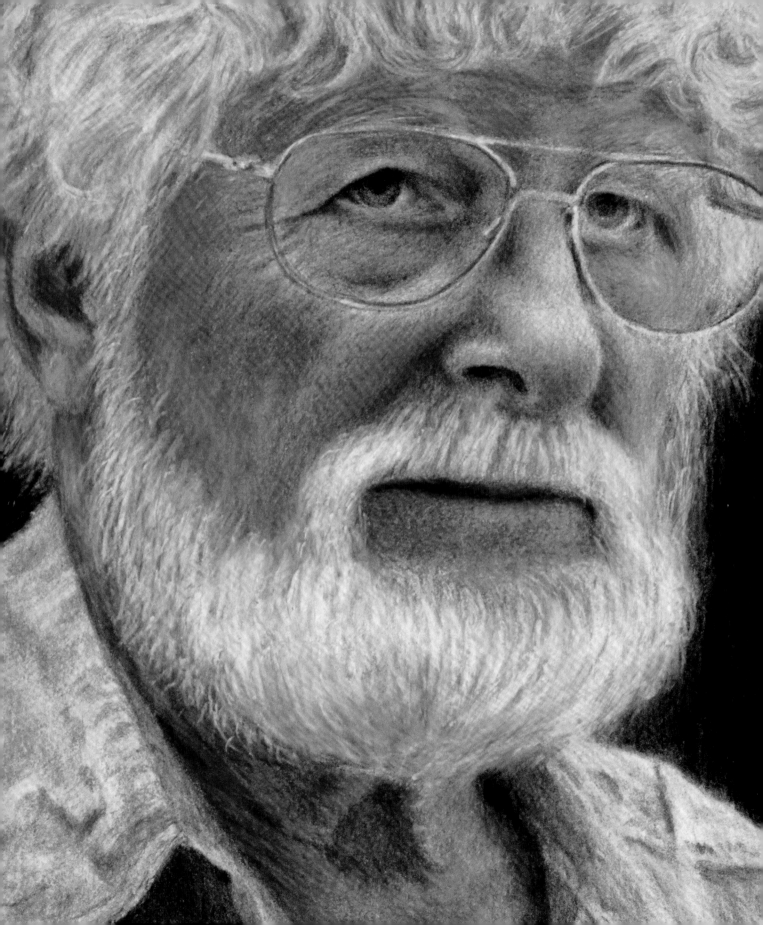

In this chapter, you will be working with a few sample reference photographs showing people that you have never met. Your task will be not only to properly render their facial features but also to convey your personal impressions. Use these references as a source of factual information, such as the shape of the face or the color of the hair, and allow plenty of space for your own creativity. Also, keep in mind the overall "how things work" principles that we discussed previously in this book. Note that I will be demonstrating various approaches rather than using a single standard formula.

Here are a few words about the materials I used in the following projects:

- **WORKING SURFACES** All of these projects are created on toothy, rigid surfaces, such as archival sanded papers mounted onto boards or 4-ply cotton boards coated with toothy clear gessoes. The use of a sturdy, not flexible working surface would be similar to the choice of oil painters who used sturdy wood panels rather than flexible cotton or linen canvases, because artworks created on canvases are more prone to cracking in the future. Colored pencil painting involves numerous layers and coating with fixatives that harden when dried. A sturdy support eliminates the danger of cracking due to the flexing of the surface.

- **COLORED PENCILS** All colors suggested here are considered to have an appropriate level of lightfastness. You can use your preferred colored pencil brands; however, keep in mind the content of wax or oils in them affects the properties of the

layering process. Remember that you can use the Color Match and Color Compare tools on our website www.BrushAndPencil.com to find the closest matches or color substitutes when necessary.

- **SOLVENTS, WATER-SOLUBLE COLORED PENCILS, AND WATERCOLORS** I use solvents to dissolve "oil-" and "wax-based" colored pencils, water-soluble pencils, or watercolor for a quick stain of the surface but without filling up the tooth. Remember when using any liquid medium that hard edges will be created and must be dealt with in one way or another.

- **FIXATIVES** I use ACP Textured Fixative to isolate layers and to regain the tooth during layering, Touch-Up Texture for creating extra tooth within small areas, and ACP Final Fixative to create a smooth hard surface when needed and at the end of the rendering.

- **TITANIUM WHITE** This is the most opaque white available. It is invaluable in veiling, for creating opaque coverage in lit regions, and for rendering the brightest highlights in the composition. It can be applied with the wide side of a sponge applicator on larger areas and with its edge on small details and highlights.

- **POWDER BLENDER** I apply Powder Blender with a sponge applicator and use it for blending colors and smoothing color and value transitions. When dry-blending is used with the help of Powder Blender, hard edges do not occur as they do when using any liquid solvents for blending.

Alyona Nickelsen,
Remembering Frank,
2012, colored pencil
painting on paper,
8 x 6 inches

PROJECT 1. GEORGIA

To look their best during studio photo sessions, young and inexperienced models commonly put on their biggest "say cheese" smiles, sit stiffly, and look straight into the camera lens. These images rarely result in good portrait references. They look staged, exaggerated, and anything but natural. Since photo sessions are usually time limited, the artist/photographer must be creative and act swiftly to come up with solutions that reveal the true personality of the model. Often, casual conversations about school, hobbies, friends, and the like help to lessen the awkwardness. So, while your model is focusing on the answers, be sure to shoot as many natural "off-camera" looks as you can.

Suggested colored pencils for this project:

- Prismacolor Premier colored pencils—white, cream, sand, yellow ochre, goldenrod, mineral orange, dark umber, light umber, sienna brown, sepia, permanent red, crimson red, crimson lake, carmine red, peacock blue, cobalt blue, indigo blue, black

- Faber-Castell Polychromos colored pencils—dark Naples ochre, light yellow ochre, dark cadmium yellow, light flesh, medium flesh, dark flesh, burnt ochre, sanguine, raw umber, burnt sienna, caput mortuum violet, dark sepia, rose carmine, fuchsia, pale geranium lake, burnt carmine, magenta, sky blue, Prussian blue, indanthrene blue, white

- Caran d'Ache Supracolor II water-soluble colored pencils—light ochre, dark carmine, hazel

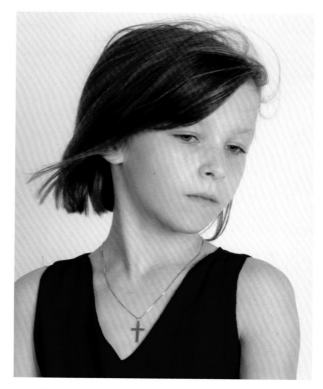

STEP 1 While chatting with Georgia about her school, I made the remark that math can be a tough subject and followed with a random subtraction example (something like 326 minus 67). Then, while she was busy proving me wrong and mentally calculating the answer, I had a few precious moments to capture her in an unposed environment.

The tilt of her head, serene gaze, and catch lights partially hidden behind the eyelashes generated a sense of solitude and repose, though the hair blown by a fan restored some dynamism to the image.

In this rendering, I cropped the reference tighter to concentrate mostly on the face, tidied up a few strands of hair, and slightly increased the overall contrast of the facial features.

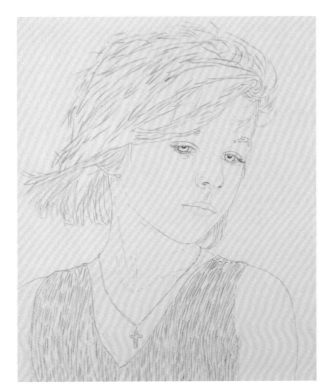

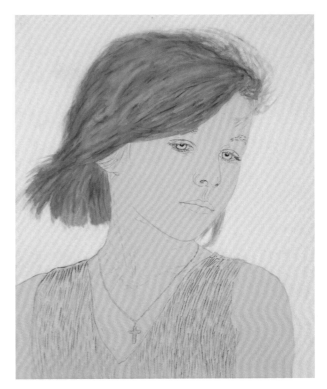

STEP 2 After the outline had been transferred to the working surface, I lightened the graphite lines with mounting putty and went over them with Prismacolor Premier colored pencils. I used yellow ochre for the body contour and all well-defined edges; crimson red for the lips; dark umber for the pupils, irises, and nostrils; light umber for the eyelashes, eyebrows, eyelids, and necklace; and indigo blue for the contour of the dress.

With strokes of dark umber, I indicated the major direction of the hair flow, and using indigo blue, the pattern of the fabric.

STEP 3 To change the natural off-white color of this sanded paper, I worked on the background first with Faber-Castell Polychromos white and Prismacolor Premier white. The strokes were applied lightly in a circular motion, and then blended with Powder Blender and sprayed with ACP Final Fixative.

Next, I applied Caran d'Ache Supracolor II light ochre followed by hazel water-soluble colored pencils to the hair. I then blended the strokes with a brush dipped in clean water. The underpainting does not affect the tooth of the working surface but simply stains it with yellows and light browns. This step creates the effect of an inner glow of the hair through subsequent layers of colored pencil.

If you prefer, for a similar effect you can use Polychromos dark Naples ochre and burnt ochre instead of water-soluble pencils and blend your strokes with Gamsol OMS.

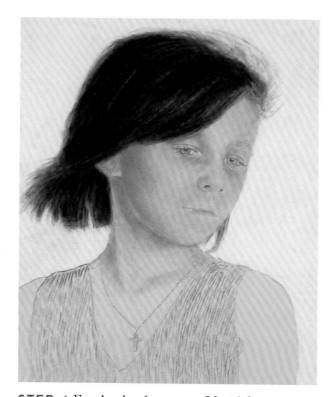

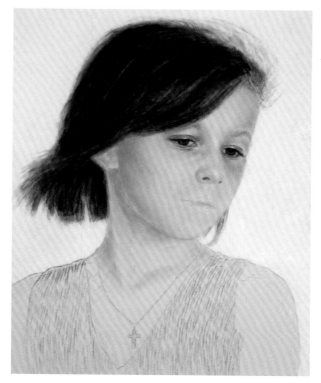

STEP 4 For the development of facial features and, later, neck and shoulder topography, I created underpainting with light layers of Faber-Castell Polychromos light yellow ochre, burnt ochre, sanguine, and indirect touches of Prussian blue in the shadowed areas. Then the elevations were wiped off the surface with a sponge applicator, and the colors were blended using coarse ¼-inch and ³/₁₆-inch short-bristle brushes and Powder Blender. This softened the edges between erasures and value transitions and evened out the underpainting of the skin tones.

After a basic division of the face into darks and lights was established, I continued rendering the hair with Polychromos burnt sienna and dark sepia. Pencil strokes were applied loosely following the direction of the hair. This allowed some underpainting colors to peek through.

STEP 5 An alternating mix of "oil-" and "wax-based" colored pencils was used at this stage to extend the blending ability of colored pencil application and to assist in the progression of skin tones.

I began modeling the facial features with the eyes and then gradually progressed into adjacent areas with Faber-Castell Polychromos light flesh, medium flesh, light yellow ochre, pale geranium lake, rose carmine, raw umber, and sky blue, and Prismacolor Premier sand, goldenrod, mineral orange, and permanent red colored pencils.

I darkened the pupils of the eyes with Premier indigo blue and black and worked on the pattern of the irises. I then lightly touched the lashes with dark umber and indigo blue, working from their base toward the ends with soft strokes and sharp pointed pencils.

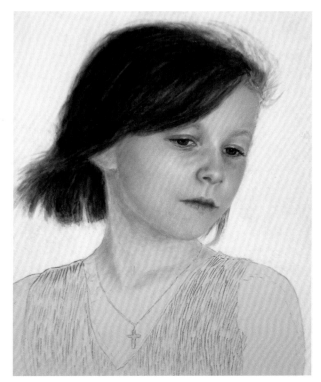

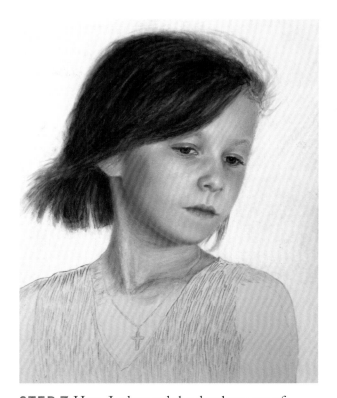

STEP 6 I continued shaping the face and its features. To create the impression of elevation, such as you see on the tip and the bridge of the nose, the cheeks, or the forehead, I used light touches of titanium white, and then lightly sprayed it with ACP Textured Fixative and continued layering colored pencils.

To shape the features and darken the values, I applied additional pencil layers, ensuring that the overall color mix was not too intense or biased toward any particular hue.

I touched the nostrils with Prismacolor Premier dark umber, crimson lake, and goldenrod. I also indicated the shape of the lips with Faber-Castell Polychromos pale geranium lake, fuchsia, and light yellow ochre, and Premier carmine red and sienna brown while avoiding the creation of hard contours.

STEP 7 Here, I advanced the development of skin tones and further articulated the facial planes with all previously used pencils and the addition of Faber-Castell Polychromos dark flesh, dark cadmium yellow, fuchsia, caput mortuum violet, and sky blue, and Prismacolor Premier yellow ochre, indigo blue, light umber, and sienna brown colored pencils. I introduced darker colors very gradually and blended strokes with a coarse ¼-inch bristle brush and Powder Blender to avoid sudden "jumps" in value transitions.

I also checked with the reference and with the edge guide frequently to make sure that likeness was maintained while shaping the facial features. Likeness can be easily affected by the wrong shape of an eyebrow, a change in the distance between the eyes, nostrils that are too wide, or lips that are too narrow.

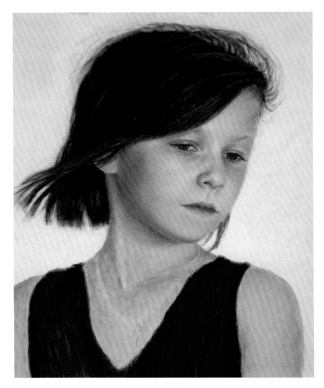

I increased the contrast of the hair with the application of Gamsol OMS to the darkest areas, followed by a few touches of Prismacolor Premier dark umber, sepia, indigo blue, and crimson lake.

The dress was underpainted with Faber-Castell Polychromos magenta and burnt carmine colored pencil blended with Gamsol OMS. If you prefer, you can use water-soluble pencils such as Caran d'Ache Supracolor II dark carmine and blend them with water.

STEP 9 In the final stage, to extend the tooth of the surface, I sprayed the hair with ACP Textured Fixative, and after it completely dried, I highlighted it with Prismacolor Premier cream, sand, yellow ochre, and white colored pencils. Rendering hair in this way creates multiple levels of lights and darks and provides the impression of volume.

I worked on the fabric of the dress with Faber-Castell Polychromos indanthrene blue and then finalized it with Prismacolor Premier peacock blue, cobalt blue, indigo blue, and black, following the folds of the material with my strokes.

Finally, the necklace was detailed with Polychromos dark Naples ochre, pale geranium lake, and burnt ochre and finished with Premier indigo blue, crimson red, yellow ochre, and white colored pencils.

STEP 8 I detailed the facial features and, later, the neck and shoulders using the same selection of colored pencils, but this time mostly with the "wax-based" group at the end of the application. This helps to stabilize the colored pencil layers on the toothy working surface.

To lower the intensity of the color mix, unify strokes, create a smooth skin-like coverage, and create the impressions of minute elevations on the face, I lightly went over the skin tones with Prismacolor Premier white, scumbling.

Alyona Nickelsen, *Georgia*, 2013, colored pencil painting on sanded paper, 14 x 11 inches

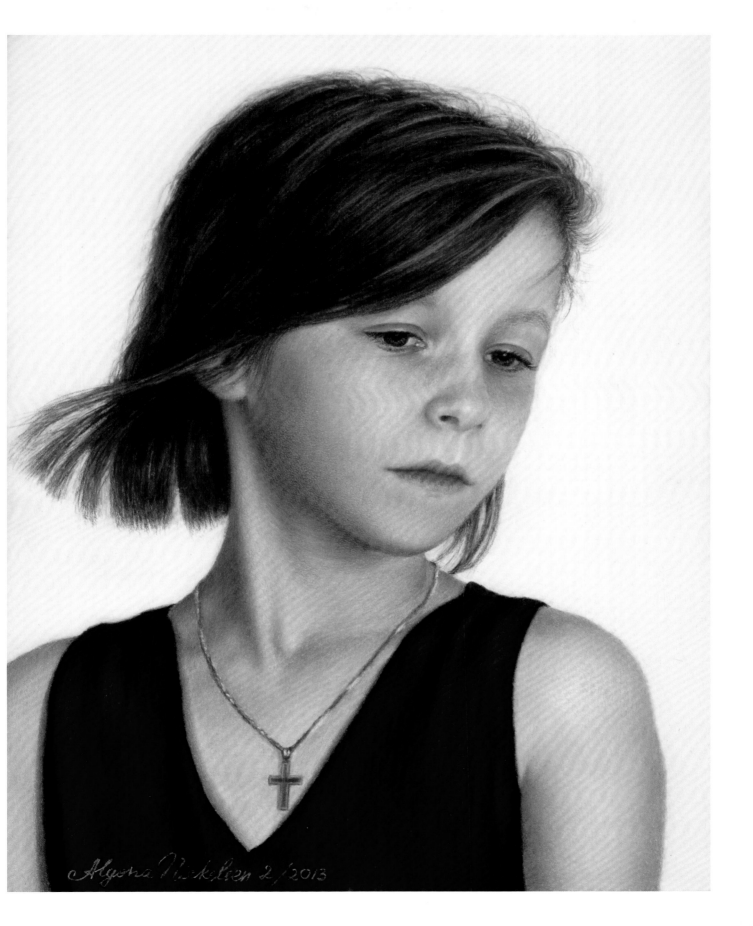
Alyona Nickelsen 2/2013

PROJECT 2. ELIJAH

Often, the concept of a portrait comes directly from the personality of the model and is supported or enhanced by other compositional elements available to the artist. For example, the overall tonality and color scheme chosen for the image would certainly contribute to the mood of the portrait; however, the pose of the sitter, facial expression, gesture, clothing, and props can also be valuable additions to the theme. Sometimes it takes a bit of intuition and even some psychological skills for the artist to recognize and adorn the personality in the final image to create a harmonious visual amalgamation of its many components.

Suggested colored pencils for this project:

- Prismacolor Premier colored pencils—white, sand, yellow ochre, Spanish orange, goldenrod, cadmium orange hue, light peach, permanent red, scarlet lake, crimson lake, burnt ochre, light umber, dark umber, indigo blue, black

- Prismacolor Verithin colored pencils—white

- Faber-Castell Polychromos colored pencils— light yellow ochre, burnt ochre, medium flesh, Venetian red, rose carmine, deep scarlet red, caput mortuum violet, burnt sienna, dark sepia, chrome oxide green, sky blue, Prussian blue, burnt umber

- Winsor & Newton watercolor—ultramarine violet

- Da Vinci watercolor—raw umber

STEP 1 Elijah's mom chose this outfit for our photo session, and it proved once more that "mother knows best" (at least, as far as her child's personality is concerned). After just a few shots, I already had a clear impression regarding the mood for this portrait. And then there was the adorable remark from Elijah himself: "I look like Mona Lisa." That comment assured me that I was on the right track.

In my rendering I wanted to convey the early-twentieth-century European feel, the openness of Elijah's gaze, and the mystery of his "almost smile."

I decided to crop the bottom of the image, tone down the background, slightly increase the contrast, and use an almost monochromatic color scheme.

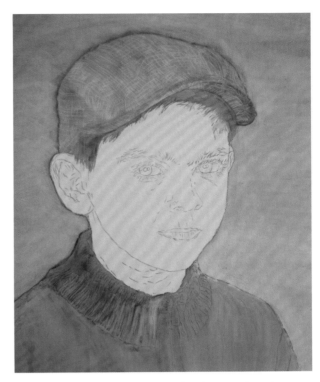

STEP 2 To begin, I transferred the outline onto toothy sanded paper and then reinforced it with Prismacolor Premier light umber.

With the same Premier light umber, I indicated the general direction of the pattern on the sweater's collar and the placement of the zipper.

To preserve the flat cap's pattern, I applied Prismacolor Verithin white pencil with moderate pressure following the lines of the pattern, including the distortions in the folds. Verithin white is perfect for this task. It produces a thin, sharp line because of the small diameter of the point and the hardness of its core. I then sprayed the cap with ACP Textured Fixative to preserve the applied pencil during the subsequent rendering.

STEP 3 Here, I covered the background with a light wash of Winsor & Newton ultramarine violet watercolor. You can also use water-soluble pencils of similar colors. I applied watercolor with a wide, flat synthetic brush working from left to right and from the top to the bottom to avoid creating any particular direction of the strokes.

Using Da Vinci raw umber watercolor thinly diluted with water, I underpainted the cap, hair, and sweater. I applied the paint with a round brush following the curves of the shapes. After the watercolor dried, the white pattern created by the Verithin white pencil on the cap remained visible, since wax repels the water and creates a light pattern against the dark background.

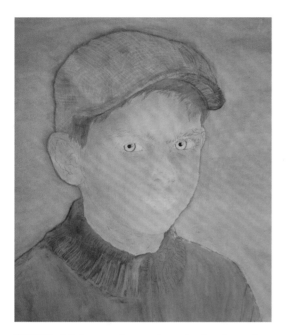

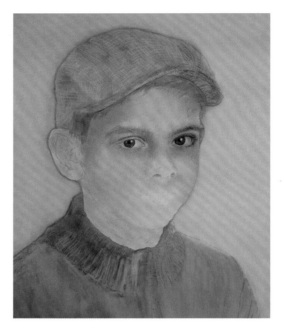

STEP 4 I began the underpainting by using Faber-Castell Polychromos light yellow ochre and an indirect application of Prussian blue for just a hint of the cool color in the shadowed areas. I blended the applied pencils with a ¾-inch coarse-bristle brush and began shaping the face, ear, and neck. I could easily adjust the values at this point, as "oil-based" colored pencils are extremely fluid and easy to move on the surface. For soft erasures and lightening values on the forehead, nose, cheeks, and chin, I used a sponge applicator and Powder Blender, wiping the applicator on paper towel after every erasure.

The pupils were indicated with Prismacolor Premier indigo blue and black pencils. The outlines of the irises were darkened with dark umber. The applied layers were secured with ACP Textured Fixative.

STEP 5 Here, development of the facial features began in the vicinity of a single eye and gradually transitioned into adjacent areas. I worked on the irises with Faber-Castell Polychromos burnt umber and chrome oxide green, and touches of Prismacolor Premier yellow ochre, applying strokes in a slightly irregular manner from the outer edges inward. I shaped the white of the eyes with Polychromos sky blue and medium flesh, and Premier sand. Eyelashes and eyebrows were lightly indicated with Premier light umber and dark umber.

I continued to work on the skin tones with Polychromos medium flesh, rose carmine, caput mortuum violet, and sky blue, and Premier light peach and goldenrod. Alternating "oil-" and "wax-based" pencils stabilized the colored pencil application on the toothy rigid surface. At the same time, it allowed me to easily blend my strokes with a coarse ¾-inch bristle brush and to lighten values with mounting putty while mixing colors and shaping facial features.

I also applied a light layer of Polychromos sky blue to the background, and then blended my strokes using Powder Blender and a sponge applicator.

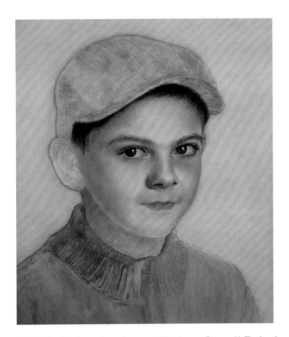 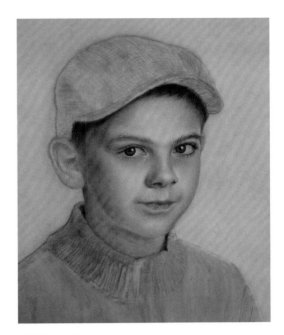

STEP 6 Another layer of Faber-Castell Polychromos sky blue was added to the background and sprayed with ACP Final Fixative. I then continued working on the skin tones with the addition of Polychromos deep scarlet red, Venetian red, and burnt sienna, and a few touches of Prismacolor Premier cadmium orange hue, scarlet lake, and Spanish orange. I added slight touches of more intense yellows, oranges, and reds to the overall cool shadows to bring some light and life to them. I blended the strokes using Powder Blender, and then I "elevated" the values with Premier white following the curves of the face. I indicated the lips with touches of Polychromos deep scarlet red and Premier permanent red, working from the inside toward the outer edge in short choppy strokes. I worked with my strokes just to the end of the curve, avoiding outlining the shapes.

The hair was created by applying Polychromos dark sepia and burnt sienna, and Premier burnt ochre with light striking strokes following the direction of the natural hair growth.

STEP 7 I then slowly progressed toward the shadowed areas of the face and began shaping the jawline, ear, neck, and chin using the same collection of pencils. Going over the majority of skin tones with sharp-pointed Prismacolor Premier white, I "stabilized" the application of the more fluid "oil-based" pencils. This also lowered the intensity of the color mix, giving a more natural look to the skin tones. I smoothed the occasional unwanted strokes and merged the value and color transitions.

I further defined the lips and darkened the values of the upper lip and its cast shadow with Premier crimson lake and a bit of dark umber. I added a few touches to the lower lip with Premier burnt ochre and blended the lip edges into the skin tones using Premier light peach and Faber-Castell Polychromos medium flesh.

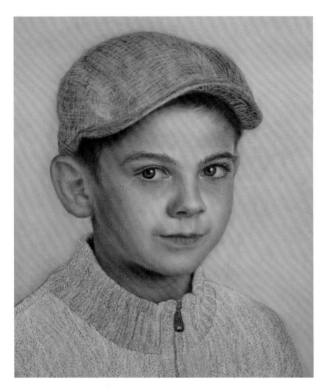

STEP 9 In the final stage, I adjusted the values using the same selection of colored pencils.

I worked on the overall colors of the cap in the same manner and added some touches of Prismacolor Premier permanent red and Spanish orange to the areas under the light, and permanent red, indigo blue, and burnt ochre to the shadows. To increase the contrast, I touched the darkest values of the hat with Premier black.

I shaped the curves of the sweater by going over the established white pattern with Faber-Castell Polychromos caput mortuum violet, burnt ochre, and burnt umber, and Premier burnt ochre and light umber, holding the pencil almost parallel to the surface. In this manner, the values were darkened while the light pattern was preserved.

I finished the piece by darkening the zipper's pull tab with Premier indigo blue, scarlet red, dark umber, and black and used some white for the highlights.

STEP 8 I worked on the darkest values with Faber-Castell Polychromos Prussian blue and caput mortuum violet, and Prismacolor Premier indigo blue, crimson lake, and dark umber. I touched the shadows lightly with Premier Spanish orange and permanent red. The reflected light on the jawline was created with Premier light peach and sand.

The pattern of the cap was addressed with Polychromos caput mortuum violet, Prussian blue, and burnt ochre, holding the pencil point almost parallel to the surface and skipping over the white pattern that was created earlier.

The impression of a knitted sweater was formed by applying sharp-pointed Premier white pencil following the direction of the pattern and using short striking strokes at slightly above-normal pressure.

Alyona Nickelsen,
Elijah, 2013, colored
pencil painting
on sanded paper,
14 x 11 inches

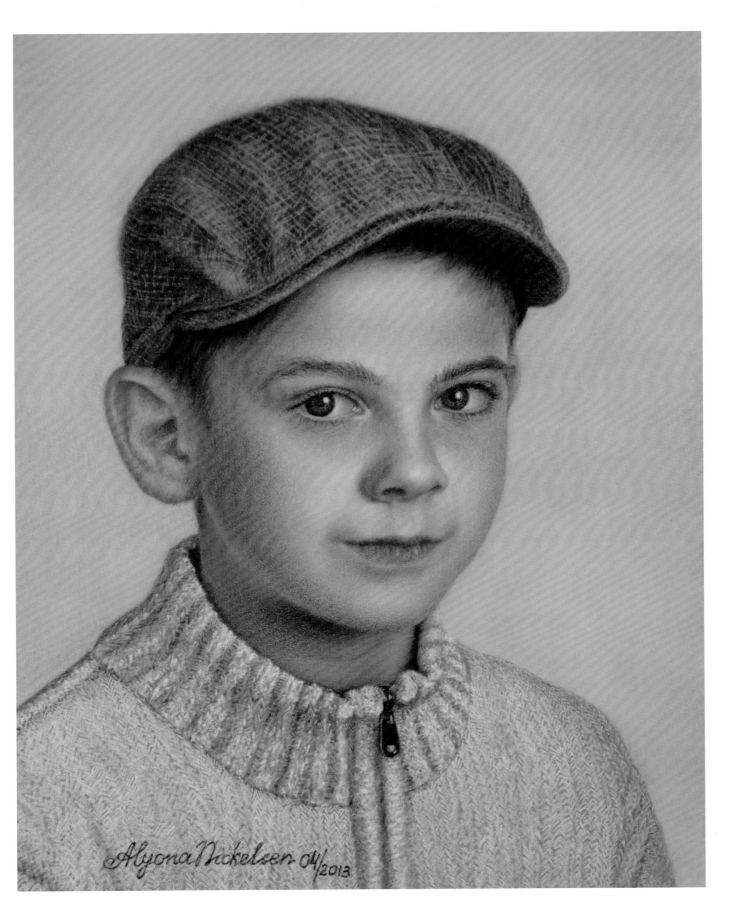

AlyonaNickelsen 04/2013

PROJECT 3. RYAN

Outgoing personalities often create an upbeat and exiting atmosphere during photo sessions. All at once, they present the artist/photographer with a wealth of information about the true nature of the subject and provide a perfect opportunity to document it via the magic of the camera lens; thus, our major task here is to play along, act swiftly, and take as many shots as we can. It is a good idea to always make sure you have an extra battery charged and an extra memory card handy, as time will fly and you would not want to miss that perfect shot. After the session, you can sift through the scores of images and select the best. Of course, the most successful would represent the most vivid impressions of the model.

Suggested colored pencils for this project:

- Prismacolor Premier colored pencils—white, cream, light peach, yellow ochre, goldenrod, cadmium orange hue, permanent red, crimson lake, light umber, dark umber, light aqua, muted turquoise, true blue, indigo blue, black

- Faber-Castell Polychromos colored pencils— cadmium yellow lemon, dark Naples ochre, light yellow ochre, dark cadmium yellow, cadmium orange, light flesh, medium flesh, dark flesh, rose carmine, pale geranium lake, deep scarlet red, burnt ochre, raw umber, burnt sienna, burnt umber, chrome oxide green, sky blue, cobalt blue-greenish, cobalt green, cobalt turquoise, Prussian blue

- Caran d'Ache Luminance colored pencils— anthraquinoid pink

- Faber-Castell Albrecht Durer water-soluble colored pencils—burnt umber, dark chrome yellow

STEP 1 Despite the blackout curtains on the windows, Ryan brought plenty of light into my studio. I'm not sure whether it was her radiant hair, stunning eyes, or the abundance of stories she had to tell, but I had the feeling that the sun was shining and the birds were singing while she was present. Additionally, she happened to be a budding artist and took the opportunity to draw my own portrait in between the photo shots. Unbelievable!

After looking through the endless string of lovely images, I selected the one in which Ryan had taken a few steps away from the camera and then suddenly turned back, looking straight at me. This shot had everything I wanted to preserve: her easygoing, bubbly personality and, of course, that gorgeous untamed hair. In my rendering, I opened the shadows of the face, modified the colors and values of the background, and fine-tuned the overall contrast to better frame the subject.

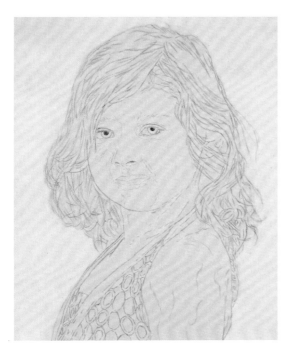 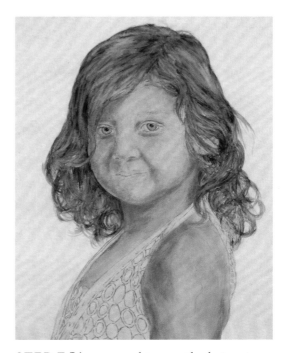

STEP 2 The outline was first transferred onto toothy sanded paper and reinforced with Prismacolor Premier light umber and dark umber.

I then worked on the background with a few layers of Faber-Castell Polychromos white, blended it with Powder Blender using a large rounded sponge, and secured it with ACP Textured Fixative in a few light layers, letting them dry completely in between.

STEP 3 I began working on the hair using Albrecht Durer burnt umber and dark chrome yellow watercolor pencils, separating darks and lights and illustrating its flow. Then, I lightly blended applied pencils with water using a synthetic brush and, again, followed the flow of the hair with every stroke. I finished the layer with a coat of ACP Textured Fixative and let the surface dry completely. (A hair dryer can be used to speed up the process.)

I began the overall underpainting of darks and lights on the face, neck, and shoulder with Faber-Castell Polychromos light yellow ochre and raw umber colored pencils. It was then blended with Powder Blender preparing a base for further development of skin tones and shapes.

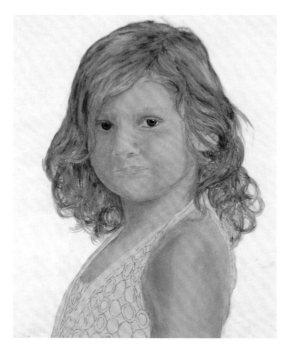

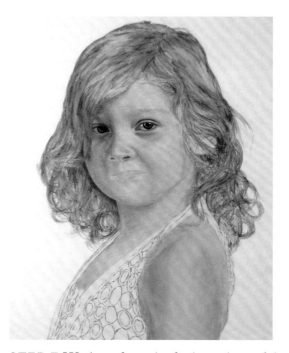

STEP 4 The pupils and irises of the eyes were darkened with Faber-Castell Polychromos burnt umber, chrome oxide green, and Prussian blue.

I continued the underpainting of skin tones with Faber-Castell Polychromos burnt ochre, light flesh, medium flesh, and dark flesh. The facial features, neck, and shoulder were then modeled using the wipe-off technique. To lighten values I lifted applied color with a sponge applicator, wiping it on a paper towel after each erasure. I also used a small piece of mounting putty for this purpose by gently rolling it across the area to be lightened. The entire underpainting was secured with ACP Textured Fixative.

STEP 5 Working from the farthest plane of the face in the shadow and moving toward the viewer, I began "sculpting" facial features by heightening protruding areas with Faber-Castell Polychromos white and then introducing reds, blues, and yellows to the skin tones with Faber-Castell Polychromos dark Naples ochre, dark cadmium yellow, sky blue, and rose carmine; Prismacolor Premier yellow ochre, light peach, burnt ochre, and cream; and Caran d'Ache Luminance anthraquinoid pink.

To shape the white of the eyes, I again used a combination of low intensity yellows, blues, and reds, making sure that the overall color mix was not biased too much toward any of them.

I darkened the creases of the eyelids and eyelashes with Prismacolor Premier light umber and dark umber. The brightest highlights of the eyes were created by applying touches of Titanium White and Touch-Up Texture mixture with a fine brush.

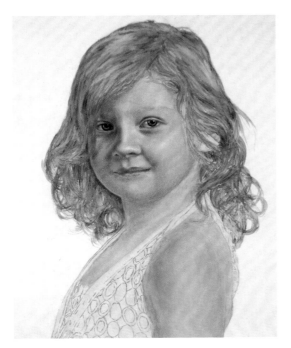

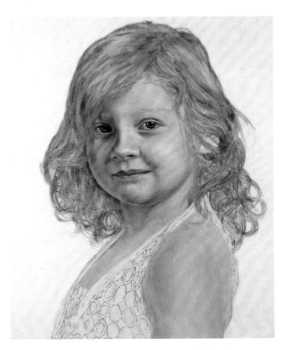

STEP 6 Continuing to shape the face, I gradually worked toward the lit areas in the same manner—the elevations were created by applying Prismacolor Premier white pencil and followed by cream, light peach, and Faber-Castell Polychromos light flesh and dark flesh.

The subject's nostrils were darkened with Prismacolor Premier burnt ochre and dark umber, and touched slightly with Faber-Castell Polychromos pale geranium lake. I then began shaping the nose itself, warming up colors at the junction of shadow and light with touches of Faber-Castell Polychromos dark cadmium yellow and premier permanent red. With the same colors I indicated the shape of the lips using short striking strokes and following the curves. The darkest values of the lips were then touched up with Prismacolor Premier crimson lake and tiny amounts of indigo blue.

STEP 7 The overall intensity of the face was toned down by scumbling it with a sharp pointed Prismacolor Premier white and a gentle light touch. This unified the pencil strokes and created smoother value and color transitions giving the skin surface a more natural appearance. During this entire process, when the tooth of the surface was filled, I sprayed it lightly with ACP Textured Fixative, letting it dry completely before proceeding further. This allowed me to darken values by adding more layers of pencil when necessary and deepen the darkest shadows to increase the contrast and better define the shapes.

The area of the neck was rendered using the same approach and the same selection of pencils.

The reflected light on the chin and the cheek in the shadow were created by lightly going over those areas with Prismacolor Premier white followed with light peach and touches of goldenrod.

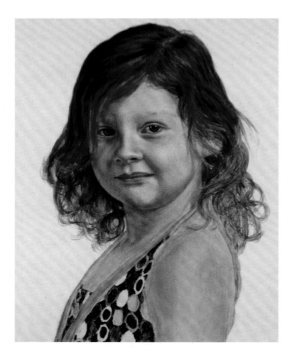

STEP 8 I achieved the darkest values of the hair by adding Faber-Castell Polychromos cadmium orange, raw umber, burnt sienna, and deep scarlet red; touches of Prussian blue; and Prismacolor Premier dark umber, goldenrod, cadmium orange hue, and indigo blue. I continued to interchange "oil-" and "wax-based" pencils, applying strokes lightly and following the flow of the hair. This allowed me to create all necessary adjustments up to the very final stage of the rendering.

The pattern of the dress was detailed according to the reference and using Faber-Castell Polychromos cobalt blue greenish, cobalt turquoise, cobalt green, and cadmium yellow lemon, and Prismacolor Premier black, white, indigo blue, muted turquoise, light aqua, and true blue.

STEP 9 Using mid and light yellows, as well as oranges from the same selection of colored pencils, I separated darks, mid values, and highlights of the hair. I made some alterations to a few curls and adjusted the overall hair color to its true appearance in real life. The lightest highlights were indicated with the mixture of Titanium White and Touch-Up Texture.

I finished shaping the neck and shoulder and finalized the look of the skin tones by going over them and lightly scumbling with Prismacolor Premier white, which created a smooth and unified appearance.

With a few more layers and moderate pressure I enhanced the colors of the dress pattern with the previously used color selection. Lastly, I covered the background with a layer of Prismacolor Premier white and sprayed the entire painting with ACP Final Fixative.

Alyona Nickelsen, *Ryan*, 2013, colored pencil painting on sanded paper, 14 x 11 inches

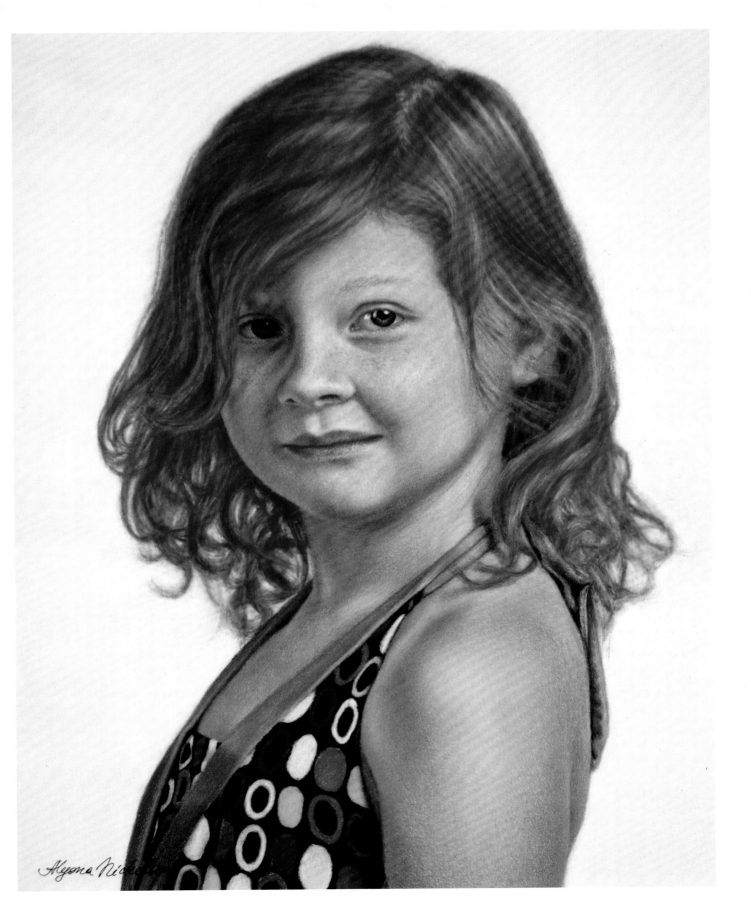

PROJECT 4. CALEB

A natural wish of teenage boys to become adults and to be treated like ones makes some of them look and act excessively serious during a photo session. In such cases, it is quite a challenge during a short meeting and being a complete stranger to convince them that displaying emotions or striking a more creative pose is not taking away from their maturity. Though it is possible to make them smile (or even giggle) for the camera if you are keeping up with the latest teenage trends or jokes, it is better to play along and reflect their "adult status" in the portrait. This will make them happy today and will make them smile years later.

Suggested colored pencils for this project:

- Prismacolor Premier colored pencils—dark umber, indigo blue, black, white, goldenrod, burnt ochre, mineral orange, permanent red, crimson red, pomegranate, jasmine, light umber, burnt umber

- Faber-Castell Polychromos colored pencils—burnt umber, dark indigo, black, white, light yellow ochre, magenta, rose carmine, pale geranium lake, deep scarlet red, caput mortuum violet, dark cadmium yellow, fuchsia, burnt carmine, dark flesh

- Caran d'Ache Pablo colored pencils—granite rose, salmon pink, Naples yellow, vermilion, gentian blue, white

- Lyra Rembrandt Polycolor colored pencils—sky blue

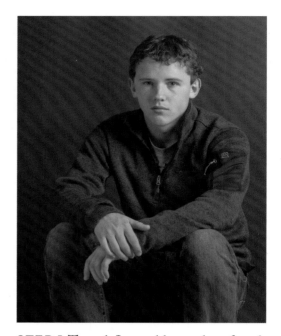

STEP 1 Though I was able to take a few shots with some evidence of Caleb's adorable smile, I decided to go with the flow and embrace his serious look in my choice for the reference. The view that attracted my attention featured a direct and open gaze straight into the camera and contrasting shadowed and lit areas of the face. The overall expression looked very natural and not staged. This composition presented me with a set of interesting textures, a wide range of values, and, I would say, a masculine but elegant color scheme to work with. This fit perfectly in a traditional portrait style, which has always been most appealing to me personally.

In my rendering, I cropped the image, adjusted contrast, and orchestrated the values in such a way that the attention of the viewer is immediately attracted to the subject's eyes.

STEP 2 I prefer to work on portraits by standing in front of an easel. In this manner, I can step back and immediately see if the values need to be darkened or lightened, the hue bias shifted, or the edges softened or sharpened. It is also helpful for keeping the overall facial features in perspective.

First, I transferred the initial outline onto sanded paper mounted on a sturdy board using Saral graphite transfer paper. I secured the edge guide on the opposite side from my working hand (I am right handed) and reinforced the outline with sharp-pointed Prismacolor Premier dark umber. Then I protected the subject portion with masking film and cut around the edges with an X-Acto knife (using a fresh, sharp blade).

STEP 3 In traditional colored pencil technique, the artist must maintain a sharp pencil point and a light touch and apply tight circular strokes; therefore, rendering a large, dark background would normally take a few days. However, this is not the case when using my new technique. The entire background here was finished quite effortlessly within just a couple of hours.

To begin, I applied the lightest color that I selected for the base color of the entire background: Faber-Castell Polychromos light yellow ochre. I applied it quickly holding the pencil at its end and gliding it across the entire background area without worrying much about either the neatness of my strokes or the sharpness of the pencil. Then, I used a large round sponge and Powder Blender to quickly blend my application of medium and evenly cover the entire background. I sprayed this layer with ACP Textured Fixative and let it dry completely. I followed in the same manner with Polychromos magenta and allowed some areas of the colors from the previous layer to show through and be slightly visible in the lightest parts of the background.

This layer was then secured with ACP Textured Fixative as well. To create the darkest values of the background, I used Polychromos dark indigo and black. I then removed the masking film and sprayed the background once more.

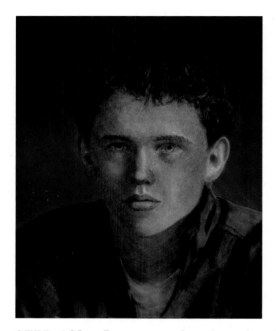

STEP 4 Next, I concentrated on the underpainting of the subject and defined its general shapes without concern about minute details. I worked with Faber-Castell Polychromos burnt umber in the darkest areas of the face and neck and applied the pencil lightly. Using sponges, short-bristle stencil brushes of various sizes, and Powder Blender, I spread the already applied medium farther into the rendering areas. To darken the values, I added more burnt umber and also introduced Faber-Castell Polychromos dark indigo. To lighten the values, I lifted them with a sponge applicator (using the wipe-off technique), cleaning the applicator by wiping it on a paper towel after each erasure.

I worked on the hair with the same pencils and blended the strands using a flat, short-bristle stencil brush from the darkest value toward the lightest with more pressure in the beginning of each stroke and less at the end, following the flow of the hair.

The overall shapes of the sweater folds were also developed with Faber-Castell Polychromos dark indigo, burnt umber, and black.

Finally, I secured and isolated the entire underpainting with ACP Textured Fixative.

STEP 5 After basic shadows were created with underpainting, I began developing the lit areas in the veiling layer. I used Faber-Castell Polychromos white and Prismacolor Premier white as well as titanium white to articulate the areas under the light. The white colored pencils were mostly used closer to the middle values, and titanium white, as the most opaque white, was used in the lightest values. Then, the white application was blended with Powdered Blender and short-bristle brushes and secured with ACP Textured Fixative. This also served to isolate the new foundation from the subsequent color layers.

STEP 6 Here, I introduced the first colors to the skin tones by glazing with Faber-Castell Polychromos rose carmine and Caran d'Ache Pablo vermilion. I then blended the applied pencils with a short-bristle stencil brush. This created color variations in the shadow and under the light. The hair was also glazed with Polychromos burnt ochre and light yellow ochre. Then, it was blended in the same manner following the flow of the hair.

STEP 7 I worked on the development of the facial features confirming often with my reference and edge guide to make sure that the likeness was maintained throughout the rendering. I further articulated the pupils with Prismacolor Premier indigo blue and black and added some color to the irises with Caran d'Ache gentian blue and Premier indigo blue, white, and a bit of jasmine. I worked on the whites of the eyes with Caran d'Ache granite rose, salmon pink, and white, and Lyra Rembrandt Polycolor sky blue. The creases of the eyelids were deepened with more Premier dark umber and crimson red. Eyebrows and eyelashes were indicated with Premier light umber and dark umber. I worked on the tones of the skin adjacent to the eyes with Premier goldenrod and jasmine, and Faber-Castell Polychromos dark flesh, fuchsia, and magenta. I then added touches of Premier permanent red and Polychromos dark cadmium yellow and deep scarlet red to the middle values.

STEP 8 The facial features were modeled further with the addition of Caran d'Ache Naples yellow to the lit areas, and Faber-Castell Polychromos burnt carmine and caput mortuum violet to the shadows. To create facial elevation, I applied Polychromos white and titanium white to the selected area and followed with additional colored pencil layers. I then darkened the nostrils with Prismacolor Premier dark umber and crimson red and shaped the lips and ears with Polychromos dark flesh and pale geranium lake and Premier mineral orange and burnt ochre. I then deepened the darkest values with more Prismacolor Premier dark umber, crimson red, and touches of indigo blue. The skin tones of the neck were developed with the same color selection, except that the overall values were kept darker and the color bias leaned toward low-key blues in the shadows and low-key warmer oranges in the lit areas.

The local color of the sweater and the darkest areas of the t-shirt were established with Prismacolor Premier indigo blue, black, pomegranate, dark umber, and mineral orange. When these colors mixed together, they created semineutral colors—various grays that were not consistent due to uneven application. I maintained the overall hue bias under the light leaning toward reddish low-intensity dark blue and with more blues and purples in the shadow. The strokes were applied unevenly with a striking motion using a hatching and cross-hatching approach and following the shapes of the folds to create the impression of the weave in the sweater.

STEP 9 In the last stages of development, I lightly scumbled skin tones with Prismacolor Premier white to create a smooth appearance and applied just a hint of Premier jasmine and Caran d'Ache granite rose. I then sprayed the entire figure lightly with ACP Textured Fixative and, after it had completely dried, created the brightest highlights on the hair, sweater, and T-shirt with Premier jasmine and white, and Lyra Rembrandt Polycolor sky blue. The brightest highlights on the eyes and lips were created with touches of titanium white over thoroughly dried Colored Pencil Touch-Up Texture. I also slightly sharpened the lit edge on the shirt with Premier white.

At the end, the entire rendering was sprayed with several layers of ACP Final Fixative to get it ready for varnishing and display without glass.

Alyona Nickelsen, *Caleb*, 2016, colored pencil painting on sanded paper, 16 x 13 inches

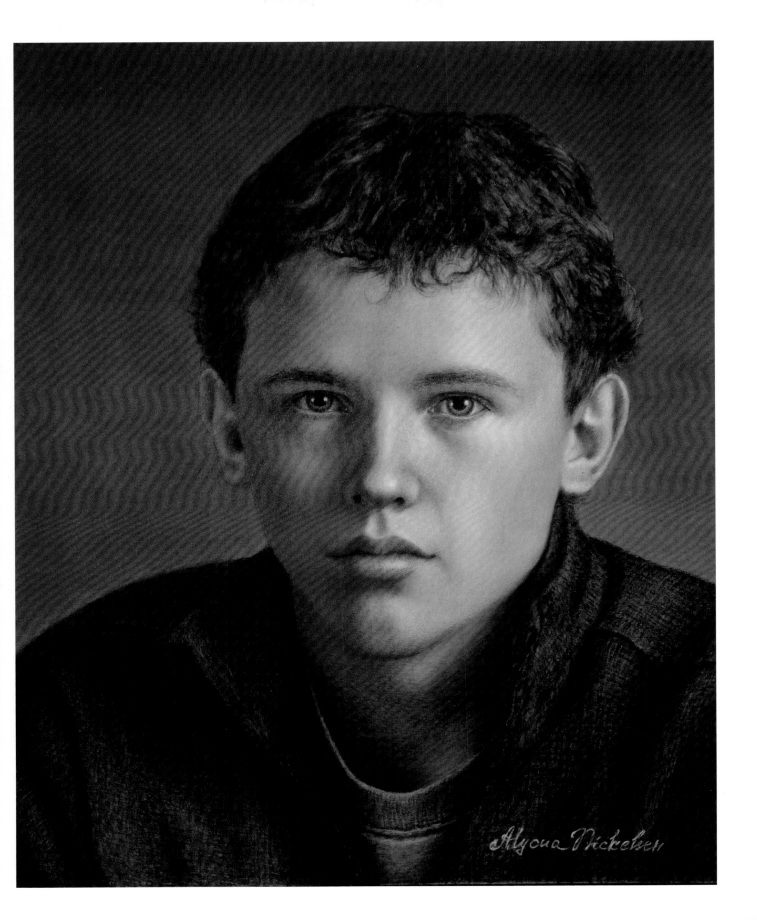

Alyona Nickelsen

PROJECT 5. JENNY

Though handling a photo session with adult models is easier in many aspects, it has its own challenges. For instance, adults are more experienced in having their photos taken and often have already formed their opinion about which clothes, makeup, hairdo, pose, and light makes them look more attractive. Of course, as an artist/photographer you must respect the wishes of your client, but when such convictions do not really have a "solid base" they can be easily convinced otherwise just by offering better alternatives. For example, clothing with busy patterns or numerous accessories could be distracting or could simply "not fit" within your vision of the portrait. So, asking the model to dress accordingly in advance or bring a change of clothing can be very beneficial. Or, let's say the makeup of your model does not enhance but instead obstructs her natural beauty. Then you might have to create two sets of images (with and without makeup) to choose from. Thankfully, in the era of digital photography, the extra pictures are not much of a burden to create and the cost of materials will not break the bank.

Suggested colored pencils for this project:

- Prismacolor Premier colored pencils—white, yellow ochre, Spanish orange, goldenrod, mineral orange, sand, light peach, permanent red, crimson red, crimson lake, light umber, burnt ochre, sienna brown, dark umber, indigo blue, black

- Faber-Castell Polychromos colored pencils— light yellow ochre, cadmium orange, madder, burnt umber, sky blue, dark indigo

- Caran d'Ache Luminance—apricot, anthraquinoid pink

- Caran d'Ache Pablo—salmon pink, vermilion

STEP 1 I had met Jenny on a few occasions before we even discussed the idea of conducting a photo session or a portrait. Each time, I was completely taken over by her cheerful and joyful personality. Her smile was so contagious that you just could not help but to smile back even if you were in the gloomiest of moods. Of course, in the portrait I wanted to showcase her signature smile, but even more so her natural beauty. So I asked her to wear "something plain" with a minimum of makeup. This strategy worked out really well. We both were very happy with the outcome.

In this rendering, I cropped the bottom of the original image and enhanced the overall contrast just a bit.

STEP 2 I prepared my working surface by covering 4-ply White Rising Museum Board with a few coats of clear Liquitex acrylic gesso. The gesso was thinned with water to a consistency of skim milk and applied in a few thin layers with a spray gun. That was left to dry and cure for no less than 24 hours. As a result, I had a working surface with very fine but very durable tooth.

I transferred the outline onto my new working surface with Saral graphite paper.

I made sure that the location of the eyes, nostrils, and lips was accurate and secured the lines with Prismacolor Premier light umber colored pencil.

STEP 3 I worked on the background with Faber-Castell Polychromos burnt umber, holding the pencil at its very end and lightly applying it to cover the entire area very quickly. I then blended the applied pencil with my finger protected by a cot, followed by more layers that were blended using Powder Blender and a sponge applicator. The background was sprayed lightly with ACP Textured Fixative. This created a smooth, even coverage with no visible direction of pencil strokes. Working on a toothy, rigid surface truly makes a difference as far as time and effort is concerned. Using this method, the coverage of the background takes a fraction of the time compared to working on traditional cotton papers.

The entire hair was underpainted with Polychromos cadmium orange, blended with a finger protected by a cot and lightly washed with Gamsol OMS. This stained the surface but did not fill its tooth, allowing me to follow with many layers of colored pencil.

STEP 4 I darkened the background with Faber-Castell Polychromos dark indigo and madder, creating a dark, low-intensity purple color mix. I blended the applied pencils with Powder Blender and sprayed lightly to secure with ACP Final Fixative.

The skin tones were then underpainted with Polychromos light yellow ochre. I lifted the applied pencil with a sponge applicator to indicate the elevations, which is similar to the wipe-off technique used in oil painting. The underpainting was secured and isolated with ACP Textured Fixative.

The irises and pupils were darkened with Polychromos burnt umber.

STEP 5 With Prismacolor Premier crimson lake, dark umber, and indigo blue, I began shaping the hair by darkening its values according to the reference. I used a sharp point and a normal touch, following the flow of the hair with my strokes. I worked on the hair from the farthest and darkest areas toward the lightest. I created the texture of the hair by lightening some values and lifting others with waxed paper. Unlike removing mediums with the adhesive of Scotch tape, waxed paper provides you with the ability to lighten the value without disturbing the surrounding areas. I then created the thinnest and lightest highlights by scraping them with an X-Acto knife, revealing the white of the original working surface.

I added touches of Premier sienna brown, yellow ochre, and Spanish orange to the lit areas of the hair and blended it lightly with a coarse-bristle brush to provide a more natural look.

STEP 6 Here, I began modeling the forehead by gradually adding reds, darkening values with browns, and "pushing" features backward with blues. I introduced new hues carefully and alternately to be in complete control of the hue bias, value, and the intensity of the color mix. In the shadowed areas, I worked with Prismacolor Premier mineral orange, crimson lake, sienna brown, dark umber, and touches of indigo blue. In the middle values, I used Premier goldenrod, crimson red, and burnt ochre. In the lit areas, I applied Premier sand, light peach, yellow ochre, and a bit of permanent red.

STEP 7 White has a tendency to make previously applied colors look lighter, cooler, and less intense. So, to tone down the chroma, cool the hue, and lighten the value, as well as to indicate the elevations of the facial topography, I worked lightly with Prismacolor Premier white or titanium white and followed with more layers of the previously used colors to adjust the properties of the color mix when necessary.

Here, I also began defining the brows, the irises, and the eyelashes with Premier dark umber and light umber.

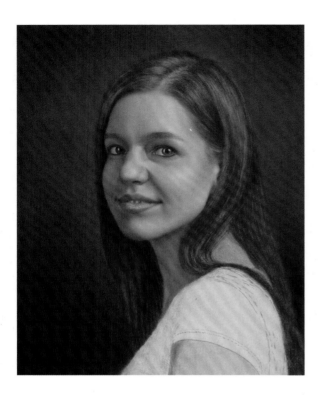

STEP 8 To warm up the color mix, I went over it with Caran d'Ache Luminance apricot and anthraquinoid pink, and Caran d'Ache Pablo vermilion and salmon pink. I continued to define the brows with Premier sienna brown, crimson red, and dark umber. I softened their edges with the help of Powder Blender, working with the edge of a sponge applicator. The pupils of the eyes, eyelashes, irises, and creases of the eyelids were further developed with Prismacolor Premier dark umber, crimson red, and burnt ochre, and then darkened with indigo blue and touches of black. The whites of the eyes were shaped with a light application of Pablo salmon pink, Premier sand, and Faber-Castell Polychromos sky blue. Then I went over them with Premier white and touched the corners of the eyes and the eyelids with Luminance anthraquinoid pink and Polychromos madder.

STEP 9 I finished shaping facial features, maintaining the color bias of the mix leaning toward warm yellows, oranges, and reds in the lit areas and toward cooler blues and purples in the shadows. With the use of Faber-Castell Polychromos dark indigo and madder, I "pushed" the shadowed areas back more. To create the impression of elevations on the face, I used Prismacolor Premier white and followed with more layers of previously used colors. The lips were shaped with Caran d'Ache Luminance anthraquinoid pink followed by Prismacolor Premier crimson red and dark umber. Then, I worked on them with Premier white to create natural texture and darkened corners with more crimson red, Caran d'Ache Pablo vermilion, and touches of Premier dark umber and indigo blue. A few touches of Premier burnt ochre warmed up the color mixes. The neck was created in the same manner, though the color bias leaned more toward cooler reds and purples. The intensity of its color mix was lowered to indicate the shadow and a farther plane compared to the face. The arm was shaped in the same manner, but the color bias leaned toward warmer yellows and oranges to indicate that the plane is closer to the viewer than the neck. The white of the blouse was composed of a combination of Pablo salmon pink, Polychromos sky blue, and Premier sand. The color transitions were blended with Powder Blender and finalized with Premier white and touches of titanium white. The highlights on the eyes and the lips were created with touches of opaque titanium white applied over Colored Pencil Touch-Up Texture. The overall painting was then sprayed with a few light coats of ACP Final Fixative.

Alyona Nickelsen, *Jenny*, 2014, colored pencil painting on acrylic gesso, 18 x 14 inches

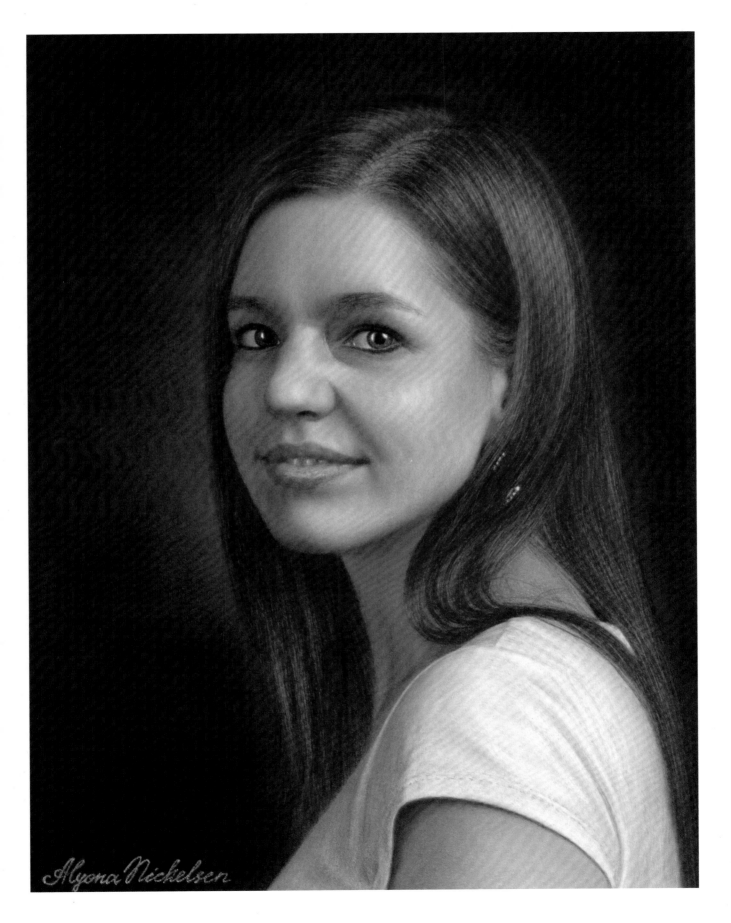

Alyona Nickelsen

AFTERWORD

"If you don't know where you are going, you might wind up someplace else."

—YOGI BERRA

Making and implementing a goal (in art and beyond) is sometimes not that straightforward, but if you know what you like, you are already halfway there. The other half is just figuring out how to get there.

To know what you truly like, you must be very honest with yourself. It is a very personal thing and cannot be based on someone else's opinion or expertise. Often, you may not even know why you like or love something (or someone). It just is. And this is probably the best indicator of authenticity.

Reaching the goal of getting something that you like may not be easy, but it is certainly easier than getting something that you do not like or want—where there's a will, there's a way. Remember back in your school days how you were sometimes so sleepy and tired while doing boring homework? Oh wait, tomorrow is a snow day (or some other reason) and there will be no school! Did you go to sleep right away? Or suddenly feel that you were not that tired and watched your favorite movie instead? Your will gives you strength and stamina. It allows you to go that necessary extra mile or put that essential extra effort into being successful and accomplishing your goals.

My goal in writing this book was to put together a comprehensive work that makes the case for colored pencil to be considered as a serious art medium with significant potential, using the portrait genre as an example. You be the judge of whether I reached my goal and proved my case; however, I can tell you that the process was a true labor of love—not always easy and pleasant, but continually passionate and determined.

My hope is that now that you have read this book, you will look at colored pencil in a new way, not as just a drawing tool but as a unique medium that is precise and

spontaneous, manageable and stable, clean and healthy, portable and comfortable. Regardless of your personal preferences or style, colored pencil has the capabilities you need to fulfill them all. It just takes a true understanding of the natural properties, right surface, correct approach, and set of tools to manipulate it the way you want. It is also my hope that manufacturers will listen more to the needs of their consumers and change their attitude toward their own product, as it is so much more than a stick of colored wax in a wood casing.

Over the years, I have tried to do my part in revolutionizing colored pencil tools and techniques, and I have been gratified by the feedback from people who have used my products. When acclaimed artist Lisa Clough-Lachri reached out to me with the following feedback, I knew I had to share one of her pieces in my book to show that my colored pencil painting technique is not just for portraits but can be used in a variety of styles—and to encourage all of my readers to try my techniques regardless of subject matter:

"Working with the Powder Blender and ACP Fixatives opened up a whole different style for me with colored pencils. In the past, I avoided working in surrealism with my pencils because I typically change my mind so much during the painting process with my designs. Traditionally, working with this medium required extreme planning because changes are so hard, if not impossible, to make. With Powder Blender I was able to erase, layer, and change things like I've never been able to do before! I even used a stencil with an eraser to create my textured background. As if I wasn't excited enough about those features, it allowed me to work extremely fast. I completed this large piece after three evenings of work instead of the usual two weeks it would have taken me for something this size!"

Lisa Clough-Lachri, *Orcas*, 2016, colored pencil on sanded paper, 15 x 23 inches

In conclusion, I would like to share a few words that came somewhere from the depths of the World Wide Web Universe.

"THE PARABLE OF THE PENCIL"

The Pencil Maker took the pencil aside just before putting him into the box. "There are five things you need to know," he told the pencil, "before I send you out into the world. Always remember them and never forget, and you will become the best pencil you can be.

ONE: Everything you do will always leave a mark.

TWO: You will be able to correct the mistakes you make.

THREE: What is important is what is inside of you.

FOUR: You will undergo painful sharpening from time to time, which will only make you better.

FIVE: You will be able to do many great things, but must allow yourself to be held and guided by the hand that holds you."

APPENDIX

The following is an analysis of the blending properties of selected colored pencil brands. For comparison, selected pencils from each brand that represent major color groups were applied on a cotton-based surface and on a nonabsorbent surface in single dense layers. Then, colored pencil swatches were blended with Prismacolor Colorless Blender, a coarse-bristle brush, and a set of the best-performing solvents. Each component of the colored pencil core is affected in its own way by different types of solvents. The results presented here were judged by the solvent's ability to "fill in the gaps" between applied pencil strokes with the following ratings:

● = excellent, when the majority of strokes were transformed into uniform coverage of the surface

● = satisfactory, when the individual strokes are significantly blurred and the space between them was mostly covered

● = poor, when the appearance of the pencil strokes as practically unchanged and the space between them was insignificantly colored

Colored pencil's performance when applied to cotton and sanded surfaces

	GAMSOL ODORLESS MINERAL SPIRITS	NATURAL ORANGE TERPENE SOLVENT	WEBER TURPENTINE NATURAL	RUBBING ALCOHOL	COPIC SKETCH COLORLESS BLENDER	LETRASET COLORLESS BLENDER MARKER	FINESSE COLORED PENCIL BLENDER PEN	PRISMACOLOR COLORLESS BLENDER MARKER
PRISMACOLOR PREMIER								
ABSORBENT COTTON-BASED SUPPORT	●	●	●	●	●	●	●	●
NONABSORBENT TEXTURED SUPPORT	●	●	●	●	◐	◐	◐	○
PRISMACOLOR VERITHIN								
ABSORBENT COTTON-BASED SUPPORT	●	●	●	●	◐	◐	●	●
NONABSORBENT TEXTURED SUPPORT	●	●	●	●	●	●	●	●

PRISMACOLOR PREMIER

A selection of 150 colors with an impressive representation in light, mid, and dark ranges of values in all major color groups. Throughout the entire collection the pencil cores seem to be soft and uniformly deliver plenty of pigment, though they are prone to breakage during sharpening. Current pigment lightfastness information is disclosed on the manufacturer's website (www.prismacolor.com). These pencils perform well using the layering technique on cotton surfaces. When pencils are layered onto a nonabsorbent surface, the waxes of the core binder grip its tooth and prevent dry pencil marks from easy smearing or blending. Multilayered pencils on cotton and sanded surfaces gradually reduce the friction, which limits layering. These colored pencils are not easily blended with dry Prismacolor colorless blender or a coarse-bristle brush.

PRISMACOLOR VERITHIN

This selection of 40 colors provides a limited representation of color, especially in the lighter range of values and the entire group of browns. The pencil core has a small diameter, feels hard but not stiff, deposits sufficient amount of pigment, and quite impressively maintains its sharp point. The manufacturer provides lightfastness information on its website (www.prismacolor.com). Pencils deposit color with a unified appearance on a cotton surface, perform well in the layering technique, and are indispensable for delicate shading, small details, and sharp edges. When these pencils are applied to nonabsorbent textured surfaces, blending with a coarse-bristle brush is both easy and productive.

BLENDING ABILITY WITH VARIOUS TYPES OF SOLVENTS

Colored pencil's performance when applied to cotton and sanded surfaces

	GAMSOL ODORLESS MINERAL SPIRITS	NATURAL ORANGE TERPENE SOLVENT	WEBER TURPENTINE NATURAL	RUBBING ALCOHOL	COPIC SKETCH COLORLESS BLENDER	LETRASET COLORLESS BLENDER MARKER	FINESSE COLORED PENCIL BLENDER PEN	PRISMACOLOR COLORLESS BLENDER MARKER
CARAN D'ACHE PABLO								
ABSORBENT COTTON-BASED SUPPORT	●	●	●	●	●	●	●	●
NONABSORBENT TEXTURED SUPPORT	●	●	●	●	●	●	●	●
CARAN D'ACHE LUMINANCE								
ABSORBENT COTTON-BASED SUPPORT	◐	●	◐	●	●	●	●	●
NONABSORBENT TEXTURED SUPPORT	●	●	●	◐	◐	◐	◐	◐

CARAN D'ACHE PABLO

A set of 120 colors with a balanced selection for all major color groups. The lightfastness information is disclosed on the manufacturer's website (www.carandache.com). The pencil core feels soft and smooth, and delivers consistently abundant quantities of pigment. These pencils maintain a sharp point for a significant period of time and do not crumble under normal pressure. They perform beautifully in multilayering techniques on cotton surfaces and blend effortlessly with a coarse-bristle brush when applied to nonabsorbent textured surfaces.

CARAN D'ACHE LUMINANCE

A selection of 76 colors with exceptional pigment lightfastness. (Additional information is available on the manufacturer's website, www.carandache.com.) The line has a considerable presence of grays and browns, though it is somewhat limited in the lighter values of reds, blues, and greens. Some pencils have a more chalky feel; however, the majority of the cores are soft, maintain a sharp point well, deliver plenty of pigment, and perform excellently in the multilayering technique. A significant quantity of wax in the cores makes lines more stable on rigid surfaces and inhibits easy blending or smearing.

Colored pencil's performance when applied to cotton and sanded surfaces

	GAMSOL ODORLESS MINERAL SPIRITS	NATURAL ORANGE TERPENE SOLVENT	WEBER TURPENTINE NATURAL	RUBBING ALCOHOL	COPIC SKETCH COLORLESS BLENDER	LETRASET COLORLESS BLENDER MARKER	FINESSE COLORED PENCIL BLENDER PEN	PRISMACOLOR COLORLESS BLENDER MARKER
FABER-CASTELL POLYCHROMOS								
ABSORBENT COTTON-BASED SUPPORT	●	●	●	●	●	●	●	●
NONABSORBENT TEXTURED SUPPORT	●	●	●	●	●	●	●	●

A 120-color selection that has a great representation of major color groups, though it is somewhat limited in the light-value range of blues and greens. Lightfastness information can be found directly on the pencil labels. The pencil glides flawlessly across a cotton surface, easily saturating it with pigment. These pencils maintain a sharp point for a significant period of time and do not crumble during sharpening or under normal pressure. They are great for producing thin lines and delicate shading, or when used in the multilayering technique. These pencils are easily blended with just a coarse-bristle brush when applied to a nonabsorbent surface.

LYRA REMBRANDT POLYCOLOR								
ABSORBENT COTTON-BASED SUPPORT	●	●	●	●	●	●	●	●
NONABSORBENT TEXTURED SUPPORT	●	●	●	●	●	●	●	●

A 72-color selection that has a limited representation of colors in the light-value range. Lightfastness information is not currently provided by the manufacturer (www.lyra.de). Pencils feel extremely smooth and effortlessly glide across the cotton surface. They do an excellent job of producing thin lines, performing very well in the multilayering technique, maintain a sharp point for a significant period of time, and deposit a good amount of pigment. Pencils sharpen well and do not crumble under normal pressure. On nonabsorbent surfaces these pencils are easily blended with a coarse-bristle brush and are superb for creating seamless value or color transitions and gradations.

Colored pencil's performance when applied to cotton and sanded surfaces

	GAMSOL ODORLESS MINERAL SPIRITS	NATURAL ORANGE TERPENE SOLVENT	WEBER TURPENTINE NATURAL	RUBBING ALCOHOL	COPIC SKETCH COLORLESS BLENDER	LETRASET COLORLESS BLENDER MARKER	FINESSE COLORED PENCIL BLENDER PEN	PRISMACOLOR COLORLESS BLENDER MARKER
DERWENT COLOURSOFT	**ABSORBENT COTTON-BASED SUPPORT**							
	●	●	●	●	●	●	●	●
	NONABSORBENT TEXTURED SUPPORT							
	●	●	●	●	●	●	●	●
DERWENT ARTISTS	**ABSORBENT COTTON-BASED SUPPORT**							
	●	●	● (light)	●	●	●	●	●
	NONABSORBENT TEXTURED SUPPORT							
	●	●	●	●	●	●	●	●

DERWENT COLOURSOFT

A 72-color selection that reasonably represents all color groups. Lightfastness information is available on the manufacturer's website (www.pencils.co.uk). Overall, these pencils feel very soft, however, not equally throughout the entire collection. Some feel slightly harder or have a chalkier consistency but are still smooth and deposit pigment evenly. On cotton surfaces, these pencils glide easily and work perfectly in the multilayering technique. Due to the softness of the core, they require frequent sharpening to maintain the point and often crumble under normal pressure. The excessive amount of wax in the core does not make it easy to blend with a coarse-bristle brush on nonabsorbent surfaces.

DERWENT ARTISTS

A selection of 120 colors with a fair representation of all major color groups. Lightfastness information is available on the manufacturer's website (www.pencils .co.uk). The pencil cores feel soft and a bit waxy. Pencils beautifully hold their sharp point, deposit plenty of pigment, do not crumble under normal pressure or during sharpening, and easily produce hard lines, create delicate color or value transition, and perform well in the multilayering technique. These pencils are also easy to blend with a coarse-bristle brush on nonabsorbent surfaces.

Colored pencil's performance when applied to cotton and sanded surfaces

	GAMSOL ODORLESS MINERAL SPIRITS	NATURAL ORANGE TERPENE SOLVENT	WEBER TURPENTINE NATURAL	RUBBING ALCOHOL	COPIC SKETCH COLORLESS BLENDER	LETRASET COLORLESS BLENDER MARKER	FINESSE COLORED PENCIL BLENDER PEN	PRISMACOLOR COLORLESS BLENDER MARKER
BLICK STUDIO ARTIST'S								
ABSORBENT COTTON-BASED SUPPORT	●	●	●	●	●	●	●	●
NONABSORBENT TEXTURED SUPPORT	●	●	●	●	●	●	●	●
SOHO URBAN ARTIST								
ABSORBENT COTTON-BASED SUPPORT	●	●	○	●	●	●	●	●
NONABSORBENT TEXTURED SUPPORT	●	●	●	●	●	●	●	●

BLICK STUDIO ARTIST'S

A selection of 91 colors with a limited representation in the light range of blues, violets, greens, and browns. Lightfastness information is disclosed on the manufacturer's website (www.dickblick.com). Pencils feel smooth in layering on cotton surfaces; however, they are prone to crumbling during sharpening as well as actual pencil application under normal pressure. Frequent resharpening is required to maintain the point. These pencils are easily blended with a coarse-bristle brush when applied to a nonabsorbent surface.

SOHO URBAN ARTIST

A selection of 72 colors with equally presented major color groups, though a bit limited in the range of light reds and greens. Lightfastness information is currently unavailable on the manufacturer's website (www.jerrysartarama.com). The pencil core seems to be firm but smooth. Pigment is consistently deposited and a sharp point is easily maintained over longer periods, allowing you to create a uniform line thickness. On nonabsorbent surfaces they can be blended to some extent with a coarse-bristle brush.

Colored pencil's performance when applied to cotton and sanded surfaces

	GAMSOL ODORLESS MINERAL SPIRITS	NATURAL ORANGE TERPENE SOLVENT	WEBER TURPENTINE NATURAL	RUBBING ALCOHOL	COPIC SKETCH COLORLESS BLENDER	LETRASET COLORLESS BLENDER MARKER	FINESSE COLORED PENCIL BLENDER PEN	PRISMACOLOR COLORLESS BLENDER MARKER
BRUYNZEEL DESIGN								
ABSORBENT COTTON-BASED SUPPORT	◐	●	◐	●	●	●	●	◐
NONABSORBENT TEXTURED SUPPORT	●	●	●	●	●	●	●	●
HOLBEIN ARTISTS'								
ABSORBENT COTTON-BASED SUPPORT	●	●	●	●	●	●	●	●
NONABSORBENT TEXTURED SUPPORT	●	●	●	●	●	●	●	●

BRUYNZEEL DESIGN

A selection of 48 colors with a reasonable representation of major color groups, though it is lacking colors in the light ranges of blues, greens, violets, and browns. Lightfastness information is currently unavailable. The color names are not printed on the pencils and are identified only by number and colored pencil ends. Cores feel exceptionally soft and smooth during application on cotton surfaces. Pigment is deposited consistently, saturating the paper with brilliant colors; however, these pencils often break during sharpening, and the point tends to crumble under normal pressure. With some difficulty they can be blended with a coarse-bristle brush on nonabsorbent surfaces.

HOLBEIN ARTISTS'

A selection of 150 colors with an impressive representation of all major color groups. Lightfastness information is not available. The cores feel exceptionally soft, smooth, and saturated with color. These pencils consistently deliver pigment, perform great in layering, maintain a sharp point for a fairly long period, do not crumble under normal pressure, and practically do not break during the sharpening process. Blending on nonabsorbent surfaces with a coarse-bristle brush is not very effective.

ABOUT THE AUTHOR

Alyona Nickelsen, born and raised in Ukraine, immigrated to the United States in 1999, where she pursued a successful career as a professional artist. Alyona has dedicated her life's work to advancing colored pencil painting techniques and promoting her favorite medium. To do this, she has developed a range of methods and materials that allow the once-limited colored pencil medium to challenge such traditional favorites as oil paints in most performance aspects. Alyona's art has received numerous awards and recognitions, and has been featured in a number of national and international publications, including *The Artist's Magazine*, *International Artist*, and *Colored Pencil* magazine. Alyona is the author of the best-selling book *Colored Pencil Painting Bible*, which is highly praised by artists at all levels of expertise, has an impressive base of fans and followers, and has been translated into the Chinese and Korean languages. Alyona Nickelsen currently resides in the state of Texas with her family and continues researching, teaching, creating, and inspiring. Visit her website at www.BrushAndPencil.com.

INDEX